GOETHE ON ART

FOR P.K.

GOETHE ON ART

SELECTED, EDITED AND TRANSLATED BY

John Gage

UNIVERSITY OF CALIFORNIA PRESS

BERKELEY AND LOS ANGELES

List of Illustrations

Introduction

Although Germany was the original home of modern aesthetics, of the art-periodical, and of the systematic study of the history of art, all of which developed there during the second half of the eighteenth century, the criticism of art came late to the German-speaking countries, and they have little to set beside the writings of Diderot or Hazlitt, Ruskin or Baudelaire, either in quality or extent. It is easy to account for this anomaly on the purely practical ground that the political divisions of Germany during the eighteenth and nineteenth centuries led to an artistic provincialism, and to a meagreness in the super-structure of teaching institutions and exhibiting societies, which gave little encouragement to the growth of this type of literature. The large Paris *Salon* from the 1740s and the London Exhibition from the 1760s, together with the Academies which supplied them, attracted a wide public, and, consequently, a good deal of journalistic attention; but there was nothing comparable in Germany until towards the end of the nineteenth century. It is not surprising that the most sustained body of German Romantic art-criticism should have been Friedrich Schlegel's *Descriptions of Paintings in Paris and the Netherlands in the Years 1802-1804*, or that this critic's only substantial treatment of modern art should have been an essay on an exhibition of German artists held in Rome in 1819. From Goethe's Weimar came a cultural periodical with the ominously exclusive title of *London und Paris*. It is thus astonishing that Weimar is the origin of the most extensive and most impressive art-criticism of the German Romantic period – except that this criticism comes from Goethe himself.

There can be no doubt of the importance of art to Goethe's spiritual development. 'I lived among painters', he wrote in his autobiography, 'and learned, like them, to look at objects with the eye of an artist ... The eye was the organ, *par excellence*, through which I apprehended the world.'[1] Goethe's way of approaching experience visually became so insistent and so notorious that a critic of his novels in 1810 characterized him as merely the cool, detached painter of life: 'time has turned him into a spectator'.[2] The poet's visual interests were not only astonishingly various, but

show too an extraordinary degree of commitment to the idea of art both as an aesthetic pleasure and as a mode of expression. What was the nature of this variety and this commitment, which is the chief justification for this anthology of Goethe's critical writings? Like all great critics, Goethe wrote largely about himself, and his art-criticism has hitherto been presented chiefly with a view to the further exploration of his character as a writer. To reverse the emphasis, to examine his role as a commentator on art, in the context of his experience of it, is a more delicate task than it might at first sight seem. On the face of it, Goethe carried out a thoroughly organized critical campaign: he founded two periodicals, the *Propyläen* and *Kunst und Altertum* (*Art and Antiquity*), as mouthpieces for his views, and between 1799 and 1805 he ran a series of annual prize-competitions for painting, according to a rigorously prescribed canon of Neo-classical style and subject-matter. Yet neither of his periodicals really established itself, and the competitions were notably unproductive – the most significant entry was submitted to the last competition by the landscape-painter Caspar David Friedrich, who had paid no attention to the rubric. That Friedrich's landscape drawings were allowed to compete at all gives us a clue to what makes Goethe an original and interesting critic: the rules are constantly bent to allow for individual cases and particular enthusiasms. We are reminded of Baudelaire, who, in his *Salon* of 1859, delivered a lengthy rhapsody on the pastel sky-studies of Eugène Boudin, none of which was exhibited. Goethe is quite unlike Schlegel in this, for Schlegel's *Descriptions*, perceptive as they sometimes are, and influential as they came to be (not least on Goethe), were written to support the thesis that the highest art is, in the most obvious sense, symbolic and religious.

The looseness of Goethe's frame of reference is witnessed by the forms his criticism took. A glance at the present collection will show that it is the characteristic production of a man of letters, rather than that of a professional critic: Platonic dialogues, a short letter-novel, reviews of books as well as of exhibitions; few of them have the relentless single-mindedness of the manifesto. And many of Goethe's most vivid observations on art and artists were never published by him, for they are asides in letters or conversations. Some of the projected articles which promise to have been especially interesting, such as the studies of dilettantism and of landscape painting, and the essays on Fuseli (pp. 220-1) and David, remained notes, or less; and Goethe wrote nothing sub-

stantial at all on Dürer, who was one of his most constant heroes
in art (Fig. 8).[3] Goethe never reduced his thoughts to systems in the
manner of his friend and collaborator Schiller, or of Jean Paul
Richter: his criticism is in every sense occasional.

Goethe had no obvious qualifications for becoming a great critic
of art. He drew enthusiastically all his life, and even supported the
publication of engravings after his drawings as late as 1821, but the
large *Corpus* of his work which has now been published[4] reveals
scarcely more than a mediocre talent (in an age when sketching
was very much the fashion), and the emphasis on technique which
is such a feature of his criticism reflects perhaps only the desperate,
helpless curiosity of an amateur who knew – as Goethe knew from
the time of his Italian journey in the 1780s – that he could never be
anything else. Some of his early drawings (for example, Fig. 1)
are interesting adumbrations of a new type of landscape which
was to occupy Friedrich some thirty years later, and they help to
explain Goethe's sympathy with Friedrich's aims. But his inability
to develop a visual idea into something substantial might well
lessen our confidence in his understanding of the more complicated
procedures of art. The same could, however, be said of Ruskin,
who was a far more talented draughtsman than Goethe. Beside
the apparent insistence on high execution and finish, far beyond
his own range, Goethe showed a marked enthusiasm for sketches
of the most summary kind, very much in the spirit of his own
work (Fig. 2), and his collection was rich in this sort of material.[5]
More important, although by his day the taste for slight and
vigorous sketches had become a conventional one, Goethe put his
interest in them – for example in the essays on Mantegna – to the
unconventional task of reconstructing the process of visual
creation.

And Goethe's attempts to be himself an artist were perhaps
responsible for his expectations that the artist should be a whole
man, rather than the amiable but narrow-minded eccentric of the
traditional image, which was still being given currency in his day,
for example in Wackenroder's *Effusions from the Heart of an Art-Loving
Monk* (1797).[6] Goethe presented the artist as a man among men,
sensitive to a whole range of human experiences, and taking upon
himself the problems of his social milieu. It was this sort of artist –
a Friedrich, a Géricault, a Goya, a Turner – who was responsible
for the extraordinary expansiveness of Romantic art. Perhaps more
than any of his contemporary critics, Goethe saw that the situation

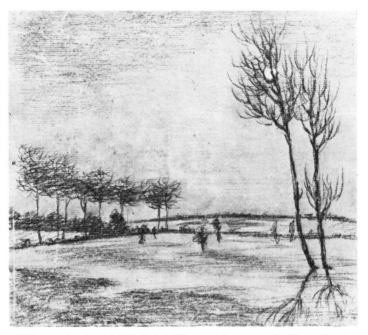

1 J. W. von Goethe, *Moolight Night in Winter at Schwansee*, 1777/8. Charcoal and white chalk, 238 × 268mm. Weimar, Goethehaus.

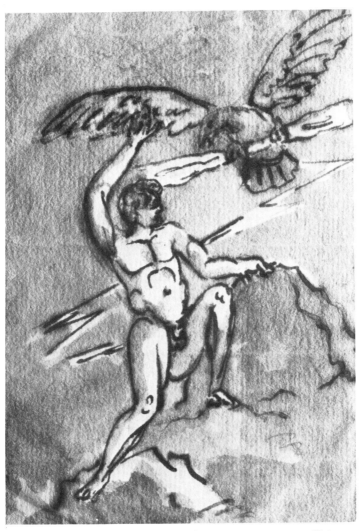

2 J. W. von Goethe, *Prometheus*, ?1809. Pencil, pen & sepia, 12 × 87cm. Weimar, Goethehaus.

of the artist had been transformed by the growth of academies and museums,[7] and in 'The Collector and his Circle', he presented the first picture of art and society in the Romantic period: part bourgeois parlour-game, part philosophical meditation. It may be argued that in this novel Goethe is closer to his time than Ludwig Tieck, whose more famous picture of Romantic art, painted in *Franz Sternbald's Wanderings* (1798), uses the more oblique vehicle of the historical novel.

This, too, is surprising, for Goethe's position in provincial Weimar could scarcely have been expected to encourage breadth of vision about art in his day, and there is, again, something desperately anxious about his insistence, in the Introduction to the *Propyläen*, that art can be discussed only in the presence of the object. As he complained to the Director of the Munich Gallery in 1814, his direct contact with works of art had become very restricted; but he went on to say that art was nevertheless hardly ever out of his mind.[8] Compared with London and Paris, not to mention Rome, which was still the art capital of the world during Goethe's lifetime, Weimar had little to offer: Goethe's art-adviser, Heinrich Meyer, wrote to an aspiring student in 1808 that it was no place for him,[9] and as for patronage, without the promptings of Goethe himself, there would have been, it seems, none above the level of decoration.[10] It may thus appear perverse to insist that Goethe writes best of his direct experience of art, rather than, as has been suggested, on matters of principle.[11] But there is in his criticism a wholly new sense of the variety of visual experience, and of the completeness in variety, for just as he saw life in terms of art, so he brought to art the experiences of his life. The further he retreated from the object, the vaguer became his thought, the more periphrastic his language and the more didactic his tone, which earned him a reputation for pomposity, brilliantly caricatured by Thomas Mann in his novel *Lotte in Weimar*. Goethe's character as sensitive observer and his role as the Reformer of German Art do not always sit well together, but the flaws of individual perception are happily never far from the marble surface, and in the fictions of dialogue and novel they surface triumphantly.

The clearest indication of the concreteness and range of Goethe's sensibility is in his collection, which included examples of every period of ancient and modern art, from Greek bronzes, Byzantine sculpture and Gothic stained-glass to the drawings of his contemporaries, Carstens and Friedrich, and a group of landscape sketches

by modern English artists, described simply as 'nebulous but estimable'.[12] Although he used historical perspective to distance himself from tendencies he could not wholly endorse (for example, in 'Heidelberg'), Goethe resisted the developing fashion for presenting collections as visual histories of art (to which much of the Romantic revival of interest in pre-Renaissance art was due). The French sculptor, David d'Angers, noted on a visit in 1829 that the poet was fond of creating the most piquant of stylistic contrasts in his display.[13] But by far the largest section of Goethe's art collection belonged to engravings, whether original prints by Dürer, Claude, Rembrandt, Tiepolo, or John Martin (the rage of England and the Continent in the 1820s), or reproductions after a very wide variety of artists. How dependent he was on copies and reproductions (for he travelled very little to look at collections after 1790) is clear from criticism gathered in this book. G. H. Noehden, who was in Weimar in the winter of 1818-1819, gives us a picture of the way in which reproductions kept Goethe in touch with the world of art:

The Elgin marbles . . . were often mentioned. Goethe only knew them from description, and, partly, from casts or drawings, while I had the good fortune of viewing those precious remains themselves. But no one that had seen them could have admired their excellence with more enthusiasm, or estimated their merit with more judgement than Goethe, though comparatively possessed of very inadequate means of information; his vigorous imagination supplied the want of ocular inspection, and the sagacity, with which he knew how to combine the materials that were afforded him, guided his opinions . . . [14]

Thus, although the immediate stimulus to writing was usually a visual one, Goethe was not invariably precise in his descriptions, even when he had the object in front of him (the essay on Mantegna offers some remarkable examples of this). The contemplation of art was for him above all an imaginative activity, and he brought to it, even at his most vividly concrete, a sense of principle and a didactic urgency of purpose, which has rightly been seen as giving his criticism a classic quality. Feeling is paramount; the artist's rules must be his own rules; the parts must above all be a function of the whole: these are the concepts which run through the body of Goethe's critical writing, and which separate it from the disjointed, *ad hoc* strictures of journeyman critics like his collaborator, Heinrich Meyer, who was nicknamed Goethe's 'Mephistopheles', but might more appropriately have been called his 'Wagner'.

For all the obstacles in his environment and in his own capabilities, Goethe produced a body of art-criticism in tune with the most

original aesthetic aspirations of his time. This needs to be empha-
sized, for it is the outstanding failures of Goethe's critical career
which have generally been the subject of study. The *Propyläen*, that
ill-fated periodical, launched at a time when aesthetic manifestoes
were appearing all over Germany, caused Goethe a good deal of
bitterness.[15] The Weimar Prize-Competitions, which had been de-
signed to put German subject-painting on the map, attracted no
artists of promise except Philipp Otto Runge, Friedrich, and Peter
Cornelius, whose contact with Goethe became really interesting
only after the competitions had long been abandoned.[16] The
polemic against German Romanticism which appeared (somewhat
after the event) in the pages of *Kunst und Altertum*, was certainly ill-
considered, but it was in the same pages that Goethe spoke warmly
of Delacroix' illustrations to *Faust*. These most publicized of his
activities have given Goethe the reputation of fighting a prepos-
terous rear-guard action, in the name of classicism, against the most
important aesthetic movement of his time.

But to term Goethe's tastes in art 'classicist' is unhelpful when
his lifetime embraced the baroque classicism of his teacher A. F.
Oeser (who had prefaced that first great German manifesto of
Neo-Classicism, Winckelmann's *Reflections* of 1755, with a design
based on Tiepolo), the mannerist classicism of Fuseli and Girodet,
and the realist classicism of David and his school. David's art was
especially interesting to Goethe: he had witnessed the strength of
David's innovations in Rome in the 1780s, he hoped to contribute
an essay on David to the *Propyläen*, and he wrote warmly of the
Oath of the Tennis Court in 1803.[17] It is no surprise that a critic who could
perceive the anatomical expressiveness of the *Laocoon*, and the living
presence of Leonardo's characters in the refectory at Milan should
prize the realism of David's style, for the assumptions lying behind
this style have much in common with that characteristic art-form
of the Romantic period, the *tableau vivant*, the fashion for which
Goethe helped to promote by the *tableaux* described in his novel
Elective Affinities (1809). Among the *tableaux* staged by Goethe for the
Grand Duchess Maria in 1813 were, indeed, two compositions by
David; the *Belisarius* and the *Oath of the Horatii*.[18]

Like David, Goethe hoped for a great artist who would take the
middle way between Romanticism and Classicism.[19] As far as the
visual arts are concerned, his attack on Romanticism touched only
a number of marginal aspects and minor figures; in his treatment
of the Romantics, and the Romantic tendencies which he sup-

ported, we sense how closely he felt the pulse of the period. In a ten-year intercourse with Philipp Otto Runge, Goethe led him away from the Dresden Romanticism of his youth towards something more naturalistic, more painterly, and more universal. Runge's early death in 1810 prevented his art from maturing, but we may imagine that it would have moved even closer to a style of symbolism of which Goethe would have approved.[20] Friedrich similarly moved further and further away from the conventional symbolism of his early work towards a purified, poetic naturalism very much in the spirit of Goethe. A good deal has been made of this painter's refusal to make cloud-studies for Goethe in 1816,[21] yet this refusal was probably due rather to the patronizing tone of Goethe's request than to the idea itself, for Friedrich made similar studies for his own use throughout his life, notably in a beautiful series of oil sketches in 1824. The brooding melancholy which Goethe attacked in some of his winter landscapes[22] was only one mood among many in his work, and the burden of Friedrich's symbolism was the reverse of pessimistic.[23] Goethe's essays on Ruisdael and Claude are wholly in the spirit of Friedrich, and it is notable that a contemporary French landscape-painter, the classicist J. B. Deperthes, also found Ruisdael the supreme artist of feeling, who alone had found 'the way to your heart'.[24]

Echoes of Goethe's thought recur throughout the literature of Romantic art. Two examples must suffice. An extraordinary conception of the primitive will-to-form in the first essay 'On German Architecture' (p. 103) filtered down to a lecture by J. M. W. Turner;[25] and the moving meditation of 1809 on the symbolism of nature (p. 73) was copied by Delacroix into a late notebook.[26] Goethe's more doctrinaire (and more easily quoted) remarks on Romanticism and Classicism should not blind us to his real engagement with some of the chief aesthetic questions of his time.

GOETHE AND HEINRICH MEYER

One of the chief problems in assessing Goethe's art criticism is the constant collaboration of the Swiss painter Heinrich Meyer (1760-1832), who was the poet's advisor on art from the time of his establishment at Weimar in 1791. The extreme ramification of Goethe's activities meant that he was very dependent on every sort of assistance, and Meyer also became a close friend. He was the most productive of the Weimar Friends of Art (*Weimarische Kunst-Freunde*), and many of the published articles signed W.K.F. are entirely his

work. The long attack on Romantic art published in 1817 under the title *Neudeutsche Religiös-Patriotische Kunst* is largely by Meyer, as is the review of Dürer's drawings in the *Jenaische Literatur Zeitung*, which was long thought to be by Goethe himself.[27] Meyer certainly supplied Goethe with art-historical notes for the essays on the *Laocoon*, Mantegna, and Leonardo.[28] In a letter of 1787, Goethe wrote that it was Meyer who had opened his eyes to detail, and initiated him into the technical element in art (*das eigentliche Machen*), and as late as 1827 Goethe claimed that their views on matters of principle were almost identical: when he acquired a new work of art, he said, he felt obliged to hide it from Meyer until he had formed his own view of it, so as not to be unduly influenced by the painter.[29] But Goethe's last secretary, Schuchardt, reported that it was only after long argument that they would agree, and now that Meyer's own *History of Art* has been published, it is clear that in detail his emphases are very far from Goethe's: there is for example very little on Mantegna's cartoons, Leonardo's *Last Supper*, or Ruisdael in his account;[30] and their views on modern art were also frequently at odds.[31] Meyer's thought is generally more abstract, and his language far flatter than Goethe's,[32] and it is for this reason that I have followed Benz in attributing to Goethe the review of Friedrich's drawings (p. 229), signed W.K.F.

SELECTION AND TRANSLATION

In making a selection from the half-dozen volumes of Goethe's writings on art in the standard, Weimar, edition of his works, I have been inclined more towards art criticism than towards art theory. I have thus excluded a number of substantial essays which depend upon texts by other critics like Winckelmann, Diderot and Sulzer, and I have excluded, too, the *Maxims on Art*, which present some of Goethe's thoughts in a deceptively concise and absolute form. Several of them recur in other contexts in this book. For this reason, too, I have included a few extracts from Goethe's letters and conversations, as well as from his autobiographical writings, where they deal with the immediate experience of works of art. With the exception of these extracts, I have tried to present each essay complete, for it is only in this way that we can sense the variety of Goethe's approaches. In the choice of longer pieces I have been guided by the large selection in the *Artemis Gedenkausgabe* (vols. xiii-xv), and by the small but well-annotated selection by Herbert von Einem in the *Hamburger Ausgabe* (vol. xii).

I have included as many pieces as possible on artists and works familiar to English and American readers, but I have omitted much on minor German artists of the period.

With the exception of some recent versions of 'On German Architecture' (1772), there has been no edition of Goethe's writings on art in English since the small selection, chiefly of early essays, translated by S. G. Ward and published as *Essays on Art* at Boston, Massachusetts, in 1845. My versions are far freer than Ward's, since Goethe's prose often seems to call for pruning; but to convey something of the period flavour I have included two immediately contemporary translations: the anonymous *Observations on the Laocoon*, published in the *Monthly Magazine* in 1799, and G. H. Noehden's rendering of the essay on Leonardo's *Last Supper*, published as a book in 1821. These are both given in their original form, with only the addition of notes.

NOTES

1. *Dichtung und Wahrheit*, II, vi.
2. Mme de Staël, *De l'Allemagne*, 1871, p. 136.
3. H. von Einem, 'Goethe und Dürer', *Goethe-Studien*, 1972.
4. G. Femmel (ed.), *Corpus der Goethezeichnungen*, 1958-1973.
5. See, for example, his fine collection of Rembrandt Drawings (Benesch Nos. 128, 301, 470, 674, 734, 1000, A.118), and for a Rembrandtesque drawing by Goethe himself, *Corpus*, IV B (1968), No. 54.
6. On the traditional view, R. and M. Wittkower, *Born under Saturn*, 1963. There are many inconsistencies in Wackenroder's view of the artist as a person peculiarly alienated from society, but this was the common interpretation of his message, and is probably the most important basis of Goethe's objection to it (see M. H. Schubert, *W. H. Wackenroder's Confessions and Fantasies*, 1971, especially pp. 12 ff. and 27 ff.).
7. See, for example, his letter on museology to J. C. von Mannlich, 6 August 1814 (published in *Hyperion*, I, 1908, p. 134).
8. ib. pp. 152-3.
9. W. Schoof, 'Goethe und der Maler L. E. Grimm', *Goethe*, XIX, 1957, p. 204.
10. See the gloomy letter from the Weimar Friend of Art, C. L. Fernow to J. C. Reinhart in Rome, 4 April 1806 (O. Baisch, *J. C. Reinhart*, 1882, p. 191).
11. For example by W. D. Robson-Scott, *Goethe and the Visual Arts* (Inaugural Lecture at Birkbeck College, University of London, 1967), p. 6.
12. For a summary catalogue, C. Schuchardt, *Goethes Sammlungen*, 1848-9.
13. P. J. David d'Angers, *Carnets*, ed. Bruel, 1958, I, pp. 44-7. Goethe's dislike of historical arrangements is also clear from the letter cited in note 7 above.
14. G. H. Noehden in J. W. von Goethe, *Observations on Leonardo da Vinci's Celebrated Picture of the Last Supper*, 1821, p. iii.
15. For the history of the *Propyläen*, see the facsimile edition, with notes by W. Freiherr von Löhneysen, 1965.

16. The course of these competitions has been detailed by W. Scheidig, *Goethes Preisaufgaben für Bildende Künstler* (Schriften der Goethe-Gesellschaft, 57), 1958.

17. *Italian Journey*, Report, August 1787 for the *Horatii*; *Goethes Werke* (Artemis Gedenkausgabe), XIII, 1954, p. 157 for the *Propyläen* article (in 1800 Caroline von Humboldt contributed a review of David's *Sabines*); *Werke, cit.* XV, 1953, p. 869 for the *Tennis Court*.

18. K. G. Holmström, *Monodrama, Attitudes, Tableaux Vivants*, Stockholm, 1967, p. 232. A third *tableau* was based on Guérin's *Phaedra and Hippolytus*, also in the Louvre.

19. P. J. David, *op. cit.* p. 56.

20. B. A. Sorensen, *Symbol und Symbolismus in den äesthetischen Theorien des 18 Jahrhundert und der deutschen Romantik*, Copenhagen, 1963, pp. 225 ff.

21. U. Finke, *German Painting from Romanticism to Expressionism*, 1975, p. 27.

22. G. Schadow in E. Cassirer, *Künstlerbriefe aus dem 19 Jahrhundert*, 1919, p. 61.

23. See especially C. D. Friedrich, *Bekenntnisse*, ed. Hinz, 1968, p. 103 ff.

24. J. B. Deperthes, *Histoire de l'art du Paysage*, 1822, pp. 436-49. See also F. Schlegel, *Aesthetic and Miscellaneous Works*, trans. Millington, 1849, p. 68.

25. J. Gage, *Colour in Turner: Poetry and Truth*, 1969, p. 112. Other links between the thought of Turner and Goethe are discussed in Chapter II of the same book.

26. E. Delacroix, *Journal*, ed. Joubin, 1932, III, p. 405. Delacroix' immediate source is H. Blaze de Bury's preface to a French translation of *Faust* (1847).

27. O. Harnack, 'Goethe und Heinrich Meyer', *Essais und Studien*, 1899, p. 164. The best general study of Goethe and Meyer is by P. Weizsäcker, in H. Meyer, *Kleine Schriften zur Kunst*, 1886, pp. viii-xl.

28. For *Laocoon*, below, p. 78; for Mantegna, Goethe, *Werke* (Hamburger Ausgabe), XII, 1953, p. 639; for Leonardo, Harnack, *op. cit.* pp. 166-7.

29. Kanzler von Müller, *Unterhaltungen mit Goethe*, 10 August 1827; Meyer, *op. cit.* p. xv.

30. Meyer, *op. cit.* p. xi; H. Meyer, *Geschichte der Kunst*, ed. Holtzhauer und Schichtling (Schriften der Goethe-Gesellschaft, 60), 1974; see also Meyer on Mantegna in *Propyläen*, III, ii, 1800 (pp. 946 ff. of the 1965 reprint).

31. See Meyer on David's *Oath of the Horatii* in 1796, *Goethes Briefwechsel mit H. Meyer*, ed. Hecker (Schriften der Goethe-Gesellschaft, 32), 1917, p. 370. Meyer seems to have been far more sympathetic than Goethe to Wackenroder's book (Schubert, *op. cit.*, pp. 10-11).

32. Weiszäcker, in Meyer, *Kleine Schriften*, pp. lxx ff., has made a detailed comparison of their styles.

I GENERAL AESTHETICS

Introduction to the *Propyläen*[1]

1798

The youth who begins to feel the attraction of nature and art believes that a serious effort alone will enable him to penetrate to their inner sanctuary; but the man discovers that even after lengthy wanderings up and down, he is still in the forecourt.

This is what has given rise to our title; the step, the door, the entrance, the antechamber, the space between the inner and the outer, the sacred and the profane, this is the place we choose as the meeting-ground for exchanges with our friends.

It will not be inappropriate if by this word *Propyläeum* the reader is reminded of that edifice that led to the citadel of Athens and the Temple of Minerva; but let no one suggest that we are presuming to attempt such artifice and splendour here. The name of the place will suggest what might have been done there, and discussions and conversations not unworthy of it will be expected.

Will not thinkers, scholars, artists be drawn to such a place to spend their best hours, and to dwell, at least in imagination, among a people endowed by nature with that perfection we desire but never attain, who achieved the continuous development of a culture that is only piecemeal and fleeting with us?

What modern nation does not owe its artistic culture to the Greeks; and, in some respects, who more so than the Germans?

So much in extenuation of our symbolic title, if that be necessary. Let it remind us that we shall depart as little as possible from Classic ground; let its brevity and its rich significance inform those friends of art whom we hope to interest in this work, that it is to present the observations and reflections on nature and art of a like-minded group of friends.[2]

He whose vocation is to be an artist should pay vital and constant attention to everything around him, observe closely all objects and their parts, and by making practical use of what he has experienced, come to observe ever more sharply, first on his own behalf, but later for such information as he will gladly give to others. To this end we shall relate and present our readers with much that we have noted in various circumstances over the years, which we trust will be both useful and agreeable.

But who will not admit that unprejudiced observations are rarer than is generally believed? We are so ready to interject our own fancies, opinions, judgements into what comes to our notice, that we do not long remain quiet observers, but begin to reflect. But we should lay no great weight on these reflections except insofar as we can rely on the nature and training of our minds.

We shall be the more confident in this matter if we consider our harmonious relationship to others, and know that we are thinking and working not alone, but in common with them. The anxiety that our way of thinking is peculiar to us, which so often comes over us when we hear others express convictions directly opposed to ours, will soften, and finally vanish when we find ourselves in like-minded company. We shall then be able to proceed with confidence, and congratulate ourselves on possessing principles which are verified by the experience of others as well as by our own.

When several persons live together in friendly intercourse, and at the same time have a common interest in advancing their culture, keeping in view their separate yet closely united objectives, they feel that their points of contact are very various and that even a tendency which seems to drive them apart, will happily reunite them again in due course.

Who has not felt the advantages of conversation in such cases? But conversation passes away, and although we do not lose any of the results of mutual cultivation, the recollection of the means by which it was arrived at vanishes.

The stages of such a common progress are better preserved by correspondence: each moment of growth is thus fixed, and while our achievement gives us a feeling of satisfaction, a retrospective look at the process of growth is instructive, and gives us reason to hope for ceaseless development in the future.

Brief essays, in which we set down from time to time our thoughts, convictions and aspirations in order to return and discuss them among ourselves after a lapse of time, are also an excellent means of furthering our own culture and that of others, a means which no one should neglect, when we consider the brevity of life and the many obstacles we meet with in the way of advancement.

It will be noticed that we are now speaking of the exchange of ideas among friends who share the common aim of their artistic and scientific development. But at the same time so great an

advantage should not be neglected in business and in the world at large.

But in matters of art and science, a limited connexion of this sort is not enough: contact with the wider public is both agreeable and necessary. Whatever of general concern a man does or thinks, belongs to the world, which brings to maturity whatever it can use of individual effort. The desire for applause which the writer feels is an instinct that nature has implanted in him, to stimulate him to higher things. He thinks he has earned his laurels, but he is soon aware that a more laborious cultivation of all his faculties is needed to keep the favour of the public, which may be captured for a few brief moments by chance and good fortune.

In earlier times the writer perceived this significance in his relationship to the public, and even now he cannot do without it. However little he may seem called upon to instruct, he still feels the need to communicate with those sympathizers scattered throughout the world. He wishes by this means to renew his relations with old friends, to strengthen present friendships, and to forge new ones with the younger generation which may last for the remainder of his life. He wishes to spare the young those circuitous paths in which he himself has wandered, and while he observes and profits from the advantages of the moment, he preserves the memory of earlier and more praiseworthy endeavours.

Our little association has been formed with this serious aim in mind: may we fulfil our undertaking cheerfully, and time will show where it leads us.

The essays we propose to publish, although by several hands, will, we hope, never contradict each other in essentials, even if the way of thinking of each author is not identical. No two men see the world exactly alike, and different temperaments will apply in different ways a principle that they both acknowledge. The same man will, indeed, often see and judge the same things differently on different occasions: early convictions must give way to more mature ones. Nevertheless, may not the opinions that a man holds and expresses withstand all trials, if he only remains true to himself and others?

The authors hope and expect to remain in harmony with each other and with the majority of the public, yet they cannot conceal the fact that many discords will be heard from various sides. This is the more to be expected because they differ from received opinion

on more than one point. Although we are far from wishing to overrule or change another person's way of thinking, we shall maintain our own firmly, and decline or accept the contest according to circumstances. But we shall always hold fast to one conviction and insist continually on those conditions that seem to us indispensable to the formation of an artist. He who has a task to perform must know how to take sides, or he is quite unworthy of it.

In promising to present observations and reflections on nature, we must at the same time state that we have in mind not only such as relate particularly to visual art and the arts in general, but also to those which relate generally to the culture of the artist.

The highest demand made on an artist is this: that he be true to nature, that he study her, imitate her, and produce something that resembles her phenomena. How great, how vast this demand is, is not always borne in mind, and even the true artist only learns it by experience in the course of his progressive development. Nature is separated from art by an enormous chasm which genius itself cannot bridge without outside assistance.

All that we see around us is but raw material. If it is rare enough for an artist, through instinct and taste, by practice and experiment, to reach the point of achieving the beautiful exterior of things, selecting the best from the good in front of him and producing at least a pleasing appearance, it is rarer still, especially in modern times, for an artist to penetrate into the depths of things as well as into the depths of his own soul, so as to produce in his works not only something light and superficially effective, but, as the rival of nature, something spiritually organic, and to give it a content and a form by which it appears both natural and beyond nature.

Man is the highest and the proper subject of art; to understand him, to extricate oneself from the labyrinth of his anatomy, a general knowledge of organic nature is imperative. The artist should also familiarize himself with inorganic matter, and with the general operations of nature, especially where, as in the cases of sound and colour, they are adaptable to the purposes of art. But what a circuitous route he would be obliged to follow, if he were to take the trouble to seek out in the schools of the anatomist, the naturalist, or the professor of science what serves his purposes. It is indeed questionable whether he would find what is necessarily most important to him there. Those gentlemen have to satisfy the quite different needs of their own students, without thinking about

the specialized and particular needs of the artist. Hence we propose to take a middle course, and although we do not imagine we can be exhaustive we may nevertheless give a survey of the whole field, and at least introduce the detailed studies.

The human figure cannot be understood merely through the observation of its surface: the interior must be laid bare, the parts must be separated, the connexions perceived, the differences noted, action and reaction observed, the hidden, constant, fundamental elements of the phenomena impressed on the mind, if we really wish to contemplate and imitate what moves in living waves before our eyes as a beautiful, unified whole. A glance at the surface of a living being confuses the observer: here, as elsewhere, we may adduce the true proverb 'We see only what we know'. For as a short-sighted man sees an object from which he withdraws more clearly than one he approaches, since he is aided by his intellectual vision, so perfect observation really depends on knowledge. How well an expert naturalist, if he can draw, imitates objects by recognizing and emphasizing the important and significant parts from which the character of the whole derives!

Just as the artist is greatly helped by an exact knowledge of the separate parts of the human figure which he must finally regard as a whole, so a general view and a glance at related objects is a great advantage, so long as the artist is capable of rising to ideas and of grasping the close relationship of things apparently remote.

Comparative anatomy has prepared a general concept of organic nature: it leads us from form to form, and by observing organisms closely or distantly related, we rise above them to see their characteristics in an ideal picture.

If we keep this picture in mind, we find that in observing objects our attention takes on a definite direction, that scattered data can be learned and retained more easily by comparison, and that in art we can in the end rival nature only when we have learned, at least in part, her method of procedure in the creation of her works.

We would also encourage the artist to pay some attention to inorganic nature, which is the more easily done now that a knowledge of minerals is so conveniently and quickly acquired. The painter needs a knowledge of stones to be able to represent them characteristically, as do the sculptor and architect in order to make use of them, the lapidary must possess a knowledge of precious stones, and the connoisseur and amateur should likewise make an effort to become familiar with them all.

Finally we advise the artist to form an idea of the general operations of nature that he may the better understand those that particularly interest him, both to increase his general culture in various ways and to know more completely what particularly concerns him. Thus we will have something further to say on this important subject.

Hitherto the painter could only marvel at the knowledge of colours displayed by scientists, without profiting from it. But still the natural feeling of the artist, his constant practice, and the needs of his situation led him on in his own way; he felt those lively contrasts of colour whose juxtaposition produces harmony; he identified certain qualities by analogous sensations; he had his warm and his cold colours, his colours to express distance or proximity, and others of the sort, by means of which he drew nearer to the universal laws of nature. Perhaps he verified the conjecture that nature's handling of colours was based on a mutual relation, a polarity, or whatever we wish to call twofold, even manifold appearance in a distinct unity, on the analogy of magnetism, electricity, and so forth.

We shall take it upon ourselves to inform the artist circumstantially and intelligibly on this subject, and we have high hopes of being able to accomplish something which will be welcome to him, inasmuch as it will be our object to explain and reduce to its principles what he has hitherto done only instinctively.[3]

So much for what we hope to impart about nature; now for what is most important in art.

This publication is divided into separate essays, and even these will be published in parts, for it is not our wish to pull a whole to pieces, but, on the contrary, to build up a complete whole out of many and various parts. It will thus be necessary to announce as soon as possible, in a general and summary way, what the reader may expect to find in our separate themes. First we shall occupy ourselves with an essay on creative art in which the known divisions will be rehearsed according to our conception and method. Here we shall be careful to set out the importance of each separate part of art, and to show that the artist cannot neglect any of them with impunity, as unfortunately happens too often.

In what we have said above, we have regarded nature as the great treasure-house of materials; we now come to the important part where art prepares these materials itself.

From the moment the artist lays his hand to any natural object,

that object no longer belongs to nature; indeed, it may be said that in that moment the artist creates it, since he extracts from it the significant, the characteristic, the interesting, or, rather, first confers their value on them.

In this way the beautiful proportions of the human figure, its noble forms and high character were first, as it were, forced out; and the realm of the regular, the significant, the complete, first circumscribed, to which nature willingly contributes her best, although elsewhere in her wide domain she degenerates so easily into ugliness and loses herself in the insipid.

The same goes for artistic compositions, their subject and content, whether drawn from fable or history. Happy the artist who does not start off on the wrong foot, who knows how to select, or rather determine, what is suitable for art!

He who wanders anxiously among scattered myths and long-winded histories looking for a subject that will have scholarly significance or allegorical interest, will often be hindered in the midst of his work by unexpected obstacles, or find, when it is finished, that he has missed his most beautiful objective. Whoever does not speak clearly to the senses will not produce a clear impression on the mind, and this is so important to us that we shall expand on it at the outset.

When the subject has been successfully discovered or invented, the treatment of it follows, and this may be divided into spiritual, sensible and mechanical.

The spiritual treatment elaborates the subject with reference to its inner coherence, picks out the subordinate themes, and, as the choice of subject generally gives the best criterion of the depth of artistic feeling, so the development of the themes is the measure of its richness, breadth, fullness and human interest.

By sensible treatment we mean what makes the work comprehensible and satisfying to the senses, which cannot do without its charms.

Finally the mechanical treatment is that which works through a bodily organ upon particular materials, giving the work its existence and its reality.

While it is our earnest desire and hope to be useful to artists, insofar as they may be able to avail themselves of our counsel or experience here or there, unfortunately we cannot refrain from making the depressing observation that every enterprise, like every man, is exposed to the influences of his time, for good or evil, and

we cannot wholly avoid the question of what reception we may expect ourselves.

Everything is subject to constant change, and when things cannot coexist, they thrust each other aside. The same goes for knowledge, for practical training, for modes of representation and for precepts. Man's objectives always remain very much the same; men still wish, as they always did, to be good artists or good poets. But the means by which these objectives are to be attained are not apparent to all, and there is no denying that nothing could be more agreeable than achieving something important without really trying.

The public has naturally a great influence on art, and in return for its applause and its money, it expects a work that will give it unmixed satisfaction and pleasure. The artist is for the most part happy to accommodate himself to this expectation, for he too is part of the public; he was brought up at the same time, he feels the same needs, his efforts have the same direction, and thus he agrees to go with the crowd that bears him on and which he enlivens.

Hence we have seen whole nations and epochs delighted with their artists, and the artists in turn mirrored in their nation and age, without either having the slightest suspicion that their way was perhaps not the right one, their taste at least partial, their art in decline and their efforts wrongly directed.

But instead of losing ourselves in generalities, let us here make an observation that relates particularly to art. For the German artist, and for the modern or northern artist in general, the transition from formlessness to form, and the maintenance of form once attained, is difficult, nay, almost impossible. Let any artist who has spent some time in Italy ask himself whether contact with the best examples of ancient and modern art has not inspired him with the desire to study and imitate the human figure, its proportions, forms and character, and to spare no pains in this pursuit, to come close to the autonomy of those works and to produce something that both satisfies the senses, and, at the same time, lifts the soul into its highest regions. But he must also confess that, after his return, his efforts relaxed little by little, for he found few who saw truly what he represented, but only such as regard a work superficially for its agreeable suggestion, and who feel and enjoy something after their own fashion.

The worst picture can speak to our perception and imagination, for its sets them in motion, makes them free, and leaves them to

themselves. The best also speaks to our perceptions, but in a higher language, one, certainly, which has to be understood, but which chains our feelings and our imagination and robs us of our will-power, for we cannot do what we please with the perfect, we are compelled to surrender to it in order to receive ourselves again, raised and ennobled.

That these are no idle dreams we shall endeavour to prove by our treatment of details, and we shall draw particular attention to one contradiction in which the Moderns so often get entangled. They call the Ancients their teachers, they attribute to their works an unapproachable perfection, and yet they distance themselves in theory and practice from the precepts which the Ancients constantly observed.

Leaving this important point, to which we shall often have occasion to return, we find others of which some notice should be taken.

One of the most striking signs of the decay of art is when we see its separate forms jumbled together. The arts themselves, in all their varieties, are closely related to each other, and have a great tendency to unite, and even lose themselves in each other. But herein lies the duty, the merit and the dignity of the artist: that he knows how to separate his own branch from the others, and to isolate it as far as may be.

It has been noticed that all visual art tends towards painting, all poetry towards the drama; and this may in future be the occasion of important observations.

The true, prescriptive artist strives after artistic truth; the lawless artist, following blind instinct, after an appearance of naturalness. The one leads to the highest peak of art, the other to its lowest depths.

This is no less true of the individual arts than of art in general: the sculptor must think and feel differently from the painter, and must set about a work in relief in a different way from the way he would deal with a free-standing statue. When the low relief is raised little by little, and then parts and figures are cut free from the ground and finally buildings and landscapes admitted, produc-ing a work which is half picture, half puppet-show, true art is in decline, and it is to be deplored that excellent artists have taken this course in modern times.[4]

When in the future we prescribe what we believe to be true, we would like it to be tested by artists, for our precepts are derived

from works of art. How seldom does one man agree with another on a matter of theoretical principle: the practical and the immediately useful are far sooner adopted! How often we see artists at a loss to choose a subject, to compose artistically, to arrange the details; and how often is the painter embarrassed by having to choose his colours! Then is the time to try out a principle; the question will then be easier to decide: do we, with its help, come closer to the great models, and to all that we love and prize, or does it forsake us in the confusion of an ill-conceived practical experiment?

If such precepts should prove useful in promoting the culture of artists, in guiding them among difficulties, they will also aid the understanding, true estimation and criticism of ancient and modern art; and they will, in their turn, be discovered again in the examination of these works. This is the more necessary to attend to since, in spite of the universally acknowledged excellence of the Antique, individuals and whole nations have often in modern times misunderstood the very things in which the highest excellence of those works consists.

A close examination of these works will be the best means of protecting ourselves against this evil. Let us now for example follow the usual procedure of the amateur of art, in order to show how necessary a thorough criticism of ancient and modern works is, if we wish to profit by it.

No person with a good eye, however uncultivated, can ever see even an imperfect, incorrect cast of a fine piece of classical sculpture without being greatly impressed by it, for even this still gives the idea, the simplicity and greatness of the form; in a word, at least the general idea, such as a man with poor eyesight could make out at a distance.

We may often observe how a strong inclination towards art is aroused through such an imperfect medium. But the effect is like the cause, and such beginners are more impressed with a blind and indefinite feeling than with the true worth and significance of the object itself. It is such as these who propound the theory that a too curious critical examination destroys our pleasure, and who decry and resist the investigation of details.

But when their experience and knowledge becomes gradually wider, and they see a sharper cast, or the original itself, their insight increases with their satisfaction, and the more so as originals – perfect originals – become known to them.

We willingly enter the labyrinth of exact observation when the details are as perfect as the whole. Indeed, we learn to perceive that we can appreciate the perfect only so far as we can discern the defective. To distinguish restorations from the original parts, the copy from its model, to contemplate in the smallest fragments the scattered excellence of the whole, is a satisfaction that belongs only to the complete connoisseur, and there is all the difference in the world between groping after an imperfect whole, and seeing and grasping a perfect one with a clear perception.

He who devotes himself to any department of knowledge should aim at the highest. Insight and practice follow widely different paths, for in practice everyone is soon aware that his portion is only a certain measure of capacity. But a far greater number of men is capable of knowledge, of insight. We may even say that every man is so capable who can deny himself, subordinate himself to objects, and who does not seek to introduce his rigid and narrow individuality, his petty one-sidedness, into the highest works of nature and art.

It is really only possible to speak usefully of works of art in their presence. Everything depends on direct apprehension, for this is what determines whether the word by which we hope to elucidate the work produces a clear impression or none at all. Hence it so often happens that the writer on art deals only in generalities, which certainly awaken the mind and the imagination; but only those readers who examine the work itself with book in hand will be really satisfied.

Thus we may often excite rather than satisfy the desires of our readers in these essays, for there is nothing more natural than that they should wish to have before their eyes any excellent work of which they read a detailed criticism, to enjoy the whole and to subject the opinions they hear concerning the parts to their own judgement. But while the authors expect to write for those already acquainted with some works and those who will see others in the future, they will do everything possible for those who have neither of these advantages. We shall mention copies and point out where casts from the Antique and ancient works themselves are to be found, especially in Germany, thus promoting as far as we can a true love and knowledge of art.

The history of art can be based only on the highest and most complete conception of art; only through an acquaintance with the most perfect objects that man has been able to produce can

the chronological and psychological progress of mankind in art, as in other departments, be displayed. At first art was a limited activity, occupied in the dry, even miserable, imitation of insignificant and significant alike. Then a more delicate and agreeable feeling for nature was developed, and finally knowledge, regularity, strength and seriousness were added, and, aided by circumstances, art rose to the heights, until at last it became possible for the fortunate genius who found himself surrounded by these aids to produce the enchanting and the perfect.

Unfortunately, works of art which proclaim such facility, which give men such a comfortable feeling, which inspire them with freedom and serenity, suggest to the artist who would emulate them that they were produced easily. The highest achievement of art and genius is an appearance of ease and lightness, and the imitator is tempted to make things easy for himself, and to work at this superficial appearance alone.

Thus art gradually declines from its high estate, in the whole as well as in details. But if we would form a true conception of art, we must descend to details, and to details of details, an occupation by no means always agreeable and attractive, but which from time to time rewards us richly with a sure view of the whole.

If the experience of looking at ancient and early modern works has provided us with certain precepts, we shall find these even more necessary to our judgement of recent and contemporary works, for in forming an estimate of living or lately deceased artists, personal considerations, respect for or dislike of individuals, popularity and unpopularity are so easily confused, that we are particularly in need of principles. Thus the investigation is aided in two ways: the influence of authority is diminished and the cause brought before a higher court. An opportunity is provided for testing the principles themselves, as well as their application, and even where we cannot agree, the point in dispute is clearly and certainly ascertained.

We especially desire that living artists, about whose work we may perhaps have something to say, should test our judgements in this way. For every artist worthy of the name is now called on to form, from his own experience and reflections, if not a theory, at least a number of rules of thumb, which he finds useful in various cases. But it must often have been noticed how apt a man is, when proceeding in this way, to advance as principles certain maxims which are adequate to his talents, inclinations and convenience.

His is the common lot of mankind; how many other departments follow the same course! But we do not add to our culture when we simply set in motion, easily and comfortably, what is already within us. Every artist, like every man, is a partial creature, and will always be one-sided. Thus, as far as possible, he should imbibe what is theoretically and practically opposed to him. The lively should cast about for firmness and seriousness, the severe should look to the light and pleasing, the strong should look for amiability, the delicate for strength, and thus each will best cultivate his peculiar nature when he seems to be abandoning it most. Every art demands the whole man, and the highest stage of art complete humanity.

Art is practical, and the cultivation of the artist begins naturally in his earliest years with the practical. The rest of his education is often neglected, whereas it should be far more carefully attended to than that of those who are able to profit from life itself. Society soon civilizes the unpolished, business makes the most open circumspect; literary works which are presented to the general public through the press meet with opposition and correction on all sides, while the artist is usually confined to his solitary studio and has few dealings except with those who buy his works, with a public which often only follows certain sickly impressions, with connoisseurs who upset him and with dealers who greet anything new with paeans of praise and estimation which would be too high even for the most perfect.

But it is time to bring this introduction to a close, lest, instead of prefacing the work, it anticipates and pre-empts it. We have now at least indicated our proposed point of departure; we shall see little by little to what extent we can and may expand on it. We hope to occupy ourselves soon with the theory and criticism of poetry, and we shall not exclude any illustrations from life in general, from travel, from the occurrences of the day, if they be the significant promptings of the moment.

The location of works of art has always been of the greatest importance to the cultivation of artists, as well as the enjoyment of amateurs. There was a time when, with few exceptions, they usually remained in their proper place and setting. Now a great change has taken place which cannot fail to have important consequences for art in general and in particular. Perhaps now, more than ever, Italy should be thought of as the great storehouse of art which, until recently, it was. If it is possible to give a general view of it, we shall

be able to show what the world has lost in tearing away so many parts of that great and ancient whole. How much has been destroyed in the act of spoilation will forever remain a secret, but it will be possible by and by to give an insight into that new body of art that has been formed in Paris.[5] We shall consider how the artist or amateur may derive most advantage from France and Italy, whereupon a fine and weighty question arises, viz. what other nations, especially Germany and England, are to do in a true cosmopolitan sense at this time of depredation and dispersal, for this is nowhere more appropriate than in the arts and sciences, with a view to making generally useful the many art treasures which lie scattered, and helping to form an ideal *corpus* of art which may happily indemnify us for what the present time tears away or destroys.

Thus much in general about the scope of a work which we hope will find a serious and sympathetic public.

NOTES

1. See pp. x , xvi on this periodical (1798-1800), which took its title from the gateway to the Acropolis of Athens.
2. The *Weimarische Kunst-Freunde* (W.K.F.): Weimar Friends of Art, consisting of Goethe, Schiller, and Heinrich Meyer, who suggested the title of the magazine. C. L. Fernow joined the group in 1804.
3. Goethe had already published *Contributions to Optics* in 1791-2, but his large work, *Theory of Colours,* did not appear until 1810 (English translation by C. L. Eastlake, 1840). Goethe's work had been preceded by a number of treatises on colour for artists published in France, England and Austria.
4. Goethe is probably thinking of Ghiberti's bronze doors to the Baptistry in Florence (1425-52), casts of which, in Gotha, are referred to in a letter to Meyer of 22 July 1796.
5. As a result of Napoleon's Italian Campaign of 1796; see C. Gould, *Trophy of Conquest,* 1965.

Commentary on Falconet
[Aus Goethes Brieftasche, 1776]

However, these tones – it might be said – this transparency in the marble which produces the harmony, this harmony itself, does it not inspire in the artist that soft and subtle gradation which he then applies in his own works? Will not plaster, on the other hand, deprive him of a source of those harmonies which so enhance painting and sculpture? This is but a superficial observation. A painter finds in natural objects quite a different harmony from that in the marble which represents these objects. Nature is the source from which he draws continually: there there is no fear of becoming a feeble colourist, as there is in working from marble. Compare, from this point of view, Rembrandt and Rubens with Poussin, who had studied marble sculpture a good deal, and tell me what a painter stands to gain from their tonality. No more does the sculptor look for harmony in his material; rather he puts it there, if he can see it in nature, and he can see it just as well in plaster as in marble. For it is wrong to say that a cast from an harmonious marble is not itself harmonious. Otherwise there would be no feeling in our models; feeling is harmony, and vice versa.[1]*

The amateurs who are enchanted by these tones, these subtle vibrations, are not wrong, for they are just as apparent in marble as they are throughout nature, only more easily perceived because of the simplicity and strength of the effect; and the amateur, because he sees them here for the first time, believes that they are to be found nowhere else, or at least nowhere else in such strength. But the artist's eye discovers them everywhere, whether he enters a cobbler's shop or a stable, whether he looks at the face of his beloved, at his boots or at the Antique, everywhere he sees these divine vibrations, these scarcely perceptible tones by means of which nature unites all objects into a whole. At each step a magic world opens before him, a world that has always and intensely surrounded every great artist whose works have inspired the awe of rivals throughout the ages, bridled every detractor, the ignorant

*[*Goethe's note*] Why is nature always beautiful, and beautiful everywhere? And meaningful everywhere? And eloquent! And with marble and plaster, why do they need such a special light? Isn't it because nature is in continual movement, continually created afresh, and marble, the most lively material, is always dead matter? It can only be saved from its lifelessness by the magic wand of lighting.

and the learned, at home and abroad; and have loosed the purse-strings of the wealthy collector.

Everyone has felt at some time in his life the power of this magic which grips the artist all the time, and animates the world around him. Who has not felt a shudder pass through him on entering the sacred grove? Who has not been taken up and shaken with a strange horror by the encircling night? Who has not seen the world turn into golden light in the company of his mistress, or felt heaven and earth melt miraculously into each other in her arms?

The artist does not only feel the effects of this, but enters into their causes. The world lies before him, I might say, as before its creator, who in the moment that he is pleased that it has been created, also enjoys all the harmonies through which it was made and in which it exists. Thus I do not at once understand the meaning of the phrase, 'Feeling is harmony and vice versa'.

And it is this that moves in the soul of the artist, that little by little forces itself into lucid expression, without having passed through the mind.

And yes, it is this magic that flees the halls and gardens of the great, for they are planned and furnished only to be passed through, as a stage on which idlers can rub each other smooth. Only where honesty, necessity and inwardness live is the power of poetry also to be found, and woe betide the artist who leaves his little cabin to flutter about in the grand palaces of the academy! For just as it is written that it is difficult for a rich man to enter the Kingdom of Heaven, so it is also difficult for a man who accommodates himself to the changing fashion, who enjoys the tinsel-magnificence of the modern world, to become an artist of feeling. All the springs of natural feeling which were abundantly open to our forefathers are closed to him. His wallpaper, which will fade in a few years, is a symptom of his mentality and a metaphor for his work.

There has already been so much ink spilled about decorum, that I might as well include it here. It seems to me that the appropriate is mistaken for the commonplace all over the world, and what is more appropriate all over the world than what is felt? Rembrandt, Raphael, Rubens seem to me to be the real saints in their religious pictures, for they feel the presence of God everywhere, in the narrow room or in the open fields, and they do not need the circumstantial splendour of temples and sacrifices to grapple Him to their hearts. I link these three masters who have usually been separated by mountains and oceans, but I could have added many

other great names and shown that all of them shared this important attribute.

A great painter, like any other, attracts the spectator by feeling all of nature's attributes, great and small, so much that the spectator imagines himself transported into the period of the story represented, and into the style and feeling of the painter. And what more can he ask than that he should be conjured into taking a truly human part in the history of mankind?

When Rembrandt presents his Madonna and Child as a Dutch farmer's wife, any little critic can see that this goes quite contrary to history, which relates how Christ was born in Bethlehem, in the land of the Jews. 'The Italians have done it far better,' says he. But how? Did Raphael paint anything more, or other, than a loving mother with her first and only child? And was there anything else to be extracted from the subject? And has not motherly love in all its nuances been a rich source of material for poets and painters in all periods? But all the simplicity and truth has been taken out of the Bible stories by the attempt to ennoble them and adapt them to the rigid decorum of the church; they no longer hold the sympathy of the heart, but dazzle the blunted sense. Mary now sits between the curlicues of a tabernacle, as if she was exhibiting her child to the shepherds for money, or perhaps she has been using the enforced idleness of childbed to make herself beautiful for the honour of this visit. That fits; that is appropriate; that does not conflict with history!

How does Rembrandt deal with this objection?[2] He takes us into a dark stable which want has forced the mother, with her child at her breast, to share with the cattle. They are both buried up to the neck in straw and clothing, everything is dark except a lamp which lights up the father, sitting with a little book from which he seems to be reading some prayers to Mary. At that moment, the shepherds come in. The first, carrying a lantern, peers into the straw as he takes off his hat: could the question 'Is this the new-born King of the Jews?' ever be more clearly expressed?

So all decorum is ridiculous, for even your painter who seems to observe it closest hardly does so for a minute! We would not approve if he set ordinary goblets on a rich man's table, and so he uses extraordinary shapes, seduces you with outlandish pots from some old lumber-room, and astonishes and overawes you with a spineless aristocracy of supernatural beings in splendid flowing robes. What the artist has not loved or does not love he should not

and cannot paint. You find Rubens' women too fleshy?[3] I tell you they were *his* women, and if he had populated heaven and hell, air, earth and water with ideal forms, he would have been a poor husband and they would not have been the mighty flesh of his flesh and bone of his bone.*

It is stupid to demand of an artist that he use many, or all sorts of forms. Doesn't even nature herself use the same facial features in whole regions? He who wants to be general ends up by being nothing at all: limitation is as necessary to the artist as to anyone who wants to create something significant. Sticking to the same subjects, to his cupboard of old household utensils and marvellous rags, is what has made Rembrandt unique. I shall only refer to light and shade here, although the same applies to drawing. Treating the same form under one sort of light will lead anyone who has eyes to see into the secrets of how it shows itself as it really is. Now, take the same form in all lights, and it will become more vivid, truer and more three-dimensional to you, so that in the end it becomes part of you. But remember that all human capacities have their limits. How many objects can you grasp so well that you can re-create them out of your head? Ask yourself this, leave your domestic round and go out, as far as you can, into all the world.

*[*Goethe's note*] In an engraving by Goudt after Elsheimer's *Philemon and Baucis*,[4] Jupiter has sat down in a grandfather chair and Mercury is resting on the floor, while the landlord and his wife are serving them in their usual way. Jupiter meanwhile looks about the room and has just noticed a woodcut on the wall, in which one of his erotic escapades, assisted by Mercury, is clearly shown. If this touch is not worth a whole warehouse of genuine antique pisspots, I will give up thinking, writing and working.

NOTES

1. É. M. Falconet, *Observations sur la statue de Marc Aurèle et sur d'autres objets relatifs aux beaux-arts*, 1771, p. 129.
2. Goethe is thinking of Rembrandt's etching, *Adoration of the Shepherds* (*with the lamp*), c. 1654 (Münz 226).
3. Falconet had alluded to the incorrectness of some of Rubens' nudes in *Observations, cit.*
4. Goethe owned two impressions of this engraving by Hendrik Goudt (after 1626) after a version of Adam Elsheimer's *Jupiter and Mercury with Philemon and Baucis*.

Simple imitation of Nature, Manner, Style
[*Der Teutsche Merkur*, February 1789]

It is not perhaps irrelevant to show exactly what we mean by these words, which we shall often use. For even if they have long been used by writers, if they seem to have been defined in theoretical works, everybody nonetheless uses them in his own way, and thinks them more or less his own according to how strongly he has conceived the idea he wishes to express by them.

SIMPLE IMITATION OF NATURE

If a naturally gifted artist, after practising his eye and hand somewhat on pattern books, soon turns to subjects in nature and copies her forms and colours exactly and conscientiously, truly and diligently, and always beginning and ending in front of her, that artist will always be worthwhile, for it follows absolutely that his works will be assured, powerful and rich in variety.

If we look closely at these conditions, it is easy to see that only appropriate but limited aspects of pleasant but also limited subjects can be treated in this way.

Such subjects must be easily procured, studied at leisure, and copied calmly; the mind that occupies itself with such work must be quiet, self-contained and satisfied with moderate enjoyments.

This sort of imitation will hence be practised by quiet, honest, limited artists on so-called still-lives. But that does not preclude a high degree of perfection.

MANNER

But more often than not the artist finds this way of working too timid and inadequate. He sees a harmony between objects which he can only introduce into a single picture by sacrificing the particular: he finds it tedious to spell out what is in front of him according to the letter; he invents his own method, makes his own language to express what his spirit has grasped in its own way, to give an object which he has repeated often its own characteristic form, without having nature before him every time he repeats it, or without even recollecting it very vividly.

Nor is it a language in which the spirit of the speaker is expressed and defined directly. And just as opinions about moral subjects are formed and arranged differently in the mind of each person who can think for himself, so every artist of this type will see, grasp and imitate the world differently: he will grasp its appearances more circumspectly or superficially, and reproduce them more stolidly or hastily.

We see that this sort of imitation is most appropriate to subjects which comprehend a large number of subordinate objects within a large whole: they must be sacrificed to the general expression of the subject at large, for example in landscapes where the whole point would be lost if we stayed timidly with the details rather than keeping the idea of the whole in the forefront of our minds.

STYLE

If art succeeds in creating, through the imitation of nature, a general language, and if a profound and accurate study teaches it more and more precisely the characteristics of things, and how they subsist, so that it surveys the whole range of forms and can juxtapose and imitate various characteristic ones, then the highest level it can reach is style, the level on which it is equal to the highest achievements of man.

Just as simple imitation depends on a quiet regime and comfortable surroundings, and manner has a facility for grouping superficial appearances, so style is based on the profoundest knowledge, on the essence of things insofar as we can recognize it in visible and tangible forms.

It would take volumes to develop what I have said, and something is to be found out about it in books, but the concept itself can only be studied in nature and in works of art. We will add a number of observations, and whenever we speak of art, we shall have the opportunity of recalling these pages.

It is easy to see that these three ways of producing works of art, presented separately here, are in fact precisely related and that the one shades into the other.

The simple imitation of easily-grasped objects (we shall use the example of flowers and fruit here) can be developed to a high degree of perfection. It is natural that someone who paints roses will soon learn to recognize and distinguish the freshest and most beautiful specimens, and will pick them out from among the many thousands offered to him by the summer. Thus there is already a choice,

even if the artist does not have a clear concept of the beauty of the
rose. He is concerned with tangible forms: everything depends on
defining the differences in texture, and the colours of the surface.
The velvety peach, the fine bloom on the plum, the smooth apple,
the glossy cherry, the brilliant rose, the variegated carnation, the
gaudy tulip: all of them he will have in the perfection of bloom
and ripeness in front of him, in the quiet of his studio: he will set
them in the most favourable light, his eye will grow accustomed
to the harmony of brilliant colours which seems to play over them.
Each year he will be able to renew these objects, and by the calm,
observant imitation of their simple being recognize and grasp their
qualities, without any laborious process of abstraction. Hence the
marvellous works of a Huysum or a Rachel Ruysch,[1] both of whom
have transcended the possible. It is obvious that such an artist can
only become greater and more significant if he adds to his talents
the expertise of a botanist; if he knows the influence of the different
parts on the health and growth of plants, from the roots upwards,
and their conditioning and mutual effect; if he observes and re-
flects on the successive development of the leaves, flowers, sexual
organs, fruit and the new seed. Then he will not simply demon-
strate his taste by his choice of subject, but he will astonish and
enlighten us by his accurate representation of these characteristics:
and in this sense it could be said that he has formed a style. On the
other hand it is easy to see how such a master, if he were not too
scrupulous, if he were intent upon expressing only the striking and
the dazzling, would soon become mannered.

Thus simple imitation operates as it were in the ante-chamber of
style. The more honestly, carefully and neatly it goes about it, the
more calmly it feels what it sees, the more deliberately it imitates
it, the more it is in the habit of reflecting, that is of comparing the
similar and distinguishing the dissimilar, and of subsuming individ-
ual objects under general concepts, the more worthy it makes
itself able to cross the threshold of the sanctuary.

Now if we look further at manner, we see that in the highest
sense and the purest meaning of the word, it may be a mean
between simple imitation and style. The more it approaches true
imitation – albeit with a more superficial approach – the more
eagerly on the other hand it tries to grasp the character of objects
and to express it clearly, the more it unites the two by a pure, vital
and active individuality, so it will become nobler, greater and more
admirable. But if such an artist neglects to stay with nature and to

think of nature, he will get further from the foundations of art, and his manner will become more and more vacuous and insignificant the more he distances himself from simple imitation and from style.

We need not repeat here that we understand the word manner in an elevated and respectable sense, so that the artists we think fall within this definition have no cause for grievance. We are simply concerned to reserve the highest honour to the word style, so that we have an expression for the highest level that art has reached or can reach. Even to recognize this level is already a great blessing, and to discuss it with those who know what they are talking about is a rare pleasure, which we shall find many occasions for stimulating in the future.

NOTE

1. Jan van Huysum (1682-1749) and Rachel Ruysch (1664-1750), Dutch flower and fruit painters.

On truth and probability in works of art: a dialogue
[*Propyläen* I, i, 1798]

In a German theatre[1] there was a sort of oval amphitheatre, with boxes filled with painted spectators, apparently engrossed in what was going on below. Many of the real spectators in the pit and the boxes did not like this at all; they took it amiss that something so untrue and improbable should be foisted upon them. This was the occasion of the conversation of which we give the general purport here.

The Friend of the Artist: Let us see if we cannot find some common ground.

The Spectator: I do not see how such a representation can be excused.

Friend: Tell me, when you go into a theatre, do you expect all you see to be true and real?

Spectator: By no means! I only ask that what I see shall appear true and real.

Friend: Pardon me if I contradict even your inmost conviction, and maintain that this is by no means what you demand.

Spectator: That would be strange! If I did not demand this, why should the scene-painter go to such trouble to draw each line in the most perfect manner, according to the rules of perspective, and represent each object with the most perfect keeping (aerial perspective)? Why take such pains with the costumes; why spend so much time ensuring their truth, so that I may be transported back into those times? And why is that actor most highly praised who expresses feeling most truly, who comes nearest to the truth in speech, gesture, delivery, and who persuades me that I see not an imitation, but the thing itself?

Friend: You express your feelings admirably, but it is harder than you may think for us to understand our feelings aright. What would you say if I replied that theatrical representations seem by no means to be really true to you, but rather only appear to be true?

Spectator: I should say that you introduce a subtlety which can only be a play on words.

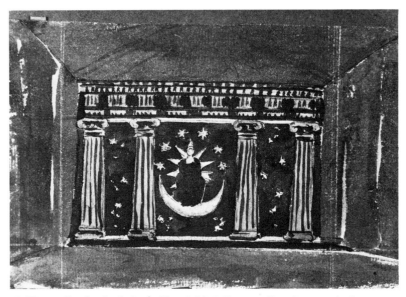

3 J. W. von Goethe, *Set Design for Mozart's Magic Flute*, 1794. Pencil, pen and ink and water colour, 10 × 15.5cm. Weimar, Goethehaus.

Friend: And I maintain that when we speak of the operations of the soul, no words can be subtle and delicate enough; and that this sort of play on words indicates a need of the soul, which, not being able to express adequately what goes on inside us, tries to work through antitheses, to answer each side of the question, and thus, as it were, to find the mean between them.

Spectator: Very well then. Only explain yourself more fully, and with examples, if you please.

Friend: I shall be glad to avail myself of them. For instance, when you are at an opera, do you not experience a vivid and perfect satisfaction?

Spectator: Yes, when everything is in harmony, it is one of the most perfect I know.

Friend: But when the worthy characters meet and compliment each other in song, sing out the letters in their hands, sing their love, their hate and all their passions, fight and die singing, can you say that the whole production, or even part of it, seems true? Or even has the slightest appearance of truth?

Spectator: You're right. If I think about it, I can't say that it has. None of these things seems true.

Friend: And yet you are completely pleased and satisfied with it?

Spectator: Unquestionably. I still recall how the opera used to be ridiculed on account of this gross improbability, and how none-theless I always derived the greatest satisfaction from it, and find more and more, the richer and more perfect it becomes.

Friend: And do you not feel completely deceived at the opera?

Spectator: I would not like to say 'deceived' – but yes – well, really, no.

Friend: You have got yourself into a complete contradiction, which seems far worse than a quibble.

Spectator: Steady on, we will soon clear it up.

Friend: As soon as it is clear, we shall be able to agree. Can I ask you some questions on the point we have reached?

Spectator: You must question me out of this dilemma, as you questioned me into it.

Friend: You do not want to call the feeling you have at an opera 'deception'?

Spectator: Not really, yet it is a sort of deception, at least, something very close to it.

Friend: Exactly, but don't you almost forget yourself there?

Spectator: Not almost; totally, when all or part of it is good.

Friend: Are you ravished?

Spectator: That has happened more than once.

Friend: Can you explain the circumstances?

Spectator: There are so many, it would be hard to list them.

Friend: Yet you have already said it: you are ravished most when everything is in harmony.

Spectator: Unquestionably.

Friend: Did this perfect production harmonize within itself, or with something in nature?

Spectator: Undoubtedly within itself.

Friend: And this harmony was surely a work of art?

Spectator: Certainly.

Friend: We denied to opera a certain sort of truth. We have maintained that it is by no means faithful to what it professes to represent. But can we deny it an inner truth, arising from its completeness as a work of art?

Spectator: If the opera is good, it certainly creates a microcosm of its own, in which everything proceeds according to fixed laws, and which must be judged by its own laws, and felt according to its own terms.

Friend: Does it not follow from this that truth of nature and truth of art are two distinct things, and that the artist should in no way attempt to give his work the appearance of nature?

Spectator: And yet it often seems to be a work of nature.

Friend: That is undeniable. But can I speak equally frankly?

Spectator: Why not? We are not standing on ceremony here.

Friend: Then I will venture to say that a work of art can seem to be a product of nature only to a wholly uncultivated spectator, whom the artist still appreciates and values even if he has only reached the first stage of understanding. But he, unfortunately, can only be satisfied when the artist descends to his level, and when the true artist, spurred on by his genius, takes wing and comes full circle in his work, he will never rise with him.

Spectator: That is strange, but go on.

Friend: It is something you would not like to hear, if you had not reached a higher stage yourself.

Spectator: Now let me try myself to arrange in order what we have discussed, and, so that we can proceed, let me take up the questioning.

Friend: I should like that even better.

Spectator: You say that a work of art could appear as a work of nature only to an uncultivated person?

Friend: Certainly. You remember the birds that tried to eat the cherries of the great master?[2]

Spectator: Surely that shows that the fruit was painted excellently?

Friend: Not at all, it just proves to me that the connoisseurs were proper sparrows.

Spectator: That does not convince me that the picture was not excellent.

Friend: Shall I tell you a more recent story?

Spectator: I usually prefer stories to arguments.

Friend: A certain great naturalist owned, among other pets, an ape, which he missed one day, and, after a long search, found in his library. The beast was sitting on the floor with the plates of a natural history book scattered about him. Amazed at this access of studiousness on the part of his pet, the man approached and saw to his astonishment and vexation, that the sweet-toothed ape had been making a meal of the beetles illustrated in various of the plates.

Spectator: It is a droll story.

Friend: And to the point, I hope. You would not compare these coloured engravings with the work of the great artist who painted the cherries?

Spectator: Hardly.

Friend: But you would put the ape with the uncultivated amateurs?

Spectator: Certainly, and with the greedy ones! You give me a strange thought: does not the uncultivated amateur ask that a work of art be natural just because he wants to be able to enjoy it in a natural, and often a crude and vulgar way?

Friend: That is exactly what I think.

Spectator: Thus you maintain that an artist debases himself when he tries to produce this effect?

Friend: I am convinced of it.

Spectator: But I still feel a contradiction here. Just now you did me the honour of numbering me among the half-educated amateurs.

Friend: With the amateurs who are on the way to becoming connoisseurs.

Spectator: Then explain why a perfect work of art seems to me to be a work of nature.

Friend: Because it harmonizes with your better nature; because it is above the natural, but not outside it. A perfect work of art is a work of the human soul, and, in this sense, is also a work of

nature. But because it gathers together scattered objects, down to the humblest, in all its significance and worth it is above nature. It will be comprehensible to a mind that is harmoniously formed and developed, one that, according to its capacities, will seek out what is perfect and complete in itself. The ordinary spectator, on the other hand, has no idea of it; he treats a work of art as he would any object he meets with in the market-place. But the connoisseur sees not only the truth of the imitation, but also the excellence of the selection and the ingenuity of the composition: the ideality of this little world of art. He feels that he must rise to the level of the artist in order to enjoy his work; he feels that he must pull himself together out of the distractions of his life, must live with the work, contemplate it again and again, and thus confer a higher mode of existence on himself.

Spectator: Well said, my friend. I have often made similar reflections on pictures, on the drama and other types of poetry, and I have had a premonition of what you have been asking. In future I will take more notice both of works of art and of myself. But, if I am not mistaken, we have left the starting-point of our discussion quite behind. You wanted to persuade me to allow these painted spectators at our opera, and although we agree about it so far, I do not yet see your arguments in defence of this liberty, nor the category into which this painted audience is to be put.

Friend: Luckily the opera is repeated tonight, and you will surely not miss it?

Spectator: On no account.

Friend: And the painted men?

Spectator: They will not scare me off, for I think myself a cut above a sparrow.

Friend: I hope that a mutual interest will soon bring us together again.

NOTES

1. This dialogue was stimulated by a visit in 1797 to a production of Salieri's *Palmyra* in Frankfurt, with sets by the Milanese painter Giorgio Fuentes (1756-1822). Goethe later visited Fuentes in his studio and tried in vain to attract him to Weimar, although in 1815 his pupil, Friedrich Beuther settled as scene-painter there (see P. Zucker, *Die Theaterdekorationen des Klassizismus*, 1925).

2. The reference is to the Greek painter Zeuxis, whose illusionism is recorded by Pliny (*Natural History*, xxxv, 54).

The collector and his circle
[*Propyläen* II, ii, 1799][1]

LETTER I

If your departure after those two days, so enjoyable, so quickly flown, made me feel a great void and chasm, your letter, which came so soon, and the manuscripts you enclosed, brought on the same mood which your presence had inspired. I am reminded of our conversations, and rejoice, as I did then, that we so often agree in our judgements about art.

This discovery is doubly valuable to me since, if I want to test either of our opinions, I have only to take an aspect of my own collection and go through it in the light of our practical and theoretical precepts. Often it comes easily and pleasantly, but sometimes I stumble, and sometimes I cannot agree with either you or myself. Nonetheless I am conscious how much is to be gained when we agree about principles, when the criticism of art, swaying like a pair of balances, is firmly anchored, and, if I may pursue the image, when both scales and pans are not in motion.

The sample you send arouses all my hopes and sympathies for your proposed publication, and I will gladly help it in any way I can. Theory has never been my forte, but if my experience can be of any use to you, it is at your service with all my heart, and, in proof of this, I will start to fulfil your request at once. By and by I will sketch for you the history of my collection, whose astonishing features have surprised many who already knew its reputation before they came. That was the case with you. You admired the exceptional richness of the most various sections of it, and your admiration would only have increased if time and inclination had allowed you to become acquainted with all my possessions.

Of my grandfather I need say only that he founded the whole collection, and how well he did it is proved by the attention with which I observed you look at everything which dates from him. You lavished so much love and admiration on this pillar of our extraordinary family home that your injustice towards other parts of it did not upset me, and I gladly lingered with you in front of those works which are sacred to me alike for their value, their age and their provenance. Certainly it depends a good deal on the

character and inclinations of the amateur where the love of form and the taste for collecting, two tendencies so often found in man, are directed, and I would say that as much depends on the time in which he lives, the circumstances around him, the artists and picture dealers with whom he is conversant, the countries he first visits or with which he has any connexions. Certainly he is influenced by a thousand circumstances of this sort. What indeed does not contribute to making him well grounded or superficial, liberal or in some way limited, comprehensive or one-sided!

It was my grandfather's good fortune to live at the best time and in the most favourable circumstances for gathering about him the sort of objects which at the moment are beyond the reach of private means. I have accounts and letters about his purchases, and how disproportionately low are the prices, compared with those of today, which the widespread interest in collecting has so exaggerated.

Yes, the collection of this worthy man is to my other possessions, to my attitudes and my judgement what the Dresden Collection is to the rest of Germany: an eternal spring of pure knowledge to the youth; a strengthener of sensibility and good principles to the man, and wholesome for everyone, even the most casual observer, for the effect of what is truly excellent is not confined to the initiated. Your remark that none of those works that date from my excellent ancestor need be ashamed of a comparison with the treasures of kings did not make me feel proud, but only pleased, for I had already dared to think the same myself.

I close this letter without having fulfilled my intention. I ramble on instead of getting on with the story. But an old man's humour shows itself in both these ways. I have hardly left myself enough room to say that uncles and nieces send their best wishes, and that Julie especially asks oftener and more urgently about our long-delayed trip to Dresden because she hopes on the way to see her new and esteemed friend. But none of your old friends can sign himself more heartily than your uncle,

<div align="right">Your truly devoted</div>

LETTER II

Your kind reception of the young man who presented himself with my letter has made me doubly happy, for it gave him such satisfaction, and through him it gave me a lively account of yourself, your circumstances, your activities and your plans.

Our animated conversation about you at first concealed how sadly he had changed during his absence. When he left for college, he was full of promise: he left school strong in the Greek and Latin languages and literature, familiar with ancient and modern history, not unpractised in mathematics and whatever else is expected of a good scholar. But now he returns a philosopher. He is particularly, indeed exclusively, devoted to philosophy, and our little circle, including myself, which can certainly boast no special taste for philosophy, is altogether at a loss what to say to him. What we understand, he does not care for; what interests him, we do not understand. He speaks a new language which we are too old to learn.

What a strange thing this philosophy is, especially the new philosophy! To drive into one's own self, to spy upon the operations of one's own soul, to shut oneself up inside oneself in order better to understand the world. Is this the way? Does the hypochondriac see things better because he is always mining and undermining himself? Truly this philosophy seems to me to be a sort of hypochondria, a spurious tendency which has been given a high-sounding name. Forgive an old man, and a practising doctor at that, for going on so.

But no more of this! Politics has never succeeded in souring my disposition, nor shall philosophy do so now. So, let us away to the haven of art, let me quickly return to my story, so that my letter may not leave out the very topic which occasioned it.

It was after my grandfather's death that my father first began to show peculiar pleasure in a particular sort of art. He delighted in the faithful imitation of natural objects, which had at that time reached a high degree of perfection through the use of water-colours. At first he bought a few examples of this; then he employed some painters to paint him birds, flowers, butterflies, and shell-fish, all of which must be copied with the greatest exactness. There was nothing noteworthy that turned up in the kitchen, garden or meadow which was not immediately fixed on paper, and he has thus recorded many varieties of different species which have proved very interesting to naturalists.

Little by little he progressed to portraits; he loved his wife and children, he esteemed his friends, and hence his collection of their likenesses.

You will also recall many little oil portraits on copper. Great artists used to paint this sort of thing as a relaxation or for their

friends; thus the practice gained in estimation and developed into a distinct branch of painting to which specialists devoted themselves.

This format has its own advantages. A life-size portrait, even if it is only a head or a half-length, always takes up more room than its intrinsic interest demands. Every well-off man of sensibility should have portraits of himself and his family at various stages of his life. Strongly characterized by a clever artist and on a small scale, they would take up little room, and thus he could collect all his friends around him, and his posterity would always find a place for such a gathering. A large portrait, on the other hand, is only too apt to vanish with its subject, and give way to heirs. And the fashions change so much that one's grandmother, no matter how well she be painted, is hardly at home among the carpets, furniture and decor of her descendants.

The artist, however, depends on the amateur of his own day, and the amateur on him. The master who alone knew how to make these little portraits died, and another turned up who painted the size of life.

My father had long desired to have an artist like this available. He wanted to see himself and his family life-size. For just as he had always insisted that every bird, every flower, every insect should be accurately imitated in point of size as well as everything else, so he wished to see his own image on canvas as accurate as in a mirror. His wish was at last granted. A clever man was found, who stayed with us for a long time. My father and mother were both handsome, my sister the most beautiful and charming girl in the neighbourhood, so they must all be painted, and that more than once. My sister especially, sat in several guises, as you have seen. Preparations were even made for a family group, but this never got beyond the sketch, since neither the subject nor the composition could be agreed on.

In the end my father was not satisfied. The artist had been trained in the French School; his pictures were harmonious, spirited and apparently natural, yet although they resembled their originals, they left much to be desired, and there were some, where the artist had attempted to please my father by adopting some of his suggestions, that were utterly ruined.

At last, however, my father's wishes were fully gratified, and in an unexpected way. Our artist's son, a gifted youth who had been trained by his German uncle, and who was to be his heir, visited

my father, who discovered in him a talent which satisfied him completely. My sister was to be painted at once; this was done with unbelievable fidelity, and a picture resulted which, if not in perfect taste, was full of nature and truth. There she stood as she used to walk in the garden, her brown hair partly falling over her forehead, partly plaited in large locks and held back with a band, her sun bonnet on her arm filled with the most beautiful pinks – which my father prized highly – and holding a peach from the tree which that year bore fruit for the first time.

Luckily these objects went together very well without being tasteless. My father was enchanted, and the painter gladly made way for his son, with whose work a completely new era began in our house, one which my father saw as the most pleasurable in his life. Each member of the family was then painted with the objects he usually had about him or which represented his chief occupation. I must say no more about these pictures. You cannot have forgotten the bizarre zeal with which our Julie gradually assembled all the accessories of the paintings as far as they were still to be found in the house, so as to convince you of the exactness of the imitations. Grandfather's snuffbox was there, and his great silver watch, his stick with the topaz head, and grandmother's work-box and earrings. Julie has even kept an ivory toy that she holds in one of the pictures of her as a child. She stood under the picture; although the toy still looked the same, the girl was far from it, and I well remember our joke about it.

In the course of a year we had portraits not only of all the family, but of all the furniture as well. No wonder the young artist found it necessary, when he was bored with his work, to refresh himself by looking at my sister, a remedy that he found the more effective that he seemed to find in her eyes what he was looking for. In short, they determined to live and die together. My mother was in favour of it, and my father was only too pleased to fix in the family a talent he could no longer do without.

It was settled that our friend should first make a journey through Germany to secure the blessing of his father and uncle, and then he would become ours for ever.

The business was quickly done, and although he was not long away, he was able to bring back a tidy sum of money that he had earned at the various courts he visited. The happy couple were united and our family became a scene of content that lasted until the death of its members.

My brother-in-law was a handsome man who got on well in life. His talent satisfied my father, his love my sister and his general friendliness myself and the rest of the household. During the summer he travelled, and he always returned well paid for his labours. The winters he devoted to his family, and he usually painted his wife and daughters twice a year.

His success in rendering even the smallest detail so faithfully as to border on deception gave my father a remarkable idea, the execution of which I must describe to you in words, since the picture itself has not survived. Otherwise I would have shown it to you.

In the upper room where the best portraits hang, the last room in the wing, you may have noticed a door which seems to lead somewhere. In fact it is a false door, and when you opened it, you were greeted by something that was more surprising than agreeable. My father seemed to be stepping forward, with my mother on his arm, and the sight startled you by its realism, which was partly the result of the situation and partly of art. Father was shown as if returning from a dinner or a *soirée*, dressed as he usually was on such occasions. The picture was painted with the greatest care, on the spot, and specifically for that situation. The figures were in perfect perspective for the point of view and the effect of the clothes was most carefully worked out. A window had to be moved so that the light might fall properly from the side to perfect the illusion.[2]

Unfortunately this work, which had been made as close as possible to reality, shared the same fate as reality. The frame and canvas had been set into the door-jamb and were thus exposed to the dampness of the wall, the effect of which was increased by the exclusion of air by the door. At the end of a hard winter during which the door had not been opened, father and mother were found to be utterly destroyed, which was the more to be regretted that they also were already dead.

I must retrace my steps a little to speak of the last satisfaction my father enjoyed during his life.

After this picture had been completed, it seemed that this art had nothing left to show him, and yet one pleasure was still in store. An artist arrived who undertook to make life-casts of the face in plaster, and to copy them in wax, coloured to the life. The likeness of his young assistant bore witness to his talent, and my father determined to submit to the operation. The experiment was

successful. The artist copied his face and hands with the greatest care and truth, a real wig and damask dressing-gown were requisitioned for the phantom, and the old boy is still sitting here behind a curtain which I did not dare to draw back for you.

After the death of my parents, the family did not stay together long. My sister died, still young and beautiful. Her husband painted her in her coffin; but his grief at her loss would never allow him to paint his daughters again, for as they grew up they seemed to inherit her beauty, divided, as it were, into two. He often made little still-lives of her various effects which he carefully preserved. These he finished very precisely and presented them to the friends he had made on his travels.

It seemed as if his grief had raised him to the ideal, for he had hitherto painted only objects in everyday use. These silent images did not lack for either unity or expressiveness. In one, the objects grouped together showed the piety of their owner; a hymn book with a red cover and gold clasps, a pretty embroidered purse with strings and tassels, from which she would dispense her charitable gifts, the goblet from which she took the Sacrament before her death, and which she had exchanged with the church for a better one. In another picture was a loaf, and beside it the knife she used to slice it for the children, the little seed-box from which she sowed in the spring, a diary of her expenses and any little occurrences, a glass with her initials engraved upon it – a childhood gift from her grandfather, which, in spite of its fragility, had outlived its owner.

He began to travel again, and to follow his usual course of life. Able only to see the present, yet always reminded of his irreparable loss by it, he could not recover his spirits: a sort of incomprehensible yearning seemed to overcome him, and the last still-life that he painted consisted of objects that had belonged to her, and which, chosen and arranged in a strange way, hinted at transitoriness and separation, and at permanence and reunion.

We found him several times in front of this picture, wrapt in reflection, which was not his wont, in a touching and agitated condition – and you will forgive me if I stop here for today, so that I may recover from this memory which I dare not think of any more.

Yet my letter must not reach you with such a sad ending, and I am handing the pen over to Julie to say –

My uncle passes me the pen so that I can give a graceful turn of phrase to his expression of devotion to you. He remains true to

that old custom of closing a letter or taking his leave of a friend with a genteel bow. We young people have never learned it; such a formality does not seem natural or sincere enough; we cannot get beyond a farewell and an imaginary handshake.

What is to be done now to fulfil this commission, this injunction of my uncle as befits an obedient niece? Can't I think of any graceful flourish, and will you think it graceful enough if I assure you that the nieces are just as devoted to you as the uncles? He has forbidden me to read his last sheet. I wonder what good or ill he has been saying of me: perhaps it is only my vanity that makes me think he has mentioned me at all. It is enough that he has let me read the first part of his letter, and there I find he has been decrying our good philosopher to you. It is neither gracious nor proper of my uncle to take so severly to task a young man who loves and respects both him and you so highly, merely because he so earnestly perseveres in a path which he believes will improve his mind. Be honest with me, and tell me if you don't think we women often see more clearly than the men because we are not so one-sided and we allow to every one his own. In fact the young man is communicative and sociable. Sometimes he talks to me, and although I do not understand his philosophy, I think I understand the philosopher himself.

Yet, after all, perhaps he has you to thank for the good opinion I hold of him, since the roll of engravings he brought from you with your friendly message assured him the best of receptions.

I am not sure I can best thank you for your remembrance and your goodness, for it seems to me there is a little mischief concealed behind your gift. Did you mean to mock your obedient servant by sending this wisp of elves, these strange fairies and spirit shapes by my friend Fuseli? How can your poor Julie help it if she is enchanted by the strange and the wild, if she likes to see marvellous things, or amuses herself with these moving and interweaving dreams set down on paper?

You have nevertheless made me very pleased, although I can see that with a second uncle comes a second rod to my back. As if the first did not give me enough to do! He can never let the children alone, without lecturing them on their pleasures.

My sister defends herself against this better than I do, for she never allows herself to be crossed. And, as a love of some form of art is essential in our family, her preference is for the graceful and whatever it is always pleasant to see around.

Her fiancé (for the affair, which was uncertain at the time of your visit, is now settled) has sent her some splendid coloured prints from England, which delight her beyond measure. But what a set of white-clad willowy beauties, with pink ribbons and pale blue veils! What interesting-looking mothers with well-fed children and handsome fathers! When they are all nicely framed in glass and mahogany, decorated with the brass rods that came with them, and hung against a lilac ground in my lady's boudoir, I shall not dare to bring Titania and her fairy court and Nick Bottom into such company.

But it looks as if I am criticizing my sister, for the best way to be satisfied with oneself is to be a little intolerant about others. And now I have finished this sheet at last, and find myself unexpectedly so near the end of the paper that there is only room for the tenth of March, and the name of your true friend, who bids you farewell.

<div style="text-align: right">Julie</div>

LETTER III

I see that Julie in her last postscript has spoken a word on behalf of the Philosopher, but I am sorry to say her uncle cannot agree with her; for the young man not only abides by his peculiar method, which I cannot by any means share, but his mind also dwells on topics about which I neither think nor have ever thought. Even in the midst of my collection, where I soon find common ground with everyone, I can find no point of contact with him. He has lost even the historical and antiquarian interest he once seemed to have in it. Moral philosophy is his special study, about which I know nothing save what my heart tells me. His next preoccupation is Natural Law, of which I never feel the lack, for our judicial system is just and our police active; and the Law of Nations, which my uncle taught us to despise when I was very young, is the chief object of his career. It is all over with the conversations, from which I promised myself so much pleasure: I can value him as an excellent man, love him for his goodness, and serve him willingly as a relative, but, alas! we have nothing to say to each other. My pictures leave him cold and my prints silent.

But while, sir, I am venting my spleen to you, like a true German stage uncle, experience restrains me and reminds me that it is not the way to get on with people to exaggerate the differences which happen to divide us.

Let us therefore rather wait and see what the future holds for us, and I will not neglect my duty towards you, but continue with my account of the founders of my collection.

My paternal uncle, having distinguished himself as a brave officer, was from time to time employed in various affairs of state, and finally in very important ones. He knew most of the princes of the day, and by receiving gifts decorated with their likenesses in enamel and miniature, he became a connoisseur of works of this type. Gradually he assembled the portraits of dead as well as of living potentates, from the gold snuff-boxes and diamond settings that came back to the goldsmiths and jewellers, so that in the end he possessed a complete *Almanach de Gotha* in pictures.

As he travelled a good deal, and wished to keep his treasures by him, he was able to make it very compact. He never showed it without its being enlarged by the addition of some living or dead prince from one jewel-box or another, for a specialized collection has a way of attracting all the waifs and strays, and even the affection of an owner for some single, isolated treasure is overridden, and vanishes by force of numbers.

From portraits, among which were some full-length, allegorical ones, such as princesses in the guise of nymphs and huntresses, he later extended his collection to other small pictures of the same sort, always paying more attention to exquisite finish than to the higher aims of art, which are, nonetheless, by no means foreign to this class of painting. You have yourself admired the best of this collection; I have added only little and occasionally.

And now at last I have to speak of myself, the complacent owner of this famous and highly-praised collection, and often enough its vexed custodian. From my youth upwards, my inclinations were diametrically opposed to those of both my uncle and my father.

Whether I inherited the rather more serious leanings of my grandfather, or whether, as often happens with children, I abandoned the ways of my father and uncle out of a spirit of opposition, I will not pretend to decide. Suffice it to say that, while the former wished that art should follow exactly in the steps of nature by means of the closest imitation and the most scrupulous execution, and the latter prized a small picture only so far as it was crammed with an infinite number of small touches, and always kept a magnifying-glass to hand to increase his wonder at the labour, I could only enjoy sketches which gave me a vivid idea of what was still to be carried out.

The admirable examples of these that I found in my grandfather's collection, and which may have shown me that a sketch may be as accurate as it is spirited, served to kindle my enthusiasm without guiding it. Boldly drawn sketches, roughly washed in with ink, were what delighted me, and even where a few strokes rendered what was in effect only the symbol of a figure, I knew how to interpret them, and prized such works beyond measure. Such were the beginnings of the little collection which I began in my youth and continued as I got older.

In this I maintained a constant opposition to my father and my brother-in-law. And as neither of them knew how to come to terms with my point of view, or to attract me to theirs, I became more persistent and strengthened in my position.

Although, as I have said, I prized a spirited handling above all things, yet many finished works naturally found their way into my collection. Without being aware of it, I learned to prize the brilliant execution of brilliant sketches; I learned to value precision, although I also made it an indispensable condition that there should be feeling in every touch.

This development was aided by the etchings by various Italian masters which (including yours) are still in my collection; and I was thus progressing on the right path, when another enthusiasm soon drew me back.

Order and completeness were the two qualities I desired my little collection to possess. I read the history of art, I put my prints in order according to school, master and date. I made catalogues, and I must say in my own praise that I never heard the name of any good master or learned about any good artist without seeing if I could acquire one of his works, so that I might not simply praise his merits in words, but have them before my eyes.

Thus it stood with my collection, with my knowledge and its direction, when the time came for me to go to college. My devotion to my profession, which was to be medicine, the absence of all works of art, new objects around me, a new life, all these forced back my love of art into the depths of my heart, and I found occasion to practise my eye only on whatever was excellent among illustrations of anatomy, physiology and natural history.

Yet before the end of my academic career, I found the opportunity of visiting Dresden, which opened a new prospect to me, and one that has had its effect on my whole life. With what delight, nay, intoxication, did I wander through the sanctuary of that gallery!

How many presentiments were then realised! How many gaps in my historical knowledge filled! How my view was expanded over the splendid hierarchy of art! I looked back and congratulated myself on the family collection, which was one day to be mine, and the recollection of it was accompanied with the most delightful feelings; and since I could not be an artist, I would have been in despair if I had not from my birth been destined to be an amateur and a collector.

I will not detain you with the effect other collections produced on me, with what I have done besides to increase my knowledge, how my love of art has kept pace with all my other occupations, and has stayed with me like a guardian angel. I will only say that all my other faculties were diverted to the exercise of my profession, that my practice soon required all my attention, and that this very different occupation only seemed to add to my love of art and to my passion for collecting.

What remains you will readily guess from your knowledge of me and my collection.

When my father died and I inherited this treasure, I had sufficient knowledge to fill in the gaps I found, not simply as a collector, because they were gaps, but rather as a connoisseur, because they were worth filling; and I am strengthened in my conviction that I am doing the right thing by finding that my tastes correspond with the judgements of many sound men I have met. I have never been to Italy, yet I have tried to make my taste as universal as possible. How far I have succeeded you are fully able to judge. I will not deny that I might and should have cultivated a purer taste in this or that direction, but who could live with thoroughly purified tastes?

That is enough about myself for the present, and for ever. Would that all that egotism could find an outlet in my collection! For the rest, let 'to give and to receive' be our watchword, which can be spoken by none with greater affection and confidence than by

<div align="right">Your truly devoted</div>

LETTER IV

You have once again given me proof of your friendly remembrance by lending me the first part of the *Propyläen*, and even more by enclosing the manuscript drafts which by their greater fullness make for a livelier impression and greater clarity. You have answered the challenge at the end of my last letter in a really friendly

way, and I thank you for your gracious reception of the short account of my collection.

These printed and manuscript pages recall to me those pleasant hours of which you were the cause, for you went far out of your way, in miserable weather, to visit a private collection. At least it satisfied you in a number of ways, and its owner had the good fortune to make a sincere friend without any lengthy overtures. I recognize in these pages the principles you then maintained and the ideas which chiefly interested you; I see that you abide by, and have even developed them, and I dare to hope that you will listen not without interest to how my affairs have gone. Your writings inspire me, and your letter challenges. The history of my collection is in your hands, and I may use it again later. For the present, I have some wishes and some confessions to lay before you.

To keep a high and unattainable ideal alive in the mind through the contemplation of works of art, to fix as best we can a hierarchy of standards by our judgement of what the artist has accomplished, to seek earnestly what is perfect, to point out the fountainhead as well to the amateur as to the professional, to elevate his standpoint, to make history and theory, criticism and practice aim for the same goal, all this is fine and praiseworthy, and such labour cannot be unprofitable.

The assay master seeks by every means to purify his precious metals, to establish a fixed standard to test all the alloys of gold and silver that may come his way. You may then take as much copper as you will, increase the weight, debase the value, mark coins or silverware according to any convention, do what you will, but the smallest change and even counterfeit coin will pass only for what it is worth, so long as we have the touchstone and the crucible by us to estimate its value correctly.

Without wanting to censure your severity, allow me to pursue the analogy and call your attention to certain broad divisions which neither artist nor amateur can do without in their daily lives.

But I cannot continue as I would wish because I have something on my mind, or rather my heart. I have a confession to make which I cannot withhold without being unworthy of your friendship. It cannot offend or displease you, so I will out with it. Each step forward has its risks, and only by daring do we make progress. But I must not dally any longer, or you will think that what I have to say is more important than it really is.

The owner of a collection who, no matter how willingly he

shows it, must yet show it more often than he would like, cannot help becoming a little malicious, be he never so mild and good-hearted. He sees total strangers making snap judgements on objects familiar to him. We do not have much opportunity to force our opinions about politics upon strangers, and our good sense forbids it, but works of art excite us, and no one is at a loss for words in their presence; no one doubts his own impressions, and he is right not to do so, but neither does any one doubt the correctness of his impressions, and this is not so good.

Since this collection came into my possession, I have met only one man who did me the honour of believing that I know how to judge the worth of my own things. He said to me, 'I do not have much time: let me see the best, most remarkable and rarest objects in each section.' I thanked him, and said that he was the first to make such a request: and I trust he did not regret his confidence in me; at least he seemed to go away fully satisfied. I will not say that he was a remarkable connoisseur or virtuoso; his manner even showed a certain indifference, and perhaps the man who loves some part is more interesting to us than one who values the whole. Nevertheless, he deserves mention as the first and last who did nothing to arouse my spirit of mischief.

Even you, I confess, fed my quiet malice without diminishing my respect and love. I was not only obliged to take the girls away – forgive me, but I cannot help chuckling to myself when I think of how you kept looking at the door while we were examining the cabinet of antique bronzes – but the door would not open again; the children had vanished, leaving the wine and the biscuits. A nod from me and they left, for I did not want my antiques to share a divided attention. Forgive this confession, and remember how on the following morning I recompensed you fully and let you see in the summerhouse not only the painted but the living family portraits, and gave you the satisfaction of a pleasant chat in view of the charming landscape: – 'Not only,' I said, and 'not only' it must remain, for this long parenthesis has ruined my sentence and I must begin a new one.

From the first you did me an especial honour by seeming to understand that we shared the same views, that I also knew how to appreciate those works you prized most highly, and I can truly say that for the most part our judgements did coincide. Here and there I thought I saw a vehement predilection, perhaps even a prejudice, but I let them pass, and thanked you for your quick-

sightedness about various neglected things which I had overlooked among such abundance. After your departure you continued to be a subject of conversation. We compared you with other strangers who had visited us, and we were thus led into a general comparison of our guests. We found great differences in the way people look at art, and in their ideas about it: but we found too that certain preferences recurred more or less in the various spectators. Aided by their entries in our visitors' book we began to group together those of similar leanings. From then on our spite was converted to observation: we examined our guests more closely and arranged them in the following groups. I say 'we' because, as usual, I took the girls along with me; Julie was especially useful and generally hit the nail on the head, for women have an instinct for men's prejudices. But Caroline would allow the highest place only to those who were absolutely overwhelmed by the rare and beautiful examples of English mezzotint in her quiet room. You were not, but your want of perception has nonetheless not lowered you much in the good child's eyes.

If you think about it, there are plenty of art-lovers of our sort, and it is natural to start with them – if we leave out of account a little prejudice for or against, more or less liveliness or deliberation, tolerance or severity – so I think your *Propyläen* has a good chance, for I not only imagine, but know such people.[3]

If I cannot reproach you here for your severity in art matters – for your strictness towards artists and amateurs – yet, out of consideration for the many who will read what you write, even if you have no other readers than those who have seen my collection, I must ask one thing for the benefit of art and its friends: viz. that on the one hand you should tolerate all sorts of art, that you should value the most specialized artists and amateurs, as long as they do not claim to be exclusive; and on the other I warmly recommend you to oppose earnestly those who from the narrowness of their conceptions, and from an unhealthy partiality, would like to substitute their darling pampered speciality for the whole. With this aim in view, let us set about a new sort of collection which does not consist of bronzes or marbles, ivories or silver, but one in which the artist and the critic, and especially the amateur, may find himself.

I am really only able to send you the slightest sketch, for the end result may be briefly summarized, and besides, my letter is already long enough. My introduction is ample, and you yourself will help me to expand the conclusion.

As usual, our little academy first looked at itself, and we soon found someone in each category within the family.

There is a class of artists we have called *Imitators*, for whom imitation carried to the highest perfection is the only objective and the highest pleasure. My father and brother-in-law belonged to this class, and the connoisseurship of the one and the art of the other left nothing to be desired in this branch. Imitation is never happy until it can set the copy as far as possible in place of the original.

The accomplishment of this end requires great accuracy and clarity, and here another class comes in, which we call *Dotters*, for whom the execution rather than the imitation is the object in view. They are the best pleased with the subject that may be made up of the most dots and strokes. My uncle is among these. This sort of artist seems to be trying to fill up space to infinity, and to persuade us that matter is infinitely divisible. The real value of this gift is when it presents us with a miniature replica of some well-loved person so that we may have them constantly in view, one whom the heart has treasured like a jewel, who can best be set among other jewels. Natural history also owes much to this class of men.

When we were looking at this category it occurred to me that I, with my early tastes in art, was diametrically opposed to it. All those who attempt to express too much in a few strokes, just as the last group effect too little with their infinity of points and lines, we call *Sketchers*. This term does not refer to those masters who outline proposed compositions for their own or others' judgement; we mean those who have never developed beyond sketching, and have thus never reached the goal of art, which is completeness, just as, for their part, the Dotters are not conscious of the beginning of art, which is ingenuity and inventiveness.

The Sketcher usually has too much imagination: he delights in poetical or even fantastic subjects, and he is always somewhat exaggerated in execution. He rarely falls into the error of weakness or meaninglessness, which often goes together with good execution.

As for the class in which the soft, the pleasing, the agreeable prevails, that has been espoused by Caroline, who solemnly protests she will have no nickname given to it. But Julie submits herself to fate and judgement, whether severe or charitable, together with her friends, the poetic and ingenious Sketchers.

From this soft style it is a natural progression to the woodcuts and engravings of the early masters, whose works, in spite of their

hard, severe, dry style, never fail to please us with a certain stern and independent character.

We then suggested several further divisions, which may however be subsumed under the above, such as *Caricaturists*, who look only for what is singularly repulsive and physically and morally deformed; *Improvisors*, who will sketch you any subject off the cuff with wonderful speed and cleverness; *Scholars*, whose works cannot be understood without a commentary; *Scholar-Amateurs*, who cannot leave the simplest work without its commentary, and so on, as I shall elaborate later. For the present I conclude with the hope that, if the end of my letter provokes your merriment over my presumption, it may atone for the beginning, in which I ventured to rally my worthy friend on some amiable weaknesses. I beg you to do the same for me, if my boldness does not repel you. Find fault with me, hold up the glass to my oddities, and you will add to the gratitude (though you cannot add to the devotion) of

<div align="right">Your eternally devoted</div>

LETTER V

The freedom of your answer reassures me that you have taken my letter in good part, and that your heavenly faculty for this has not been disturbed. Your letter was a propitious gift to me at a propitious moment. If good luck more often than misfortune comes in single doses, I, at any rate, am at present an exception to this rule. Your letter could not have found a more acceptable or a more pregnant moment to arrive, and your remarks on my odd classification could not have been more timely than when, like a bursting seed, they fell onto fruitful soil. Let me now relate what took place here yesterday, so that you may learn how a new star has risen in my firmament, a star with which yesterday's letter came so happily in conjunction.

Yesterday a stranger appeared, whose name I was already familiar with, and who has the reputation of a skilful connoisseur.[4] I was pleased to see him, showed him over the whole of my collection, and let him choose what he liked to look at in more detail. I soon noticed his practised eye for works of art, and especially for their history. He knew the pupils as well as the masters, he knew the reasons for doubtful attributions, and in general his conversation was highly interesting to me.

Perhaps I should have opened myself to him more quickly, had not my role as listener made me more passive from the start. His

judgement in many cases agreed with mine, and I was often obliged to admire his sharp and practised eye. Our first difference arose from his unmitigated hatred of all mannerists: I felt hurt for some of my favourite pictures, and was curious to discover the source of such a dismissal.

My guest had been late arriving, and the fading light prevented us from looking any further. I gave him a bite to eat, to which our Philosopher was also invited, for he and I have become closer of late. I must tell you, in passing, how this came about.

Merciful Heaven, foreseeing the peculiarities of men, has given a means towards unity as well as division; my Philosopher is much taken with Julie's grace (he had not seen her since she was a child). His good sense leads him to want to entertain the uncle as well as the niece, and our conversation is usually about the interests and the passions of men.

Before everyone else had arrived, I seized the opportunity of coming to the rescue of my poor mannerists against the stranger. I spoke of their beautiful rendering of nature, their well-realized handling, their agreeableness, adding, to be on the safe side, that I said this only to ask indulgence for them, admitting that the highest beauty which is the object of art is in fact quite a different thing.

He replied (with a smile that did not altogether please me, for it seemed to express an overweening complacency, and a sort of pity for me), 'Do you still hold the view then that beauty is the aim of art?'

I answered that I was not aware of any higher.

'Can you tell me what beauty is?' he asked.

'Perhaps not,' I replied, 'but I can show it to you. Let us go and see my fine cast of the Apollo or the beautiful bust of Bacchus, even by candlelight, and see if we cannot agree that they are beautiful.'

'Before we go on this quest,' said he, 'it will be necessary to examine this word "beauty" more closely, with its derivation. "Beauty" (*Schönheit*) comes from "Appearance" (*Schein*): it is simply an appearance, and not worthy to be the object of art. Only the perfectly characteristic deserves to be called beautiful: without character there is no beauty.'

Struck by this way of expressing it, I answered: 'Granted (though it has not been proved) that beauty must be characteristic, it follows nevertheless from this only that character lies at the root

of beauty, and by no means that they are identical. Character bears to the beautiful the same relation as the skeleton to the living man. No one will deny that bone-structure is the foundation of all highly organized forms of life. It consolidates and defines the form, but it is not the form itself, still less is it the cause of that final manifestation, which as both the concept and the outer clothing of an organized unity we call beauty.'

'I cannot go into analogies,' said my guest, 'and from what you say yourself it is evident that beauty is something incomprehensible, or the operation of something incomprehensible. What cannot be understood is nothing: what we cannot make clear in words is nonsense.'

I: Can you then clearly express in words the effect that a coloured body produces in the eye?

He: That is another case, which I will not be drawn into. It is enough that character can be indicated. You find no beauty without it, for then beauty would be empty and meaningless. All the beauty of the Ancients is only character, and only from this quality is beauty developed.

Meanwhile our Philosopher had arrived and was chatting to my nieces, when, hearing us speaking seriously, he came up, and the stranger, encouraged by a new audience, proceeded:

'That is just the trouble, when good minds get hold of such false principles, which have only a colour of truth, and expand on them. None adopt them so willingly as those who neither know nor understand anything about the subject. Lessing has thus foisted on us the principle that the Ancients cultivated beauty alone, and Winckelmann sends us to sleep with his still greatness, his simplicity and repose.[5] But the art of the Ancients appears in every conceivable form. These gentlemen stay with Jupiter and Juno, the Genii and the Graces, and cover up the base forms and the thick skulls of the barbarians, the shaggy hair, filthy beard, scrawny bones and wrinkled skin of deformed age, with its protruding veins and dangling breasts.'

'For God's sake,' I exclaimed, 'are these then original works of the best period of ancient art which show such frightful subjects? Or are they not rather minor works, occasional pieces, the creations of an art that must demean itself according to circumstances, an art in decline?'

He: I will give you an example which you must examine and judge for yourself. You will surely not deny that the *Laocoon* (Fig. 4), the

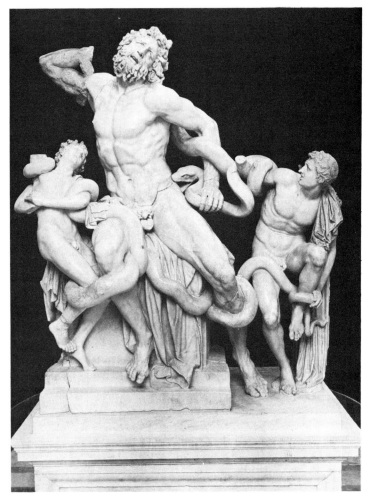

4 *Laocoon*. Rome, Vatican Museum. Photograph by the Vatican Museums.

Niobe, the *Dirce and her stepsons* are original works.[6] Stand in front of the *Laocoon* and see nature in full revolt and desperation. The last choking pang, the desperate struggle, the maddening convulsion, the working of the corrosive poison, the violent ferment, the obstructed circulation, suffocating pressure and paralytic death.

The Philosopher seemed to look at me with astonishment, and I replied: 'We shudder and are horrified at the mere description. Truth! if this is so with the *Laocoon*, what are we to say of the pleasure we derive from this, as from every other true work of art? But I will not meddle in the question. You must settle it with the authors of the *Propyläen*, who take the opposite view.'

'It must be admitted,' said my guest, 'that all Antiquity speaks for me, for where do horror and death rage more hideously than in the *Niobe*?'

I was confounded by this assertion, for only a short while before I had been looking at the plates in Fabroni which I at once brought forward and opened.[7] 'I find no trace in the statues of raging horror and death, but rather the subordination of the tragedy to the ideas of dignity, nobleness, beauty and simplicity; I find everywhere the artistic aim of arranging the limbs agreeably and gracefully. The character is expressed on only the most general lines which run through the work like a sort of ideal skeleton.'

He: Let us turn to the low reliefs at the end of the book. We turned to them.

I: I really find no trace of anything horrible here either. Where is this rage of horror and death? I see figures so artfully interwoven, so happily placed or arranged against each other that, though they remind me of a mournful fate, they also give me most agreeable feelings. All character is tempered, all violence elevated, and I might say that character is the foundation, but upon it rest simplicity and dignity. The highest aim of art is beauty, and its final effect is the feeling of pleasure.

The agreeable, which may not be immediately united with the characteristic, is remarkably clear in these sarcophagi. Are not the dead sons and daughters of Niobe here used as ornaments? This is the highest luxury of art: Niobe no longer decorated with flowers and fruit, but with the corpses of men, with that greatest misfortune of a father or mother, to see a flourishing family all snatched away at one go. Yes, the beautiful Genius who stands by the grave with his down-turned torch stood beside the artist

as he conceived and perfected the work and has breathed a heavenly grace over this earthly greatness.

My guest smiled at me and shrugged his shoulders. 'Alas,' said he, as I thought. 'Alas, I see plainly that we can never agree. What a pity that a man of your attainments, of your mind, will not see that these are all empty words, that to a man of understanding beauty and the ideal must always be a dream which cannot be realized, indeed, is in direct opposition to reality?

My Philosopher appeared, during the latter part of our conversation, to be growing uneasy, for though he had seemed passive and indifferent at the outset, he now shifted his chair, twice moved his lips, and, when there was a pause, began to speak.

But what he said he must tell you himself. He is here again this morning, for his part in yesterday's discussion has broken the husk of our mutual distrust, and two fair plants have sprung up in the garden of friendship.

The post goes out this morning and I am sending by it this letter which has been the cause of my neglecting several of my patients, and for this I shall expect to be pardoned by Apollo, who is the patron of doctors and artists alike.

This afternoon we can expect other remarkable scenes: Characteristic will be here again, and half-a-dozen other strangers have asked to come. The weather is delightful and everything is busy.

Julie, the Philosopher and I have made a pact that we shall let none of the peculiarities of the company escape us.

But you shall first have the conclusion of yesterday's debate, and receive only the warmest wishes of your hurried but always

<div style="text-align: right">Faithful friend and servant</div>

LETTER VI

Our worthy friend has allowed me to sit at his writing desk, and I owe him not only this confidence, but also the opportunity of addressing you. He calls me the Philosopher, and I am sure he would call me the Scholar if he knew how much I wish to cultivate myself and to learn. But unfortunately, even to think we are on the right lines seems presumptuous to other people.

When you have heard my story you will forgive my taking so active a part in the discussion on art last night, with so little experience, and only some literary acquaintance with the subject; and you will see that I confine myself to generalities, and base my right to speak chiefly on my knowledge of ancient poetry.

I will not deny that I was roused by the way my opponent be-
haved towards my friend, for I am still young, and perhaps lose my
temper at the wrong moment, deserving the less to be called a
Philosopher. My opponent's language also concerned me, for if the
connoisseur and the amateur will not abandon the Beautiful, nor
can the student of philosophy look on the Ideal as a chimera.

And now I will repeat the gist and tenor of our conversation, so
far as I can remember it:

I: Will you allow me to put in a word?

Guest (somewhat scornfully): With all my heart, but try to keep off
airy fancies.

I: I know something of the poetry of the Ancients, but little of the
visual arts.

Guest: I am sorry about that, for it means we shall hardly agree.

I: And yet the fine arts are closely related, and the lovers of each
art should not misunderstand each other.

Uncle: Go on.

I: The ancient tragic writers dealt with their material in the same
way as visual artists, unless these engravings of Niobe's family
give a completely false impression of the original.

Guest: They will do. They give an imperfect, but not a false impres-
sion.

I: Well then, we can use them as a basis, as far as it goes.

Uncle: What do you say about the method of the ancient tragic
writers?

I: The subjects they chose, especially early on, were often of an
unbearable frightfulness.

Guest: Were the ancient fables unbearably frightful?

I: They certainly were, in the same manner as your account of the
Laocoon.

Guest: Did you also find that unbearable?

I: Forgive me, I meant the subject, not your description of it.

Guest: And the work itself?

I: By no means the work itself, but what you have seen in it – the
fable, the story, the skeleton, what you call characteristic. For
if we could really see the *Laocoon* as you have described it, we
should have no hesitation in smashing it to pieces.

Guest: Strong language!

I: One may use it as well as another.

Uncle: Now then, the ancient tragedies.

Guest: Yes, these unbearable subjects.

I: Very well, but also this bearable, tolerable, beautiful, graceful handling of them.

Guest: And this is brought about by simplicity and quiet grandeur?

I: So it seems.

Guest: By the softening principle of beauty?

I: It can be nothing else.

Guest: So the ancient tragedies were not frightful after all?

I: Hardly, so far as I know, if you listen to the poets themselves. Certainly, if you only look at the raw material of poetry, if you speak of art as if it were only nature, you would call even Sophocles' tragedies disgusting and repulsive.

Guest: I will not argue about poetry.

I: Nor I about visual art.

Guest: Yes, each should stick to his own department.

I: And yet there is a unifying centre to all the arts, from which all their laws derive.

Guest: And that is –

I: The soul of man.

Guest: Oh yes! it is just like you new philosophers[8] to reduce everything to your own principles, and it is certainly more comfortable to fashion the world after your own ideas than to subject your ideas to the test of reality.

I: We are not discussing metaphysics.

Guest: If we were, I should certainly withdraw.

I: I will keep nature out of it for the time being, and consider only man, who is necessarily the subject of art, for art exists only through and for him.

Guest: Where are you taking us?

I: You yourself, when you make character the aim of art, appoint as judge the understanding which recognizes the characteristic.

Guest: Yes I do. What I cannot grasp with my understanding does not exist for me.

I: Yet man is not only a creature of thought, but also of feeling. He is a whole, a union of various intimately connected powers, and the work of art addresses itself to this whole, to this rich unity, this simple variety in him.

Guest: Do not lead me into this maze, for who will ever get me out again?

I: It will be best for us to stop arguing, and for each to maintain his position.

Guest: I shall at least hold fast to mine.

I: Perhaps we shall still find a means by which, if we do not adopt each other's positions, we can at least acknowledge them.

Guest: What is that?

I: We will look at the origin of art for a moment.

Guest: Good.

I: We will follow the work of art on its road to perfection.

Guest: If you expect me to follow, it must be by the road of experience, for I will have nothing to do with the steeps of speculation.

I: Will you allow me to begin at the beginning?

Guest: Willingly.

I: A man is well disposed towards some object, perhaps something living.

Guest: Like this pretty little dog, for instance?

Julie: Here, Bello! It is quite an honour to serve as an example in such a discussion.

I: The dog will do, and if the man we are speaking of had a gift for imitation, he would try in some way to make an image of it. But however well he does it, we have not advanced very far, for at best we have two Bellos instead of one.

Guest: I will not interrupt, but wait and see where this is leading.

I: Suppose that this man, who because of his talent we will call an artist, is not yet satisfied: his objective seems to him too narrow, too limited; he busies himself with more individuals, varieties, types, species, so that at last he sees not the creature itself, but the idea of the creature, and he is able to express this through his art.

Guest: Bravo! He is just the man for me, and his work must be characteristic.

I: No doubt.

Guest: And there I would be satisfied and ask for no more.

I: But we are going on.

Guest: I stop here.

Uncle: I should like to see what is in store for us.

I: This exercise may have established a standard that is exemplary and scientifically useful, but not satisfying to the soul.

Guest: How, then, are you going to satisfy the wonderful demands of your dear soul?

I: Not wonderful: the demands that are not satisfied are all just. There is an old myth that the Elohim once took counsel together, saying 'Let us make man after our own image'; hence man is right to say 'Let us make gods in our own image'.

Guest: We are getting into a dark region.

I: There is only one light that can help us here.

Guest: And that is –

I: Reason.

Guest: How far it is a guide, or a will-o'-the-wisp, is hard to say.

I: We need not give it a name. But let us ask ourselves what demands the soul makes on a work of art. It is not enough that it gratifies a limited desire, satisfies our curiosity or gives order and stability to our knowledge: the highest must be awakened within us, we must be inspired with reverence and feel worthy of it ourselves.

Guest: I am losing you.

Uncle: But I think I can follow a little; how far, I will try to make clear by an example. Suppose our artist had made a bronze eagle which perfectly expressed the idea of the species, and wanted to place it on the sceptre of Jupiter. Would it belong there?

Guest: That depends.

Uncle: I say no! The artist must give it something more.

Guest: What, then?

Uncle: It is hard to express.

Guest: I can well imagine it.

I: But we may get close to it.

Guest: Go on then.

I: He must give the eagle what he gave Jupiter to make him a god.

Guest: Which is –

I: The godlike, which we should never know did man not feel and have it within himself.

Guest: I still hold my ground, but you may lose yourself among the clouds if you like. I see that you mean the high style of the Greeks, which I value only so far as it is characteristic.

I: But it is more to us; it answers a high demand, though still not the highest.

Guest: You seem to be very hard to please.

I: It is fitting for him to expect much who has much in store for him. Let me be brief. The human soul is exalted when it reverences and adores, when it elevates an object and is in its turn elevated. But it cannot remain long in this state. The concept of character leaves it cold. The Ideal raises it above itself, but now it must return to itself again, and would gladly enjoy again the affection it felt for the individual, without returning to some limited view; and it will no longer forgo the significant which elevates the spirit. What would become of it now, if beauty did

not step in and successfully solve the riddle? First she warms and animates knowledge, then breathes her softening influence and heavenly charm over the significant and the elevated, and brings them back to us again. A beautiful work of art has completed the circle; it becomes an individual again, and we can embrace with affection and make it our own.

Guest: Have you finished?

I: For the present. The little circle is complete and we are back at our starting point; the soul has made its demands, and those demands have been met. I have nothing further to add. (Here our uncle was suddenly called away to a patient.)

Guest: It is the way of you philosophic gentlemen to do battle from behind high-sounding words, as if they were a shield.

I: I can assure you that I was not speaking as a philosopher just now, for these are matters of common experience.

Guest: Do you call that experience, which no one else can understand?

I: Each experience has its organ.

Guest: Do you mean a separate one?

I: Not a separate one, but it must have one peculiarity.

Guest: And what is that?

I: It must be able to create.

Guest: Create what?

I: The experience! There is no creative experience that is not itself created.

Guest: Now come on!

I: This is especially so with artists.

Guest: Well I never! How enviable the portrait-painter would be and what a clientèle he would have if he could reproduce them all without having to bother them with so many sittings!

I: Your example does not deter me, for I am convinced that no portrait can be worth anything that the painter does not, in the strictest sense, create.

Guest: (springing up): This is too much. I wish you were taking advantage of me and this was only a joke. If only the riddle were to be solved that way, how I would wring your hand, like a good fellow.

I: I'm afraid I am quite serious, and cannot reach any other conclusion.

Guest: Now I did hope that in parting we should take each other's hands, especially since the departure of our good host has lost

us a mediator in our dispute. Goodbye, Mademoiselle. Goodbye sir. I will send tomorrow to inquire whether I should wait upon you again.

So he stormed out of the door and Julie scarcely had time to send the maid after him with the lantern she held ready. I remained alone with the dear girl, for Caroline had vanished some time since, about the time, I think, that my opponent had declared that mere beauty without character must be insipid.

'You have done ill, my friend,' said Julie, after a short pause. 'He did not seem altogether in the right to me, but I cannot give unqualified assent to you either, for your last assertion was only made to vex him. The portrait painter must *create* his likeness!'

'Fair Julie,' I replied, 'how I wish I could make myself clear on this point. Perhaps in time I shall succeed. But you, whose lively spirit is at home everywhere, who not only esteem the artist but in some way transcend him, for you shape what you have never seen as if it were in front of you, you should be the last to be startled at a discussion of creation.'

Julie: I see you intend to flatter me. That will not be difficult, for I like listening to you.

I: Let us think well of man and not be bothered if what we say of him sounds somewhat bizarre. Everyone admits that the poet must be born. Everyone surely ascribes creative powers to genius, and no one thinks he is reiterating a paradox. We do not deny it to works of imagination, but the idle, the worthless man will not believe in the good, the noble, the beautiful either in himself or in others. What is its origin if not in ourselves? Ask your own heart. Does it not devise methods by acting? Is it not our capacity for good that rejoices in good? Who ever feels keenly without wishing to express that feeling, and what else do we express but what we create – not just once for all, but working and expanding it so that it may exist again, and again be reproduced? This is the godlike power of love, of which we never stop speaking and singing so that it reproduces each moment the noble features of the beloved, perfects them down to the smallest detail, embraces them as a whole, neither resting nor sleeping by night or by day, is enchanted with its own work, astonished at its own restless activity, and finds the familiar always new because it is re-created afresh every moment by the sweetest of all activities. Yes, the image of the beloved cannot grow old, for every moment is the moment of its birth.

Today I have sinned. I have broken my resolution by speaking about a subject I have not fathomed, and at this very moment I am on the way to an even greater sin. A man who feels his ignorance should keep quiet: and so, too, the lover who dares not hope to be happy. I must go before I become doubly guilty.

Much moved, I seized Julie's hand; she kept it tenderly and would not let it go. Pray heaven I do not err, have not erred! But let me go on with the story. My uncle came back and was kind enough to praise in me what I had blamed, delighted that my ideas on art agreed with his. He promised shortly to give me the practical instruction I needed. Julie also promised me playfully that she would teach me if I would be more sociable and sympathetic – I already feel that she can do with me what she will.

The maid returned from lighting the stranger's way. She was very pleased with his liberality, for he had given her a handsome tip. But she was even more enthusiastic about his politeness, for he had sent her away with a friendly word and called her 'pretty child'.

I was in no mood to spare him, and exclaimed, 'Oh yes! I can easily believe that one who denies the ideal can mistake the common for the beautiful.'

Julie reminded me jokingly that justice and moderation were also ideals we should strive for.

It was now late and my uncle asked me to do him a favour which also meant I could do one for myself. He gave me a copy of that letter in which he speaks of the various types of art lover. He also gave me your reply and asked me to study both, marshal my thoughts on the subject and be present when the expected company visited his collection, to see if we could not discover and describe more categories. I spent the rest of the night at this task and have drawn up a scheme which is pleasant, if not profound, and at least has the merit of having amused Julie this morning.

Now farewell. I note that this letter is to go with my uncle's, which is now lying on the writing-table. I have only ventured to look quickly over what I have written. How much there is to alter and to clarify! If I did as I feel I should, these pages would go into the fire rather than into the post. But it would be a sad thing for conversation if only the perfect could be communicated. In the meantime, bless our guest for having put me in a passion, and causing the ferment which led to this correspondence with you, opening the way to a new and beautiful relationship.

LETTER VII

Yet another page in Julie's writing! Again you see the hand which you once interpreted as belonging to a mind that absorbed and communicated easily, and floated over the topics lightly.

These qualities will certainly be needed today if I am to fulfil a duty which, in the strictest sense, is forced on me, for I am neither called nor fitted to it. But the menfolk will have it so, and so it must be.

I am to recount yesterday's proceedings, depict the people who visited our collection, and then to explain the interesting scheme into which every artist will be fitted in future, if he persists in being partial and does not raise himself to the contemplation of the whole. The first part, the historical, I will attempt now, and to-morrow I will see if I cannot get out of the rest.

But so that you shall see why it falls to me to write, I will briefly relate what took place last evening after our guest's departure. We had been sitting together a long time (that is, uncle, our young friend, whom we shall no longer call Philosopher, and we two sisters), and had amused ourselves with the day's occurrences and cast ourselves and our friends into the different classes of art. When we were about to disperse, my uncle began, 'Now who will give our absent friend, whom we have so often wished for and thought of today, a summary of what has happened, of the progress we have made in assessing ourselves and others? We must not fail to send him something, so that we can get something back from him, and the snowball will get larger and larger.'

I replied that I did not think it could be in better hands if our uncle related the story of our day, and our friend gave an account of the new theory and its application.

'So soon as you pronounce the word "theory",' said our friend, 'I must retreat, and hastily excuse myself, happy as I should be to please you in all things. I do not know what it is that has been leading me from mistake to mistake all day. No sooner did I break my silence about art, of which I ought first to have acquired some knowledge, than I allowed myself to be persuaded to set down on paper my notions which must seem to be theoretical, on a subject in which I am a beginner. Allow me the consolation of believing I was led into this weakness through affection for my worthy friend, but spare me the disgrace of appearing with these crudities in front of persons in whose presence I, as a stranger, would not wish to show at such a disadvantage.'

My uncle then declared that for his part he would not be able to think of a letter for the next eight days. 'My patients, near and far, demand all my attention. I must visit, write reports, go into the country. See if you can agree among yourselves, my dear children. My idea was that Julie should take up her pen forthwith, begin with the historical and end with the speculative part. She has an excellent memory for events, and in her jokes I have often noticed that she has the edge on us in reasoning. It only needs good will, and that she has most of all.'

That is what they said about me, so I am obliged to write about myself. I held out as long as I could, but at last I had to give in, and I will not deny that what decided me was a few friendly words from the young man, who has acquired I know not what power over me.

And now my thoughts are directed towards you, gentlemen, and my pen, as it were, hurries away to you. It seems to me as I write that the distance between us is fast melting away. Now I am with you, and may my story find a friendly welcome.

We had hardly risen from table yesterday when two strangers were announced – a tutor and his young charge.

Mischievous and eager for our prey, we hastened to the collection. The young gentleman was good-looking and quiet; his tutor's manners were good, though not distinguished. After the usual preliminaries, he looked round the pictures and asked permission to take notes on the most remarkable of them. My uncle good-naturedly pointed out the best pieces in each room and the stranger briefly noted down the name of the artist and the subject. He wanted to know what each work had cost and what it was worth in cash, which of course we were not always able to say.

The young man was rather pensive than observant, and seemed most inclined to linger by lonely landscapes, rocky scenes and waterfalls.

Our guest of the previous day, whom in future I will call the Characteristic, now appeared. He was cheerful and good-humoured, joked with uncle and nephew about yesterday's dispute, and assured them that he still hoped to convert them. My uncle, equally affable, led him off to an interesting picture. Our friend seemed jaded and sad, and I rallied him about it. He admitted that his opponent's good humour had disturbed him for the moment, but promised that he would get over it.

We were noticing how affably uncle talked to his guest, when a

lady entered with two companions. We girls, who had put on our best in the expectation of this visit, hastened to welcome her. She was friendly and sociable, and we did not mind the touch of sternness which suited her age and station. Although she was a head shorter than my sister and me, she seemed to look down on us, and to be pleased with her superiority of mind and experience.

We asked her what she wanted to look at, but she assured us that she preferred to walk round a gallery alone, so that she might be left to her own thoughts. We left her to her thoughts, and kept a suitable distance.

Observing that she expressed her disapproval of some Dutch pictures and their low subjects, to her companions, I thought to recommend myself by placing on the easel a little cabinet containing a superb reclining Venus. The master is uncertain, but its great excellence is generally agreed. I opened the doors of the cabinet, and asked her to step into a good light. But it was no good. No sooner had she set eyes on the picture, than she cast them down, and looked at me with evident displeasure. 'I did not expect,' she said, 'to have such a subject placed before me by a young and modest girl.' 'Why not?' said I. 'You ask me why not?' replied the lady. I gathered myself together and said with apparent innocence, 'Certainly, gracious lady. I see no reason why I should not show you this picture, especially as I thought I was showing my respect by bringing out this gem of our collection at the beginning, for it is usually reserved till last.'

Lady: So this nudity does not disturb you?

I: I do not know why I should be disturbed by the most beautiful thing the eye can see. And besides, this subject is not new to me, for I have seen it since I was a child.

Lady: I cannot praise your tutors, who let you get used to such subjects.

I: Pardon me! but how could they have prevented it? How could they have done otherwise? They taught me natural history, they showed me birds in their feathers, animals in their coats, fish in their scales. Was it possible to hide the form of man from me, since all this leads to it? Certainly if I had seen all men cowled, I should have invented faces to go with them. And am I not a girl myself? How can you hide man from himself? It is surely a fine school of modesty to acquaint us with the truly beautiful, for we think well enough of our own looks!

Lady: Humility radiates from within, and true modesty needs no

outward stimulus. It seems to me part of a lady's duty to bridle her curiosity and restrain her inquisitiveness, or at least keep it out of the way of objects that might, in so many senses, become dangerous.

I: There may be some, my lady, who can be formed by such negative virtues. But as far as my education is concerned, you must blame my uncle. He often said to me: 'Get used to the free contemplation of nature, she will always excite serious reflections, and the beauty of art will sanctify the feelings that arise from her.'

The lady turned round and spoke to her silent companions in English. She did not seem altogether satisfied with my openness. She turned away, and as she was by an *Annunciation*, I took her to it. She looked carefully at the picture, and finally expressed her admiration of the angel's wings, and their natural appearance. After staying there for a time, she hastened off towards an *Ecce Homo*, where she remained in a state of rapture. But, as that suffering face did not seem to do me any good, I tried to put Caroline in my place. I motioned to her, and she left the young gentleman who was standing with her in the window and at that moment putting a piece of paper back into his pocket.

On my asking her how he had entertained her, she answered, 'He has been reading me some verses which he has written to his absent mistress. They are very pretty,' she added; 'get him to show them to you.' But I had no opportunity of talking to him, for just then he went over to the lady and announced that he was a distant relative. She naturally turned her back on our Lord Christ to greet her Lord Cousin; art was forgotten for a while, and a lively conversation on general and family topics ensued.

Meanwhile our young philosophic friend had attached himself to one of the lady's companions, whom he had discovered to be an artist, and was going with him from picture to picture in the hopes, as he afterwards told us, of learning something. But this was not to be so, although the man seemed to possess considerable knowledge, for his remarks turned on the various deficiencies of each work. Here the drawing, there the perspective was out; in one there was no keeping, in another the colours were badly laid on, or the brushwork was poor; one shoulder did not fit the body, this halo was too white, that fire too red, this figure did not stand on the right plane – and with such remarks he destroyed all enjoyment of the pictures.

In order to relieve my friend, who, as I saw, did not seem much edified, I called to the tutor and said, 'You have seen the best pictures and noted down their value: here is a connoisseur who can acquaint you with their faults, which it is also interesting to know.' But no sooner had I set my friend free than we found ourselves worse off than before, for the lad's other companion, a scholar who all the while had been sternly wandering about the rooms on his own examining the pictures with a glass, began to complain how few of them showed a proper attention to costume. He found the anachronisms the most insufferable of all, he said, for how could a man endure to see St Joseph reading from a bound book, Adam digging with a spade, or St Jerome, St Francis and St Catherine all in the same picture with the infant Christ. Faults like these were so common that you could not look round any picture gallery with satisfaction.

My uncle out of politeness attended from time to time to the lady as well as the others, but he was apparently most at home with the Characteristic, who also recalled that he had met the lady in some other collection. They began to walk about talking of other things, hurrying past the many and various objects in the remaining rooms, so that at last we felt a hundred miles from the art we were surrounded by.

In the end it was our old servant who claimed the greatest attention. He could be called the deputy-custodian of our collection, for he takes people round it when my uncle is prevented from doing so or when we know that they are only coming out of curiosity. He has thought up amusing stories for certain of the pictures, and always comes out with them. He knows how to astonish visitors with the high prices of the paintings, takes them to see the puzzle pictures, shows a number of remarkable relics, and especially delights his audience with the automata.

On this occasion he took charge of the lady's attendants and one or two others of the same ilk, and in his way was entertaining them better than we had been able to do with the other guests. Finally he made the clockwork drummer, which uncle had long since exiled to a side room, play a short piece for his group, and the more distinguished company also gathered round and was at once put into a good mood by this piece of vulgarity. It was dark by the time they had seen the third section of the collection. The travellers could not spend another day with us and hurried back to their inn, leaving us alone for the evening.

Then we set to telling our stories and repeating our malicious comments, and if our guests were not always too gentle with the pictures, I must admit that we treated *them* rather brusquely.

Caroline was especially upset that she had not been able to divert the young gentleman's attention from his distant mistress to herself. I said that there can be nothing worse for a girl than to hear a love poem about someone else, but she contradicted me and maintained that it seemed beautiful, even edifying, to her. She also had an absent lover and hoped that he was doing just the same as this young stranger in the company of other girls.

Over a cold supper, where we did not omit to drink their healths, our young friend was asked to give his general impression of the artists and amateurs, which he did with some hesitation. Exactly how it sounded I cannot repeat today, for my fingers are tired and so is my mind. I must also see if I cannot get out of this business. It is all very well to relate the peculiarities of our visitors, but I have reservations about going any deeper, and so, for today, please let me creep quietly from your presence.

<div style="text-align: right">Julie</div>

LETTER VIII

Julie's writing again! I am writing to you today of my own free will, and even out of a certain perversity. After I had resisted taking over the final task yesterday, and giving you an account of the rest, it was decided that a solemn academic conference should be held this evening to talk the matter over and to put you in the picture. Now the menfolk have set about their task and I am encouraged to undertake myself what you have generously supported, and this evening I hope to give you a pleasant surprise. For men sometimes start what they would not be able to finish if we women did not intervene at the appropriate moment and help them out with what, though easily begun, is difficult to complete.

Something strange happened when we tried to classify the amateurs who came yesterday, for they did not fit any of our categories, and we could find none for them. When we complained to our Philosopher about this, he replied, 'My classification may have other faults, but it does you honour that, apart from the Characteristic, none of your guests this time fits into it. My categories only designate obsessions, which may be seen as inadequacies if the personality of the artist is limited in this way, or as faults if he

deliberately persists in this limitation. But the false, the unbalanced and the irrelevant have no place here. My six categories designate the qualities which, if they were united, would add up to the true artist or the true amateur, but which, as I know from my slight experience and see from your notes, only too often occur by themselves.'

Now to work!

First category: Imitators
This gift can be seen as the basis of art, but it is questionable whether it ever gets any further. If an artist begins in this way, he may rise to the heights, but if he stays with imitation, he will be given the disparaging title of copyist. But if a man of this temperament wants to progress in his limited speciality, there is a need for realism which the artist must supply and the amateur enjoy. If he cannot manage to rise to true art, he takes the worst sort of direction and ends up painting statues or perpetuating his image in a damask dressing-gown as our grandfather did.

The taste for silhouettes is close to this sort of fashion. Such a collection is interesting enough in a portfolio, but walls should not be decorated with these sombre, half-real images.

The imitator simply reproduces his subject without adding to it or taking us beyond it. He brings us into a single, limited world, and we are amazed at the possibility of its being done: we feel a certain pleasure, but the work cannot really set us at our ease, for there is no artistic reality there in the sense of an aesthetic image. The moment this is manifested in some way, the portrait acquires great charm, such as we feel with many German, Dutch and French portraits and still-lives.

(N.B. Do not be confused and think that because you see my writing this all comes out of my little head! At first I wanted to underline everything that comes word for word out of the notes in front of me. But then too much would be underlined. You will easily see where I am simply quoting, and you will even find some of your own words from your last letter.)

Second category: Imaginers
Our friends had a good deal of fun with this group. They seemed to provoke them beyond measure, and although I was there and admitted that I belonged to this class and demanded that it should be treated justly and civilly, I could not stop them being called a

whole host of names which were less than complimentary. They were called Poeticizers, because instead of recognizing the poetry of art, and striving for it, they wanted to compete with the poets themselves, to chase after its special excellences and so they overlooked and neglected their own advantages. They were called will-o'-the-wisps, for they so liked to follow apparitions and to make much of imagination, without bothering about how much perception can do. They were called Phantomists because they were attracted to empty ghosts, Phantasmists because they included dream-like distortions and incoherence, Nebulists, because clouds were the most appropriate foundation for their airy imaginings. In the end they even wanted to dismiss them, after the fashion of German rhymsters, as Tipsy and Misty (*Schwebler und Nebler*). It was said that they lacked reality or existence, not to speak of the beautiful reality of artistic truth.

If a false naturalism was attributed to the Imitators, the Imaginers did not get off without the stigma of false nature, and other objections of the same sort. I noticed that they wanted to provoke me from the start, and I certainly obliged them by losing my temper. I asked them whether genius is not manifest chiefly in invention, and whether this advantage of the Poeticizers could be disputed, whether we should not be grateful when the mind is delighted by a well-chosen dream image, whether the possibility of the highest art is not implicit in this quality, which has been called so many outlandish names, whether there is anything more effective against the tediously prosaic than this capacity to create new worlds, whether it was not a rare talent and a rare fault which must be referred to with awe, even when it was found in the by-ways?

The men soon gave in. They reminded me that they were only referring to one-sidedness, that this very quality, because it could be so excellently effective in the whole of art, could also do great damage when it claimed to be unique and independent. The Imitator could never hurt art, for he brings it laboriously to a stage where the true artist can and must take over, but the Imaginer is infinitely damaging to it because he drives it out beyond its limits, and the greatest genius is needed to bring it back from this vagueness and unbounded licence to the true centre in its proper allotted sphere.

There was some further debate for and against, and in the end they asked me whether I must not admit that satirical caricatures,

the greatest destroyers of art, taste and morals, were not the logical development of this tendency.

Certainly I could say nothing in defence of them, although I must also confess that these ugly things sometimes amuse me, and that *Schadenfreude*, that original sin of all the tribe of Adam, is, if highly spiced, a not unsavoury dish.[9]

Let us proceed.

Third category: Characteristics
You are already familiar enough with these, for you have heard plenty about the argument with a remarkable individual of this type.

If it is important for me to approve of this group, I can assure you that I do, for if my beloved Imaginers have to employ especial characteristics, then something characteristic must already be there: if I must amuse myself with the significant, then I am well able to accept that the significant is also taken seriously by some. Thus if a Characteristic like this is preparing the ground so that my Poeticizer does not turn into a Phantasmist, or even get lost among the Tipsy and Misty, he earns my praise and esteem.

My uncle also seemed to be more in favour of his friend in art after the last conversation, and took the part of this class. He thought that in a certain sense they might also be called Rigorists, for their abstractions and their reduction of everything to ideas always established something and led to something, and the Characteristic was an especially valuable antidote to the vacuity of other artists and amateurs. But the obstinate little Philosopher showed his teeth again here and maintained that their one-sidedness did far more damage by limiting art than the expansiveness of the Imaginers, precisely because they seemed to be in the right; and he assured us that he would never abandon his struggle against them.

It is odd that a Philosopher can seem so compliant in some things and so rigid in others. If only I knew where it is leading.

I see from his notes that he attacks them with all sorts of names. He calls them Bags-of-bones, Sharpers, Stiffs, and notes at one point that a purely logical existence and an intellectual process is not enough for art, and is no help to it. I am not going to worry my head over what he means by this.

The Characteristics also lack the beautiful facility which is the conditions of art. That may well be so.

Fourth category: Undulators

This title refers to those who are the opposite of the foregoing, those who love what is soft and pleasing, without character and significance, which leads in the end at most to an insipid charm. They are also called Serpentiners, and we recalled the time when the Serpentine Line was taken as the model and symbol of beauty, and was thought to have achieved a good deal.[10] This serpentinism and softness depends in both artists and amateurs on a certain feebleness or sloth, and, if you like, on a certain sickly excitability. This sort of work succeeds with those who want to see in a picture only a little more than nothing, and in whom a soap-bubble, rising colourfully into the air, always arouses a pleasant feeling. Since works of this sort can hardly have any substance or any other real content, most of their merit consists in their handling and in a certain visual charm. They have neither significance nor power and that is why they are generally welcome, like self-effacement in society. For it is right that social conversation should only be a little more than nothing.

As soon as the artist or the amateur abandons himself to this tendency, art fades away like the dampened string of an instrument, or like water in sand. The handling gets progressively flatter and weaker: colour goes from painting, the hatchings of the engraving become dots, and everything goes up in smoke for the delectation of the delicate amateur.

We soon dealt with this subject on account of my sister, who, as you know, cannot abide jokes about it, and is vexed the moment her perfumed world is disturbed. Otherwise I should have tried to include the Nebulists in this class, and to rescue my Imaginers from it. I hope, gentlemen, that you will perhaps take account of this when you review the proceedings.

Fifth category: Miniaturists

This group came out of it well. No one felt he had cause to put them down, many spoke up for them, and few against.

From the point of view of effect, they are not at all unpleasing: they fill small spaces very carefully with dots, and the amateur may keep the work of years in a small case. The best you may call Miniaturists; those whose work lacks spirit or a feeling for the whole, or who cannot unify their work, may be criticized as Dotters.

They are not far from true art, but are simply in the same

situation as the Imitators; they always remind true artists that they must also have the quality which is here in isolation in order to be complete and to give their work the highest finish.

My uncle's letter to you has just reminded me that he also had a good and tolerant word to say for this class, and we do not want to bother these friendly people any further, but rather wish them power, significance and unity.

Sixth category: Sketchers

Uncle had already joined this group, and we were not inclined to speak too harshly of them, when he himself pointed out that the Designers could promote an imbalance in art just as much as the protagonists of the other classes. Art should not simply speak to the mind *through* the senses, it must also satisfy the senses themselves. Then the mind may join in and give its approval. But the Sketcher speaks directly to the mind, and thus bribes and seduces the inexperienced. A good, half-defined idea, sketched out as it were symbolically, does not detain the eye, but excites the mind, the wit, the imagination, and the amateur is taken by surprise and sees what is not really there. Drawing, proportion, form, character, expression, composition, harmony, finish are no longer in question: they are replaced by the illusion of themselves. Mind speaks to mind, and the means by which this should happen is done away with.

Good sketches by great masters, those enchanting hieroglyphs, are usually the start of an enthusiasm for art and slowly lead the amateur to the threshold of the whole of its world, from which, if he once looks onward, he will never turn back. But the aspiring artist has more to fear than the amateur if he lingers in the realm of invention and design, for, if he moves faster through the door into the realm of art, he is also the first to run the risk of staying on the threshold.

That is roughly what my uncle said.

But I have forgotten the name of the gifted and promising artist who concentrated exclusively on this aspect and who has not fulfilled those hopes that were vested in him.

My uncle had a portfolio of the work of such artists in his collection, and held that it was interesting to compare them with the sketches of great masters who were also capable of making finished works.

When we had done as much as we could to consider these six

categories separately, we began to bring them together again, for indeed they are found together in particular artists, as I have had occasion to remark in the course of my report. Thus the Imitators were sometimes found in the company of the Miniaturists and sometimes with the Characteristics. The Sketchers might throw in their lot with the Imaginers, the Bags-of-bones of the Undulators, and these in their turn would find themselves quite at home with the Phantomists.

Each union produced a work of a higher type than the purely specialized one, which in any case could only be found very rarely, as experience showed.

In this way we returned to our starting-point: namely, that the perfect artist could only arise through the union of these six qualities, just as the true amateur must possess all six tendencies as well.

Half of our half-dozen took things too seriously, strictly and anxiously, the other half too playfully, lightly and casually. True art can only come from the inner union of seriousness and play,[11] and if our one-sided artists and amateurs are paired off:

> The Imitator with the Imaginer
> the Characteristic with the Undulator
> the Miniaturist with the Sketcher

we have, in the union of opposites, one of the three conditions of perfect art, as I can show in the following diagram:

EARNEST	EARNEST AND PLAY	PLAY
Alone	Together	Alone
Individual inclination	General education	Individual inclination
Manner	Style	Manner
Imitator	Artistic truth	Phantomist
Characteristic	Beauty	Undulator
Miniaturist	Perfection	Sketcher

Here is the summary of the whole. My task is ended, and I take my leave of you the sooner since I am convinced that arguments for and against will start where I leave off. The other matter I have on my mind, a confession which is not exactly about art, I will make a point of writing about in my next, and I will cut myself a new quill for it as this one is so worn out that I have to use the back to say farewell and sign my name, towards which I hope you will, as always, remain friendly,

<div align="right">Julie</div>

NOTES

1. This short letter-novel was the joint work of Goethe and Schiller, who appears in it in the guise of the young Kantian philosopher who is gently teased in the style of conversation on pp. 53-8.

2. Goethe may be thinking of the *trompe-l'oeil* portraits of the Frankfurt painter J. D. Bager (1734-1815), whose work he knew in his youth (A. Feulner, *Der Junge Goethe und die Frankfurter Kunst*, 1932, fig. 22, and pp. 53 f.).

3. This and later puffs for the periodical had little effect, and the project was abandoned with much bitterness in 1800.

4. Goethe is referring to Aloys Hirt (see p. 200 note 3), who visited Weimar in 1797, and whose essays in Schiller's *Horen* are quoted in what follows.

5. For Winckelmann and Lessing, see p. 77, notes 1 and 2.

6. For the *Laocoon* and the *Niobe*, see pp. 78, 80. The *Dirce and her Stepsons* refers to the bound Dirce in the large group known as the *Farnese Bull* in the Palazzo Farnese in Rome. It is a Roman copy of a second-century Greek original.

7. Angelo Fabroni, *Dissertazione sulle Statue appartenenti alla Favola di Niobe*, 1779, pls. 18, 19.

8. Goethe is referring to the followers of Kant, whose treatise on aesthetics, *Critique of Judgement*, had been published in 1790.

9. Goethe's distaste for caricature persisted (see his conversation with Kanzler von Müller, 18 May 1821), but at the end of his life he took a fancy to the didactic picture-stories of the Swiss originator of the modern comic-strip, Rodolphe Töpffer (see Biedermann, *Gespräche*, iv, pp. 316-7, 428).

10. Goethe is alluding to Hogarth's *Analysis of Beauty*, which had appeared in a German translation in 1754.

11. This idea was expanded by Schiller in his *On the Aesthetic Education of Man* (trans. Wilkinson and Willoughby, 1967).

Natural symbolism
[Goethe to J. D. Falk, 14 June 1809
(Biedermann, II, p.40)]

... While he [the painter Kaaz[1]] is here I want to arrange a little album from among my drawings. We talk too much. We ought to talk less and draw more. For my part, I should like to lose the habit of conversation and, like nature, express myself entirely in drawings. That fig tree, this little snake, the chrysalis lying there in front of the window quietly awaiting the future – all these are pregnant with meaning. Indeed, anyone who knew how to decipher them properly would soon be able to do without all writing and speech! The more I think about it, the more speech seems to be useless, idle, I might almost say effete, so that we are terrified in the face of the quiet earnestness of nature, and her silence, whenever we encounter it concentrated into a solitary rockface or in the desolation of the ancient hills! I have – pointing to his doodle – brought together on this paper a mass of flowers and vegetation in a way which is remarkable in itself. These phantoms could be even crazier and more fantastic, and the question is whether they don't really exist somewhere.

In drawing, the soul draws out part of its inmost being into music, and those are the greatest of nature's secrets which, for their principles, rest on the drawing and modelling by which they are divulged. The combinations in this field are so infinite that there is even a place for humour. I will only mention the mistletoe; how much of the fantastic, the whimsical and the bird-brained there is in the summary pen-strokes it makes! It leaves its airborne seed like a butterfly in this or that tree, and clings to it until it is full-grown ...

NOTE

1. On him, H. Geller, *C. L. Kaaz*, 1961.

Drawings
[Goethe to Eckermann, 5 July 1827]

... Goethe showed me a fine drawing by an Italian master[1] representing the boy Jesus in the Temple with the doctors. He then showed me an engraving after the finished picture of this subject,[2] and made many observations, all to the advantage of the drawing.

'I have recently been fortunate,' said Goethe, 'in buying many excellent drawings by famous masters very cheaply. Such drawings are invaluable, not only because they give the artist's mental idea in all its purity, but also because they put us into his mood at the moment of creation. In every stroke of this drawing of the boy Jesus in the Temple we perceive the clarity and serene resolution of the artist's mind, and this state of mind is transferred to us as we look at it. Visual art has the great advantage that it is purely objective and attracts us without exciting our feelings too violently. A work like this one either speaks to us very decisively or not at all. A poem, on the other hand, makes a far vaguer impression, exciting different feelings according to the personality and capacities of each hearer.'

NOTES

1. Eckermann may well be mistaken and this drawing is probably a version of Rembrandt's *Christ among the Doctors*, of which the original is in the Louvre and a copy in Vienna (Benesch 885). The section on Goethe's Rembrandt drawings is vague in Schuchardt's catalogue (I, c. 874-7:18, *Drawings by Rembrandt and his School*), and no drawing of this subject is among the authentic drawings from the collection listed by Benesch.
2. Rembrandt, *Christ among the Doctors*, 1652 (Münz 222), of which Goethe owned an impression. This is an original etching, and not, as Eckermann suggests, a reproduction of a painting.

II CLASSICAL ART

The Laocoon
[Goethe to C. T. Langer,
30 November 1769 (in French)]

... At the end of last month I made a very pleasant tour to Mannheim. Among the many pretty things I found there, and among the many magnificent things which strike the eye, nothing gripped my whole being so much as the Laocoon group, recently cast after the original in Rome. I was in ecstasies over it, so much so as to overlook almost all the other statues that were cast with it, and which are now in the same room. I have made some comments on the Laocoon, which throw a good deal of light on the famous dispute among such great protagonists.[1] But as we see every day that no genius is universal, that a good poet is not a good architect at the same time, it is just the same with Lessing, Herder and Klotz. To talk about the fine arts you need to be more than just a critic and to know how to frame pretty hypotheses. I have written to Oeser[2] about my discoveries, and I shall try this winter to organize them, to make a fair copy and give the piece some elegance next year, when I hope to go through Mannheim on my way to Strasbourg.[3]

NOTES

1. Goethe is referring to J. J. Winckelmann, *Reflections on the Imitation of Greek Art in Painting and Sculpture* (1755), which maintained that the figure of Laocoon bore his pain in silence because of the greatness of his soul, and G. E. Lessing, *Laocoon* (1766), which held that this was because the artist had observed the rules of visual art, and put beauty before expression. Goethe on this occasion at once came to the conclusion that the silence of Laocoon was because 'he could not cry out ... The whole powerful and artistic posture of the torso was conditioned by two factors: the struggle against the snake and the recoiling from the instantaneous bite. To lessen the pain, the lower part of the torso was drawn in, which made screaming impossible...' (*Dichtung und Wahrheit*, II, xi). Klotz and Herder were defendants of Winckelmann against Lessing.
2. A. F. Oeser (1717-1799), Goethe's drawing-master in Leipzig, and a follower of Winckelmann. Goethe's letter has not survived.
3. This essay, the manuscript of which Goethe had lost by 1797 (*cf.* Goethe to Schiller, 5 July 1797), was the basis of the following article.

Observations on the Laocoon[1]
[*Propyläen* I, i, 1798]

A true work of art will always have something of infinity in it to our minds, as well as a work of nature. We contemplate it, we perceive and relish its beauties, it makes an impression, but it cannot be thoroughly understood, nor its essence nor its merit be clearly defined by words. In the observations we are about to make on the Laocoon, we do not pretend to exhaust this fertile subject; what we have to say is rather on occasion of this excellent monument than upon it. May it soon be again exposed to the public eye,[2] so that every amateur may have an opportunity of satisfying himself concerning it, and of speaking of it according to his own ideas!

When we would treat of an excellent work of art, we are almost obliged as it were to speak of art in general, for the whole art is contained in it, and everyone may, as far as his abilities allow, by means of such a monument, develop whatever relates to art in general. For this reason we will begin here with some generalities.

All the beautiful monuments of art represent human nature; the arts of design have a particular relation to the body of man; it is only of these last that we are now speaking. Art has many degrees or steps, on each of which may appear artists of distinction; but a perfect work of art unites all the qualities which we only meet elsewhere dispersed.

The most beautiful monuments of art which we are acquainted with present to us:

Nature to the life and of an elevated organization. Above all things we expect to find in it a knowledge of the human body in all its parts, dimensions, interior and exterior, in its forms and its movements in general.

Characters. A knowledge of the difference of their parts as to form and effect. Qualities are separated and present themselves isolated; from thence arise characters and it is by this means that we can trace a significative reciprocal relation between the different monuments of art, just as the parts of a compound work may have a significant relation between themselves. The object is:

In repose or in motion. A work and its parts may be presented either

subsisting of themselves, and only indicating their existence in a tranquil manner, or as very animated, acting, impassioned, and full of expression.

The Ideal. To attain this, a profound solid sense endowed with patience is required in the artist, to which should be joined an elevated sense to be able to embrace the subject in its whole extent, to find the highest degree of action which it means to represent, and consequently to make it exceed the bounds of its limited reality, and give it in an ideal world, measure, limits, reality and dignity.

Grace. But the subject and manner of representing it are submitted to the sensible laws of art, that is to say, to order, perspicuity, symmetry, opposition, &c. which renders it to the eye, beautiful, that is to say, graceful, agreeable.

Beauty. It is moreover submitted to the law of intellectual beauty, which results from the measure, to which man, formed to figure and produce the beautiful, knows how to submit everything, even extremes.

After having first indicated the conditions which we require in a work of art, elevated art, I may say much in a few words when I maintain that our groupe contains them almost all, and that we can even develop them by the observation of this group alone.

It will not be expected of me to prove that the artist has shown a *profound knowledge of the human body, that which characterizes it, together with the expression and the passion.* It will appear, from what I shall say in the sequel, how the subject is conceived in an *ideal* and *elevated* manner; no one will doubt that we ought to give the epithet of *beautiful* to this monument, who can conceive how the artist has been able to represent the extreme of physical and intellectual sufferings. But some may think it perhaps paradoxical, that I dare advance that this groupe is at the same time full of grace. I shall say a few words on this head.

Every work of art must announce itself as such, which can only be done by what we call *sensual beauty* or *grace.* The ancients, far enough in this respect from the modern opinion that a monument of art should become again to appearance, a monument of nature, would characterize their works of art as such, by a select order of the parts; they assist the eye to investigate the relations by symmetry, and thus an embarrassed work becomes easy to comprehend. From symmetry and oppositions resulted the possibility of striking out the greatest contrasts by differences hardly sensible.

The care of the ancient artists to oppose varied masses to each other, to give especially a regular and reciprocal position to the extremities of bodies in groupe, is very happy and very well imagined, in order that each work of art may appear to the eye like an ornament, and abstraction made from the subject which it represents, and by seeing the most general contours only at a distance. The antique vases furnish us with a number of examples of similar groupe, very graceful; and it would be possible to propose a series of the most beautiful examples of a composition, symmetrical and agreeable, beginning with the groupe of the most tranquil vase to the extremely animated groupe of Laocoon. I think therefore, I must repeat that the groupe of Laocoon, besides its other acknowledged merits is moreover a model of *symmetry* and of *variety*, of *repose* and of *motion*, of *opposition* and of *gradation*, which present themselves together to him who contemplates it in a sensible or intellectual manner; that these qualities, notwithstanding the great pathetic diffused over the representation, excite an agreeable sensation, and moderate the violence of the passions, and of the sufferings, by *grace* and *beauty*.

It is a great advantage in a work of art, to submit by itself, to be absolutely terminated. A tranquil object only shows itself by its existence, it is terminated by and in itself. A Jupiter with a thunderbolt placed on his knees, a Juno who reposes with majesty, a Minerva absorbed in reflection, are subjects which have not, so to speak, any relation to what is out of them; they repose upon and in themselves, and they are the first and dearest objects of sculpture. But in the beautiful mythic circle of art in which these isolated and self-subsisting natures are placed and in repose there are smaller circles, where the different figures are conceived and executed in relation with others; each of the Muses, for example with their conductor Apollo, is conceived and executed separately, but it becomes yet much more interesting in the complete and varied choir of the nine sisters. When art passes to the impassioned significative, it may moreover act in the same manner, or it presents to us a circle of figures which passion puts into a mutual relation as Niobe with her children, persecuted by Apollo and Diana;[3] or it shows us the same work, the movement at the same time with its cause. We need only mention here the young man full of grace who is drawing a thorn from his foot,[4] the wrestlers,[5] two groups of fauns and nymphs at Dresden,[6] and the animated groupe of Laocoon.

It is with reason that so great stress is laid on sculpture, because it strips man of everything which is not essential to him. It is thus that in this admirable groupe Laocoon is only a simple name; the artists have taken from him his priesthood, all that is national and Trojan in him, all the poetical and mythological accessories; all in fact that mythology has made of him is done away; he is only now a father with his two sons, menaced with death by the bite of two serpents. Neither are these animals sent by the gods, but only natural serpents, potent enough to be the destruction of many men; neither their form nor their action shows that they are extraordinary creatures sent by the gods, to exercize the divine vengeance. Conformably to their nature, they approach by sliding on the surface of the earth; they inlace and fold round their victims, and one of them only bites after having been irritated. If I had to explain this groupe and if I were unacquainted with every other explication, I should call it a tragic idyll. A father sleeps at the side of his two sons, they are inlaced by two serpents, and at the instant of waking, they strive to extricate themselves from this living cord.

This work of art is, above all, extremely important by the representation of the moment of the action. When in fact a work ought to move before the eyes, a fugitive moment should be pitched upon; no part of the whole ought to be found before in this position and, in a little time after, every part should be obliged to quit that position; it is by this means that the work be always animated for millions of spectators.

To seize well the attention of the Laocoon, let us place ourselves before the groupe with our eyes shut, and at the necessary distance; let us open and shut them alternately and we shall see all the marble in motion; we shall be afraid to find the groupe changed when we open our eyes again. I would readily say, as the groupe is now exposed, it is a flash of lightning fixed, a wave petrified at the instant when it is approaching the shore. We see the same effect when we see the groupe at night, by the light of flambeaux.[7]

The artist has very wisely represented the three figures in graduated situations, and which differ from each other. The eldest son is only interlaced at his extremities, the other is more so; it is especially the chest that the serpent has interlaced; he endeavours to deliver himself by the motion of his right arm; with his left hand, he softly removes the head of the serpent, to prevent it from clasping his breast once more; the serpent is on the point of

sliding underneath his hand; *but it does not bite.* The father on the contrary, would employ force to deliver himself, as well as his two children, from the embraces; he grips one of the two serpents, who being now irritated, bites him in the haunch.

To explain the position of the father, both in general, and according to all the parts of the body, it appears to me reasonable to suppose that the momentaneous sensation of the wound is the principal cause of the whole movement: the serpent has not bit, but he bites, and he bites in the soft and delicate part of the body, above and a little behind the haunch. The position of the restored head has never well expressed the true bite; happily, the traces of the jaws have been preserved in the posterior part of the statue, if these very important traces have not been lost in the actual transportation of the monument.[8] The serpent inflicts a wound on the unhappy Laocoon, precisely in the part in which man is very sensible to every irritation, and even where the slightest tickling causes that motion which we see produced here by the wound; the body flies towards the opposite side, and retires; the shoulder presses downwards, the chest is thrust forward, and the head inclines on the side which has been touched. As afterwards in the feet, which are enfolded by the serpent, and in the arms which struggle, we yet see the remains of the situation or preceding action, there results combined action of efforts and of flight, of suffering and of activity, of tension and of relaxation, which perhaps would not be possible under any other condition. We are lost in admiration at the wisdom of the artist, when we try to apply the bite to any other place: the whole gesture, the whole movement would be changed and nevertheless we cannot imagine it more proper: it is therefore a principal merit in the artist to have presented us with a sensible effect, and also to have shown us the sensible cause of it. I repeat it – the point of the bite determines the actual movement of the members; the flight of the inferior part of the body, its contraction, the chest which advances, the shoulder which descends, the movement of the head, and even all the features of the countenance, are, in my opinion, decided by this momentaneous, painful, and unexpected irritation.

But, far be it from me to wish to *divide* the unity of human nature, to wish to deny the action of the intellectual force of this man of a form so excellent, to overlook the sufferings and the efforts of a great nature. Methinks I also see the inquietude, the fear, the terror, the paternal affection, moving in those veins, swelling in

that heart, wrinkling that front. I readily admit that the artist has represented, at the same time, the most elevated degree, both of corporeal suffering and of intellectual sufferings: but I would not have us to be transported too feelingly at the monument itself, at the impressions which the monument makes upon us, especially as we do not see the effect of the poison in a body which has just been seized by the teeth of the serpent, as we do not see the agony in a sound, beautiful body, which makes efforts, and which is but just hurt. Let me be permitted to make an observation here, which is of considerable importance for the arts of design: the greatest pathetic expression which they can represent depends on the passage from one stage to another. Let us view a lively infant, who runs, leaps, and amuses himself, with all the pleasure and energy possible, who afterwards has been suddenly struck hard by one of his comrades, or who has been wounded either physically or morally: this new sensation is communicated to all his members like an electrical shock; and a similar, sudden, and pathetic passage in the most elevated sense, is an opposition of which we have no idea, if we have not seen it.

In this case, it is therefore evident that the intellectual man acts as well as the physical man. When in a like passage there still remain evident traces of the preceding state, there results a subject the most elegant for the arts of design: this is the case of the Laocoon, where the efforts and the sufferings are united at the same moment. It is thus that Eurydice, who is bitten in the heel by a serpent on which she has trod, at the instant when she is crossing a meadow, and is returning, satisfied with the flowers she has gathered, would be a very pathetic statue, if the artist could express the double state of satisfaction with which she walked, and of the pain which arrests her steps; not only by the flowers which are falling, but further by the direction of all her members, and the undulation of the folds.

When we have seized, in this sense, the principal figure, we may cast a free and sure glance on the proportions, the gradations, and the opposition of all the parts of the entire work.

The subject chosen is one of the happiest that can be imagined. Men struggling with dangerous animals, and moreover with animals which act, not as powerful masses, but as divided forces, which do not menace on one side alone, which do not require a concentrated resistance, but which, according to their extended organization, are capable of paralysing, joined to the great move-

ment, already spreads over the *ensemble* a certain degree of repose
and unity. The artist[9] has been able to indicate, by degrees, the
efforts of the serpents: one only infolds; the other is irritated, and
wounds his adversary. The three personages are also chosen with
much wisdom: a robust and well-made man, who has already
passed the age of the greatest energy, and who is less capable of
supporting grief and suffering. Let us substitute for him, in imagin-
ation, a young man, lively and robust, and the groupe will lose all
its value! With him suffer two young persons, who, in proportion
to him, are very small. They are, moreover, two beings susceptible
of the sentiment of pain. The youngest makes unavailing efforts,
without, however being able to succeed; his efforts even produce
a quite opposite effect. He irritates his adversary, and he is hurt by
him. The eldest son is only slightly inlaced; he does not yet feel
himself oppressed nor affected with pain; he is afraid at the wound
and momentaneous movement of his father; he utters a cry,
endeavours to extricate his foot from the serpent which has
inlaced it; he is therefore here an observer, a witness who takes a
part in the action, and the work is terminated.

What I have only hitherto touched on *en passant*, I shall here again
notice particularly: and that is, that all the three figures have a
double action, so that they are occupied in a very various manner.
The youngest of the sons would extricate himself by raising his
right arm; and he pushes back the head of the serpent with his
left hand; he would alleviate the present evil, and prevent a greater
one; this is the highest degree of activity which he can now exert
in his constrained state. The father makes efforts to disembarrass
himself from the serpents, and the body would, at the same time,
avoid the bite which it has just received. The movement of the
father inspires the eldest son with horror, and he endeavours to
extricate himself from the serpent, which, as yet, has only infolded
him slightly.

I have already said above, that one of the greatest merits of this
monument, is the moment which the artist has represented, and
it is on this point that I shall now add a few words.

We have supposed that the natural serpents have intwined a
father sleeping by the side of his sons; that the different movements
of the action might have a certain gradation. The first moments,
during which the serpents infold the body then asleep, announce
events; but it would be an insignificant moment for the art. We
might, perhaps, imagine a young Hercules sleeping and infolded by

serpents, and the artist might lead us to guess by his figure, and the tranquillity of his sleep, what might be expected from him when awake.

Let us go further and let us imagine the father and his sons feeling themselves interlaced by serpents; in whatever manner this may be, we shall see that there is only a single moment in which the interest is the greatest; it is that in which the body is so infolded that it can no longer defend itself; in which the second, although yet in a condition to defend itself, is nevertheless wounded; and in which the third has, lastly, some hope of saving itself. The youngest son is in the first state, the father in the second, the eldest son in the third. Let us endeavour to find yet another state: let us try to distribute the parts differently from what they are here!

In reflecting then on this action, from its commencement, and finding that it has arrived to its highest degree, we shall soon perceive, by representing to ourselves the moments which are to follow that which is figured by the monument, that the groupe must entirely change, and that we cannot find another moment of the action which is so precious for the art. The youngest son will be stifled by the serpent that infolds him; or if, in his situation, which deprives him of all succour, he irritates it further, the serpent will bite him. These two states are insupportable, because they are extremes which ought not to be represented. As to the father, the serpent may bite him again in other parts; but then all the situation of his body would be changed, and the first bites would be lost for the spectator, or they would become disgusting, if the artist had a mind to indicate them. There is yet another case: the serpent may turn away, and attack the eldest son; this last is then brought back to himself; there is no longer any personage interesting himself in the action; the last appearance of hope disappears from the groupe, and the representation is no longer tragical, but cruel. The father, who reposes now upon himself, in his greatness and his sufferings, would turn round towards his son, and he would become an accessory figure, interesting himself with another figure.

In his own sufferings, and those of another, man has only three sensations, fear, terror, and compassion: he forsees with inquietude the evil which approaches him, he perceives on a sudden an evil which strikes him, and he takes part in the suffering which yet remains, or which has already passed; all the three are represented and excited by this monument, and even by the most suitable gradation.

The arts of design, which always labour for the moments when they choose a pathetic subject, will seize that which excites terror, poetry on the contrary, will choose those which excite fear and compassion. In the group of Laocoon, the sufferings of the father excite terror to the highest degree; sculpture has done in it all that it could do; but, either for the sake of running through the circle of all human sensations, or of moderating the violent impression of terror, it excites compassion for the situation of the youngest son, and fear for that of the eldest; leaving yet some hope for this last. It is thus that the ancients gave, by variety, a certain equilibrium to their works; that they then diminished or strengthened an effect by other effects, and were enabled to finish an intellectual and sensible whole.

In a word, we may boldly maintain, that this monument exhausts its subject and that it happily executes all the conditions of the art. It teaches us, that if the artist can communicate his sentiment of the beautiful to tranquil and simple objects, this same sentiment shows itself nevertheless, in its greatest energy and all its dignity, when it proves its force by figuring varied characters; and when in its imitation, it can moderate and retain the violent and impassioned expression of human nature.

The moderns have often been mistaken in the choice of subjects for pathetic representation in sculpture. Milo, whose two hands are locked in the rift of a tree, and who is attacked by a lion, is a subject which the artist will endeavour in vain to represent in such a manner as to excite a pure and true interest. A double grief, unavailing efforts, a situation which deprives him of all relief, can only excite horror, and cannot even touch.[10]

Lastly, I shall drop a word or two on the relation of this subject to poetry.

We are unjust towards Virgil and poetry, when we compare, be it only for an instant, the most finished chef d'oeuvre of sculpture, with the episodical manner in which this subject is treated in the Æneid.[11] As the unfortunate Aeneas is to relate himself that he and his compatriots have committed the unpardonable fault of suffering the horse to enter their city, the poet has only to contrive means to excuse this action; everything tends to this, and the history of Laocoon is only a rhetorical figure, in which we may very well allow of some exaggeration, provided that it answers the end which the poet designs it should. Immense serpents then proceed out of the sea; they have a crest on their head; they light

on the children of the priest who had insulted the horse; they infold, bite, and pollute them with their venom; they afterwards infold the breast and the neck of the father, who runs to their succour, and they raise their heads to shew their victory, whilst the unfortunate one they oppress calls for succour in vain. The people, who are struck with terror at this spectacle, fly; no one dares any longer undertake the defence of his country; and the hearer and reader, affrighted at this marvellous and disgusting history, alike consent that the horse shall enter into the city.

The history of Laocoon, in Virgil, is only therefore a means to attain a more considerable end; and it is yet a great question whether this event be a proper subject for poetry.

Some observations on the Groupe of Laocoon and his two sons
The right leg of the eldest son is of a most agreeable elegance. The expression, and the turn of the members in general, and of the muscles, is admirable in the entire work. In the legs of the youngest son, which are not remarkably elegant, there is something so natural, that we find nothing like it under this relation; the legs of the father, especially the right leg, also possess great beauty.

Restorations[12]
A considerable part of the serpents, and probably the two heads, are of modern workmanship.

The left arm of the father, up to the juncture of the shoulder, and the five toes of the left foot, are restorations: the right foot, however, has suffered nothing.

In the *eldest son*, the end of the nose, the right hand, the three first toes of the left foot, the end of the great toe in the right foot have been restored; the belly having been somewhat damaged on the right side, this part has also been restored.

The end of the nose, the right arm, two fingers in the left hand, and the five toes in the right foot of the youngest son have been restored.

It is only the right arm of Laocoon which has been well restored in burnt earth, and as most say, by Bernini,[13] who, nevertheless, if it be really his work, has herein surpassed himself. The other restorations, which I have just mentioned, are in marble; they are carefully done, but with little art, and with convulsive contortions, in the taste of the school of Bernini. It is thought they were done by Cornachini.[14]

NOTES

1. The translation given here is an anonymous one, printed in the *Monthly Magazine*, vii, 1799, pp. 349-52, 399-401. The original spelling and punctuation have been retained.

2. The group was taken from the Vatican to Paris as a result of Napoleon's Italian Campaign of 1796.

3. Goethe is thinking of the Roman copy after a fourth-century Greek group, attributed to Praxiteles or Skopas, of *Niobe and her Daughter* in the Uffizzi in Florence. The group originally included sons and other daughters killed by the arrows of Apollo and Diana.

4. The *Spinario*, a first-century A.D. Roman bronze in the Palazzo dei Conservatori in Rome.

5. A late Hellenistic marble group in the Uffizzi.

6. Probably two Hellenistic marbles of a satyr wrestling with a hermaphrodite.

7. Goethe planned for the *Propyläen* an essay on viewing statues by torchlight. On this important feature of the aesthetics of the period: J. J. L. Whiteley, 'Light and Shade in French Neo-Classicism', *Burlington Magazine*, 117, 1975, pp. 768 ff.

8. There is no reference to this in the list of the major restorations given by M. Bieber, *Laocoon: The Influence of the Group*, 1967, p. 24 n. 15 (see below note 12).

9. Goethe has forgotten that he had earlier referred to the three artists Hagesandros, Polydoros and Athenodoros of Rhodes, who, according to Pliny (*Natural History*, xxxvi, 37) carved the work.

10. But for the frequent treatment of this subject in painting and sculpture, especially in France: R. Rosenblum, 'On a Painting of Milo of Crotona', *Essays in Honor of W. Friedlaender*, 1965.

11. Virgil, *Aeneid*, ii, 199 ff.

12. Goethe's information derives from Meyer, who published an essay on the restorations to the group in the *Propyläen* in 1799. Bieber (*loc. cit.*) lists the following major restorations:

Laocoon: whole of right arm, with shoulder and snake, part of the other snake near the left knee.

Elder Son: tip of nose, right hand and part of arm above snake, part and head of snake biting Laocoon's hip.

Younger son: tip of nose, right arm with uppermost coil of snake.

13. This supposition has now been abandoned.

14. Agostino Cornachini (1685-c. 1740).

The Elgin Marbles
[Italian Journey, Report, August 1787]

The Chevalier Worsley,[1] who had just come back from Greece,
was perfectly willing to show us the drawings he had brought with
him, among which the copies of Phidias' works on the pediment
of the Acropolis [*sic*] left a decisive and ineradicable impression
on me, which was the stronger that, stimulated by the powerful
forms of Michelangelo, I had made a closer and more attentive
study of the human body than hitherto.

[Draft of a letter to Wilhelm von Humboldt, 16 September 1799]

... Have the goodness to hurry along the news of the Athenian
bas-reliefs, for they are a subject which has always very much inter-
ested me and on which I always wanted to be better informed. If
it should prove possible to procure a cast of a single rider and a
single draped figure, you would make me very happy. Unfortun-
ately people are rather careless with works of art in Paris.[2] They
allow tracings to be taken from paintings etc. Since these fragments
are to be restored, and since plaster of Paris is available, and the
damaged things are perhaps even being re-cast, it is a question of
whether something might not be snapped up. Even the smallest
fragment would give me enormous pleasure.

[Goethe to Duke Karl August of Weimar, 23 May 1817]

Elgin Marbles[3]
A work of great significance. The catalogue of what the collection

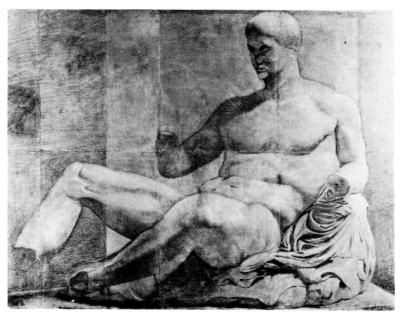

5 W. Bewick, *Copy of the Illissus from the Parthenon Frieze*. Weimar, Goethehaus.

contains is important and heartening, and we also gain beautiful insights from the fact that there is a discussion of the collections of remains from Phigalia and Aegina which are already in England, of the contents and cash values of all of them.[4]

Now the hearings on the artistic and cash values of the Elgin collection, and how it may be acquired, are quite remarkable. All the gentlemen are agreed on the high excellence of these works, yet the motives for their judgements, and especially the way in which they make comparisons with other well known and fine works are very strange and uncertain. If someone had provided a short outline of the history of art in its successive periods, the matter would have been clear, everything would have been in its place and would have been assessed for what it was worth. Certainly the silliness of the question whether these works are as good as the Apollo Belvedere would have been apparent at once. It is nonetheless very interesting to read what Flaxman and West say about this.[5] Henry Bankes Esq. in the chair certainly does not understand a thing about it, and he must have been very dishonest, for since he consciously and calmly let pass the ironic answers of some of the witnesses and went on asking inappropriate questions, he must be a model of dissembling.

Your Royal Highness was quite right to notice that a draped figure is missing, of whose excellence the fifth and ninth plates after the drawings of 1683 give us an inadequate but powerful idea. It is certainly among the most magnificent things ever produced by art, and in the catalogue is to be found on p. 70 under Parthenon A. No. 6, 'Group of two female figures', and No. 13, 'Female figure sitting (supposed to belong to group marked No. 6)' probably also belongs to it.

A sizeable drawing of these three figures, perhaps somewhat larger than those of plates 10 and 11, showing Hercules and Illissus would be a great gift with which Your Highness might help the Weimar Friends of Art.

Indeed I remember your Highness spoke of the copies that you were having made in Paris, probably from the same drawings of 1683 which Stuart used.[6]

[Goethe to Sartorius, 20 July 1817]

... But what would certainly bestir me, if I were more mobile, would be the Elgin Marbles and the like, for here is the Book of the Law and the Gospels together; everything else you can do without. The provisional publication certainly raises our hopes for more to come. I have sent to England for engravings (or, for the time being, drawings) as soon as possible. They at least give you some idea, which has a good effect ...

[Goethe to Heinrich Meyer, 28/29 October 1817]

The most precious things have arrived from England: we don't know how to cope with them. The Elgin Marbles with their whole train, illustrated again and at least more conveniently, are almost as familiar to us as if we had seen them. The prices of the casts are also there, and the Continent will soon be swamped with these magnificent forms, like cheap cotton goods. I am going to order the horse's head at once so that it will be impossible to do without the heroes that go with it ... Someone has produced a history of art, full of fine phrases but as good as can be expected at present, which will serve at the same time as an introduction to the Marbles, for the most interesting thing in the book is the story of how the love of sculpture fragments began and spread in England.[7] Lord Arundel was the first. I can say nothing about the rest for it is too human, amazing, peculiar, fatal and unpleasant.

[*Diary and Yearbook* 1818]

This year a new epoch for the understanding of how the highest art began. We had already received news and drawings of the Aegina

Marbles, and we saw outlines and finished reproductions of the
works from Phigalia (Fig. 6).[8] We were nonetheless still far from the
greatest, and so we applied ourselves diligently to the investigation
of the Parthenon and its pediment sculptures, as they were still to
be seen by the travellers of the seventeenth century, and received
from Paris copies of their drawings which, although they were only
slight outlines, nevertheless gave a clearer idea of the intention of
the whole than it is possible to do today with the destruction of the
building. We were sent black chalk copies from the school of the
London painter, Haydon, the same size as the originals, of which
the Hercules and the figure resting in the lap of another and the
third seated figure of the group left us duly amazed.[9] Some of the
Weimar Friends of Art had also seen the casts several times, and
they strengthened our view that here was the highest stage of
artistic endeavour in Antiquity.

[Goethe to B. R. Haydon, 16 February 1819 (in English)[10]]

In answer to your polite letter which you did me the honour
of addressing to me last November, permit me to remark that if
such men as Messrs Bewick and Landseer have great reason to
rejoice at having found in you so able and so distinguished a
master, you must, on the other hand, feel an equal degree of
satisfaction to have had it in your power to make your pupils
acquainted with such excellent models as those which your
country of late has had the good fortune to acquire.

Those of us at Weimar who love and admire the arts share your
enthusiasm for the remains of the most glorious period, and hold
ourselves indebted to you for having enabled us to participate to
such a degree in the enjoyment and contemplation of those works
by means of such happy copies.

We look forward with pleasure (though we may not live to
witness it) to the calculable effect and influence which will be
produced upon the arts by those precious relics, in England as
well as in other countries.

NOTES

1. Richard Worthley (1751-1805), whose collection was published in 1824 as *Museum Worthleyanum*.

2. A section from the Parthenon frieze had been in the Louvre since about 1783 (W. St Claire, *Lord Elgin and the Marbles*, 1967, pp. 59, 126).

3. *Report from the select committee of the House of Commons on the Earl of Elgin's collection of sculptural marbles*, 1816.

4. The frieze sculptures from Bassae near Phigalia had also been brought to London (St Claire, pp. 207-8 and see below, pp. 95-8), but the Aegina Marbles were acquired in 1816 by the Bavarian Crown, although they were discovered in 1811 partly by an English expedition, and it was hoped that they might come to England (St Claire, pp. 203 ff).

5. For the generally favourable evidence of Benjamin West and John Flaxman, St Claire, p. 254.

6. James Stuart and Nicholas Revett, *Antiquities of Athens*, 1762-1764, which Goethe borrowed from the Weimar Library from 1795 to 1796 (Keudell No. 55).

7. James Dallaway, *On Statuary and Sculpture among the Ancients*, 1816 (Keudell No. 1109).

8. Goethe knew of the discoveries at Aegina in 1812, and in 1817 studied J. M. Wagner's *Bericht über die Äginetischen Bildwerke* and drawings by Aloys Hirt (Grumach, ii, pp. 521 f.). For the copies from Phigalia, see below, pp. 95-8.

9. The copies were by William Bewick and Charles Landseer (see F. Cummings, 'B. R. Haydon and his School', *Journal of the Warburg and Courtauld Institutes*, 28, 1963, especially p. 372, and *id.* 'Phidias in Bloomsbury: B. R. Haydon's Drawings of the Elgin Marbles', *Burlington Magazine*, 106, 1964, p. 323).

10. B. R. Haydon, *Correspondence and Table-Talk*, i, 1876, p. 340.

The Relief from Phigalia
[Goethe to Louise Seidler,
February 1818]

*The vitality, the breadth of the style, the composition and handling of the relief,
all this is magnificent. On the other hand, with so much beauty, it is hard to under-
stand the cramping of the figures, which are often less than six heads in height,
and the careless proportions of the individual parts, where a hand or a foot is often
as long as a whole leg, and so on. And it should be said that there are reminiscences
of the Colossus in almost every posture.*[1]

But what, dear friend, would you say to the confirmed worship-
per of Greek art, when he says that he admits all this, neither
excuses it nor wants to get round it, but maintains that all these
shortcomings were foreseen, intentional, done on principle. For
sculpture is first of all the servant of architecture: a frieze on a
Doric temple demands forms close to the proportions of its general
shape, and in this sense alone the bold and the compressed must
be preferred.

But why, when we have admitted them, are there still dispropor-
tions within these relationships themselves, and how far should
they be excused? They should not be excused, but praised, for,
when an artist deviates intentionally, he is on a higher plane than
us, and we should not argue with him but worship him. In repre-
sentations of this sort it is important to emphasize the power of the
forms working against each other. How would the bosom of the
Amazon queen here hold its own against the Herculean man's
chest and the powerful horse's neck, if her chest were not expanded
and her buttocks not thus squared and spread out. The retreating
left leg does not enter into it, for it serves only a subordinate part
of the rhythm of the whole. As for the extremities – the hands and
the feet – it is only a question of whether they are placed correctly
in the picture, and it is all the same if the arm she raises, or the leg
that points to the right spot is too long or too short. With this
broad idea we have come back to where we started, for no individu-
al master has the right to be intentionally inadequate, only a whole
school.

And yet there is an example of this, too.

6 Louise Seidler, *Copy of Part of the Relief from Phigalia*. Weimar, Goethehaus.

Leonardo da Vinci, who was a whole world of art unto himself, and with whom we can never concern ourselves enough, was just as daring as the artists of Phigalia. We have considered his *Last Supper* thoroughly, and in so considering it, have worshipped it, so we may be allowed to have our little joke about it. Thirteen people are sitting at a very long, narrow table, and they are suddenly shaken by something. A few remain seated, others start to rise, still others stand up. They fascinate us by their behaviour, which is at once moral and passionate, but these good people must be careful not to try and sit down again, for even if Christ and St John squeeze close together, at least two will have to sit on someone else's lap!

Yet this itself betrays the hand of the master: that he makes a mistake intentionally in the interests of higher things. Probability is the condition of art, but within the realm of probability the highest – what would otherwise not be manifest – must be given. Correctness is not worth sixpence if it is nothing more.

Thus the question is not whether in this sense any of the main limbs are too large or too small for their context. In all of the three copies of the *Last Supper* which we have in front of us, the heads of Judas and Taddaeus could not be together at the same table, and yet, especially if we had the original in front of us, we would not quibble about it, for Leonardo's infinite good taste (we hope we are using this vague term in a very precise sense here) was able to help the spectator over this problem.

And does not the whole art of the theatre depend on such precepts? Only it is an impermanent art, corrupting us and leading us astray with its poetry and rhetoric, and it cannot be criticized as if it were painted, carved in marble or cast in bronze.

We have an analogy – or perhaps it is only a metaphor – in music: there it is equal temperament,[2] in which the notes which do not want to relate exactly to each other are stretched and teased out so that hardly any of them retain their original identity, but all are completely obedient to the composer's will. He uses them as if everything were quite all right. He has won his trick, because the ear does not want to judge, but simply to enjoy, and to communicate its enjoyment. But the eye is backed by a pretentious understanding which is amazed at its own importance when it proves that something it sees is too long or too short.

Let us turn to the question of why we see so many quotations from the Colossus of Monte Cavallo. My answer is that it is already

standing there twice. The best can only be done once: happy the man who can repeat it! The Ancients were nourished by this feeling in the highest degree. The posture of the Colossus, which allows of various delicate adjustments, is the only one suitable to an active hero. You cannot surpass it, and to use it again and again, with variations for different purposes, shows the highest understanding and the greatest originality.

But it is not only this borrowing which is to be found in the bas-relief you have sent me. Hercules and the Amazon Queen move against each other in the same way as Neptune and Pallas on the west pediment of the Parthenon. And so it must always be, because it cannot be developed any further. Even if we allow that Pallas is in the centre of the pediment at Aegina, and Niobe and her youngest daughter somewhere else,[3] these are only the early stages of art. The centre must not be accented, and in a perfect composition, whether in sculpture, painting or architecture, it must be empty or unimportant, so that the attention is concentrated on the sides, without our thinking what their effectiveness derives from.

But as we have now started to remove objections, which is something we ought not to do, we should return to the merits of the bas-relief in front of us without any other considerations in mind.[4]

NOTES

1. Goethe quotes a passage from the letter with which Louise Seidler accompanied the full-size drawing of part of the Phigalia frieze, which she sent to him in 1818. She had made her drawing from a cast in Munich, for the frieze, excavated in 1811, had gone to the British Museum in London. The *Colossus* is the so-called *Horse-Tamers* of Monte Cavallo in Rome.

2. Acoustically 'pure' intervals of the musical major third and perfect fifth occur in nature, and are heard as *overtones*; but a keyboard instrument cannot be played if tuned solely on the basis of pure intervals. *Equal temperament* was the system, introduced during the eighteenth century, in which tuning slightly 'tempered' the pure intervals within the octave, rendering it fit to be played in all keys. Goethe had been making a study of musical theory between 1810 and 1815, in the hopes of composing a book on music similar to his *Theory of Colours*, 1810, (see H. John, *Goethe und die Musik*, 1927, especially pp. 122-49).

3. On the Niobe group in the Uffizzi, see pp. 80, 88 n. 3. The English architect C. R. Cockerell had published a reconstruction of the group as a centrepiece to a pediment in Rome in 1816, and several German theorists were occupied with this question at the time.

4. The letter is unfinished.

The Temple of Minerva at Assisi
[*Italian Journey*, 26 October 1786]

I had learned from Palladio and Volkmann[1] that a noble Temple of Minerva was still standing [at Assisi] in perfect repair. Thus I left my *vetturino* at Madonna del Angelo [*S. Maria degli Angeli*] to go on to Foligno alone, and myself set off, in the teeth of a stiff gale, for Assisi, for I had longed to go on foot through this lonely region. On my left I passed with aversion the mass of churches (in one of which the remains of St Francis are resting) piled up like a Babel on top of each other, for I thought to myself that the people there were of the same stamp as my [former] travelling companion, the Italian captain.[2] I asked a handsome youth the way to Sta. Maria della Minerva, and he accompanied me to the top of the town, for it lies on the side of a hill. At last we reached what is, properly speaking, the old town, and look! the laudable structure stood before my eyes: the first complete monument of Antiquity I had ever seen. A modest temple, as befits so small a town, and yet so perfect, so well conceived, that it would be an ornament anywhere. First of all, the site. Since I read in Vitruvius[3] and Palladio how towns should be built and temples and public buildings sited, I have had a great respect for such things. The Ancients had a great natural gift for it. The temple stands about half-way up the hillside, where two hills meet on the level which is still called the *Piazza*. This itself rises slightly, and is intersected by the meeting of four roads, which form a somewhat compressed St Andrew's cross: two from below and two from above. The houses now opposite the temple blocking the view from it were probably not there in ancient times. If you imagine them removed, you have a view to the south over a rich and fertile country, and at the same time Minerva's sanctuary will be visible from all sides. The line of the roads is probably very ancient, since they follow the shape and gradient of the hill. The temple does not stand in the middle of the level, but its site is so arranged that travellers approaching from Rome have a fine foreshortened view of it. Not only the temple should be sketched, but its happily-chosen site as well.

Looking at the façade, I could not enough admire the brilliant logic of the design, here as elsewhere. The order is Corinthian,

the spaces between the columns being somewhat over twice the diameter of the columns themselves. The bases of the columns, and their plinths, seem to rest on pedestals, but this is only apparent, for the socle is pierced in five places, and at each of these five steps ascend between the columns and bring you to the level on which the columns stand and from which, too, you enter the temple. The daring idea of cutting through the socle was just right, for as the temple is situated on a hill, the flight of steps would otherwise have been carried up to such a height as to have lessened the area of the temple itself. It is impossible to tell how many steps there were originally, for, apart from one or two, they are all choked up with rubble or cemented over. Reluctantly I tore myself away from the sight, resolving to call the attention of architects to this building so that an accurate drawing of it may be made. For I shall again have occasion to remark what a sorry thing tradition is. Palladio, whom I trust in everything, certainly gives an illustration of this temple, but he can never have seen it himself, for he puts real pedestals on the level, so that the columns are far too high, and the result is a sort of unsightly Palmyra monstrosity.[4] In reality it looks so full of repose and gentle beauty as to satisfy both eye and mind. I cannot express what impression this work made on me, but it will always bear fruit.[5]

NOTES

1. A. Palladio, *I Quattro Libri dell'Architettura* (1570), Bk. IV, ch. xxvi. Goethe had recently acquired a copy of Consul Smith's 1770-1780 edition in Padua. J. J. Volkmann, *Historisch-kritische Nachrichten von Italien*, 2nd. ed. 1777, III, p. 431 f. Volkmann was Goethe's chief guidebook.
2. Goethe had discussed Protestantism with his thoughtless and superstitious companion, a captain in the Papal army, earlier in the journey.
3. Vitruvius Pollio, the chief Roman architectural theorist, and Palladio after him, established the choice of site as the first basic principle of building. See below, pp. 196-200.
4. Goethe is probably referring to the ruins of the Temple of Baal at Palmyra, published in Wood, Bouverie and Dawkins, *The Ruins of Palmyra*, 1753 ff.
5. See *Architecture 1795*, below, pp. 196-200.

III MEDIEVAL AND RENAISSANCE ART

On German architecture [1772]

D. M.

Ervini a Steinbach[1]

As I wandered about your tomb, noble Erwin, looking for the stone which should have told me *Anno domini* 1318 *XVI Kal. Febr. obiit Magister Ervinus, Gubernator Fabricae Ecclesiae Argentinensis*, and could not find it, and none of your fellow-townsmen could show it to me, so that I could pour out my veneration at that holy place – then was I deeply grieved in my soul, and my heart, younger, warmer, more innocent, better than now, vowed to you a memorial of marble or sandstone (according to what I could afford) as soon as I should come into the quiet enjoyment of my inheritance.

Yet what need you a memorial! You have erected the most magnificent one for yourself, and although your name does not bother the ants who crawl about it, you have the same destiny as that Architect who piled up his mountains to the clouds.

It was given to few to create the idea of Babel in their souls, whole, great, and with the beauty of necessity in every smallest part, like trees of God. To even fewer has it been granted to encounter a thousand willing hands to carve out the rocky ground, to conjure up steeps on it, and when they die, to tell their sons, 'I am still with you in the creations of my spirit; complete what is begun, up to the clouds.'

What need have you of a memorial! And from me! When the rabble utters holy names, it is superstition or blasphemy. The feeble aesthete will forever be dizzied by your Colossus, and those whose spirits are whole will recognize you without need of an interpreter.

Now then, excellent man, before I risk my patched-up little ship on the ocean again, and am more likely to meet death than profit, look at this grove where all about the names of my loved ones are still green.[2] I cut yours on a beech tree, reaching upwards like one of your slender towers, and hang this handkerchief of gifts by its four corners on it. It is not unlike the cloth that was let down to the Holy Apostle out of the clouds, full of clean and unclean beasts;[3] also flowers, blossoms, leaves and dried grass and

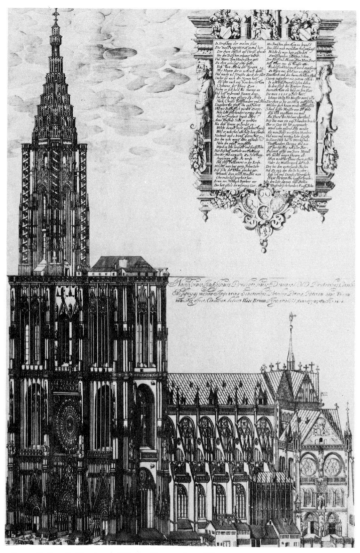

7 Jean Achard, *Strasbourg Minster*. Engraving. Weimar, Goethehaus.

moss, and night-sprung toadstools – all of which I gathered, botanizing to pass the time, on a walk through some place or other, and now dedicate to your honour until they rot away.

'It is in a niggling taste,' says the Italian, and passes on. 'Puerilities,' babbles the Frenchman childishly after him, and triumphantly snaps open his snuffbox, *à la greque*.[4] What have you done, that you should dare to look down your noses?

Has not the genius of the Ancients risen from its grave to enslave yours, you dagoes? You scramble over the ruins to cadge a system of proportions, you cobble together your summer-houses out of the blessed rubble, and think yourselves the true guardians of the secrets of art if you can reckon the inches and minutest lines of past buildings. If you had rather felt than measured, if the spirit of the pile you so admire had come upon you, you would not simply have imitated it because *they* did it and it is beautiful; you would have made your plans because of truth and necessity, and a living, creative beauty would have flowed from them.

You have given your practical considerations a colour of truth and beauty. You were struck by the splendid effect of columns, you wanted to make use of them, and walled them in. You wanted colonnades, too, and ringed the forecourt of St Peter's with alleys of marble which lead nowhere, so that mother nature, who despises and hates the inappropriate and unnecessary, drove the rabble to convert your splendour into public cloaca, and men avert their eyes and hold their noses before the wonder of the world.[5]

That is the way it goes. The whim of the artist serves the obsession of the rich: the travel writer gapes, and our *bels esprits*, called philosophers, spin out of the raw stuff of fairy tales the history of art up to our times, and the evil genius murders true men in the forecourt of the sanctuary.

Rules are more damaging to the genius than examples. Before he arrives on the scene, some individuals may have worked out some parts, but he is the first from whose soul those parts emerge as an everlasting whole. But school and rule fetter all power of perceiving and acting. What does it matter to us, you new-fangled French philosophizing connoisseurs, that the first man – whose needs made him ingenious – hammered in four stakes, lashed four posts over them, and put branches and moss on the top?[6] From this you deduce the needs of today, and it is just as if you wanted to rule your new Babylon[7] according to the feelings of simple patriarchal societies.

It is also wrong to think that your hut was the first. Two stakes at each end, crossed at their apex, with another as ridgepole are, as you may daily see in the huts of field and vineyard, a far more basic invention, from which you could not even extract a principle for your pig-sty.

So none of your conclusions can rise to the sphere of truth. They all swim in the atmosphere of your system. You want to teach us what we should use, because what we do use cannot be justified according to your principles.

The column is close to your heart, and in another part of the world you would be a prophet. You say, 'The column is the first and most important component of the building, and the most beautiful. What sublime elegance of form, what pure and varied greatness, when they stand in rows!'[8] Only be careful not to use them out of turn: their nature is to stand free. Woe to those wretches who have wedded their slender growth to lumpish walls! And yet it seems to me, my dear Abbé, that the frequent repetition of this impropriety of walling columns in, by which the moderns even stuff the intercolumnia of ancient temples with masonry, might have given you pause. If your ear was not deaf to truth, these stones at least might have preached it to you.

The column is, on the contrary, no part of our dwellings; rather it contradicts the essence of all our buildings. Our houses do not arise from four columns in four corners, but from four walls as four sides, which are in place of columns, and exclude them, and where you tack them on, they are a tiresome excrescence. That goes, too, for our palaces and churches, except for a few instances which I need not notice. So your buildings present surfaces which, the more extensive they are, and the higher they soar, the more they oppress the soul with intolerable monotony. It would be a sad day for us if the genius of Erwin von Steinbach did not come to our rescue: 'Diversify the enormous walls; you should so build towards heaven that they rise like a sublimely towering, wide-spreading tree of God which, with its thousand branches, millions of twigs and leaves more numerous than the sands of the sea, proclaims to the surrounding country the glory of its master, the Lord.'

The first time I went to the Minster, my head was full of the common notions of good taste. From hearsay I respected the harmony of mass, the purity of forms, and I was the sworn enemy of the

confused caprices of Gothic ornament. Under the term Gothic, like the article in a dictionary,[9] I threw together all the synonymous misunderstandings, such as undefined, disorganized, unnatural, patched-together, tacked-on, overloaded, which had ever gone through my head. No less foolish than the people who call the whole of the foreign world barbaric, for me everything was Gothic that did not fit my system, from the lathe-turned gaudy dolls and paintings with which our *bourgeois gentilshommes* decorate their homes to the sober remains of early German architecture, on which, on the pretext of one or two daring curlicues, I joined in the general chorus: 'Quite smothered with ornament!' And so I shuddered as I went, as if at the prospect of some mis-shapen, curly-bristled monster.

How surprised I was when I was confronted by it! The impression which filled my soul was whole and large, and of a sort that (since it was composed of a thousand harmonizing details) I could relish and enjoy, but by no means identify and explain. They say it is thus with the joys of heaven, and how often have I gone back to enjoy this heavenly-earthly joy, and to embrace the gigantic spirit of our ancient brothers in their works. How often have I returned, from all sides, from all distances, in all lights, to contemplate its dignity and his magnificence. It is hard on the spirit of man when his brother's work is so sublime that he can only bow and worship. How often has the evening twilight soothed with its friendly quiet my eyes, tired-out with questing, by blending the scattered parts into masses which now stood simple and large before my soul, and at once my powers unfolded rapturously to enjoy and to under-stand. Then in hinted understatements the genius of the great Master of the Works revealed itself to me. 'Why are you so sur-prised?' he whispered to me. 'All these shapes were necessary ones, and don't you see them in all the old churches of my city? I have only elevated their arbitrary sizes to harmonious proportions. How the great circle of the window opens above the main door which dominates the two side ones: what was otherwise but a hole for the daylight now echoes the nave of the church! How, high above, the belfry demands the smaller windows! All this was necessary, and I made it beautiful. But ah! if I float through the dark and lofty openings at the side that seem to stand empty and useless, in their strong slender form I have hidden the secret powers which should lift those two towers high in the air – of which, alas! only one stands mournfully there, without its intended decoration

of pinnacles, so that the surrounding country would pay homage to it and its regal brother.'

And so he left me, and I sank into a sympathetic melancholy until the dawn chorus of the birds who lived in the thousand openings rejoiced at the rising sun and woke me from my slumber. How freshly the Minster sparkled in the early morning mist, and how happily I could stretch out my arms towards it and gaze at the harmonious masses, alive with countless details. Just as in the eternal works of nature, everything is perfectly formed down to the meanest thread, and all contributing purposefully to the whole. How the vast building rose lightly into the air from its firm foundations; how everything was fretted, and yet fashioned for eternity! Genius, it is to your teaching that I owe it that I am no longer dazzled by your profundities, that a drop of the rapturous quiet of the spirit sinks into my soul, which can look down over such a creation and say, as God said, 'It is good.'

And now I ought not to be angry, holy Erwin, if the German art expert, on the hearsay of envious neighbours, fails to recognize his advantage and belittles your work with that misunderstood word 'Gothic'. For he should thank God that he can proclaim that this is German architecture, our architecture. For the Italian has none he can call his own, still less the Frenchman. And if you do not wish to admit this advantage yourself, at least prove to us that the Goths already built like this: you will find it difficult. And if in the end you cannot demonstrate that there was a Homer before Homer, we will willingly leave you the story of lesser efforts that succeed or fail, and come to worship before the work of the master who first welded the scattered elements into a living whole. And you, my dear spiritual brother in the search for truth and beauty, shut your ears to all the blather about fine art; come, look, and enjoy. Take care that you do not profane the name of your noblest artist, and hasten here to see his excellent work. If it makes an unpleasant impression on you, or none at all, good luck to you, harness your horses and be off to Paris!

But it is to you, beloved youth, that I feel closest, for, standing there, you are moved and cannot reconcile the conflicting feelings in your soul. At one moment you feel the irresistible power of this vast whole, and the next chide me for being a dreamer since I see beauty where you see only rugged strength. Do not let us be divided by a misunderstanding. Do not let the effete doctrine of modern

pretty-prettyness spoil you for roughness that is full of meaning, so that in the end your sickly sensibility can only tolerate meaningless polish. They would have us believe that the fine arts arise from our desire to beautify the objects around us.[10] This is not true! For not the philosopher, but the man in the street and the artisan use the word in the only way it could be true.

Art is formative long before it is beautiful, and it is still true and great art, indeed often truer and greater than 'fine art' itself. For in man's nature there is a will to create form which becomes active the moment his survival is assured. As soon as he does not need to worry or to fear, like a demi-god, busy even in his relaxation, he casts around for a material into which he can breathe his spirit. And so the savage articulates his coconut shell, his feathers, his body with fantastical lines, hideous forms and gaudy colours. And even if this making visibly expressive is made up of the most arbitrary forms, they will still harmonize without any obvious relationship between them, for a single feeling has created a characteristic whole.

Now this characteristic art is the only true art. If it becomes active through inner, unified, particular and independent feeling, unadorned by, indeed unaware of, all foreign elements, whether it be born of savagery or of a cultivated sensibility, it is a living whole. Hence among different nations and individuals you will see countless different degrees of it. The more the soul is raised to a feeling for those proportions which alone are beautiful and eternal, whose principal harmonies may be proved but whose secrets can only be felt, in which alone the life of godlike genius is whirled around to the music of the soul – the more, I say, this beauty penetrates the being of the mind, so that it seems to be born within that mind, so that nothing satisfies the mind but beauty, so that the mind creates nothing but beauty out of itself, so much the happier is the artist, and the more magnificent, and the lower we prostrate ourselves and worship the Lord's annointed.

And no one will remove Erwin from his high place. Here is his creation. Come up and acknowledge the deepest feeling for truth and beauty of proportion, brought about by the strong, rugged German soul on the narrow, gloomy, priest-ridden stage of the *medii aevi.*

And our *aevum*? That has renounced his genius, has driven its sons about after strange growths, to its ruin. The frivolous Frenchman

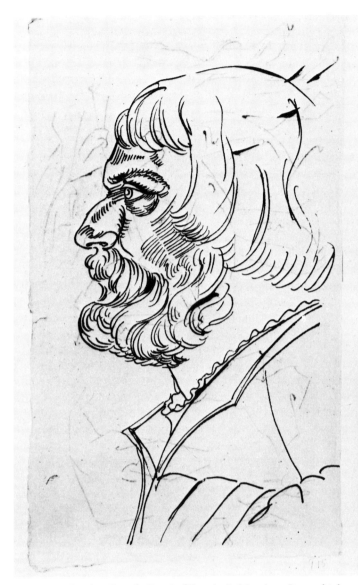

8 J. W. von Goethe, *Copy of a Portrait of Dürer by E. Schön,* ?1828. Pen and ink, 34.6 × 20.7cm. Weimar, Goethehaus.

who gleans far worse at least has the wit to pull his loot into a single whole; he does build a magic temple of a Madeleine for his Greek columns and German vaults. But I have seen one of our artists, when he was asked to devise a porch to an old German church, prepare a model with stately Antique columns.[11]

I do not wish to rehearse how much I hate our tarted-up doll-painters. With their stagey poses, false complexions and gaudy clothes they have caught the eye of the ladies. Your wood-carved face, O manly Dürer, whom these novices mock, is far more welcome to me (Fig. 8).

And you yourselves, excellent people, to whom it was given to enjoy the highest beauty, and now step down to proclaim your happiness; even you harm genius, for it will be raised and moved on no other wings than its own, not even the wings of the morning.[12] It is our own power, unfolded in a childhood dream, and developed in youth until it is strong and agile like the mountain lion as he rushes on his prey.[13] Hence nature is the best teacher, for your pedagogues can never create the diversity of situations in which genius may exert and enjoy its present powers.

Hail to you, youth, with your sharp eye for proportion, born to adapt yourself easily to all sorts of form! When, little by little, joy in the life around you wakes and you feel a jubilant and human pleasure after the fears and hopes of toil: the delighted shout of the wine-harvester when the fulness of autumn swells his vats, the lively dance of the mower when he hangs his sickle, now idle, on the beam. If the strong nerve of desire and suffering becomes more manfully alive in your brush, then you have striven and lived enough, and enjoyed enough, and are sated with earthly beauty; you are worthy to rest in the arms of the goddess, worthy to feel at her breast that by which the deified Hercules was reborn. Receive him, heavenly Beauty, you mediatrix between gods and men, so that he may, more than Prometheus, bring down the bliss of the gods upon earth.

NOTES

1. D.M. = *Divis Manibus*, an inscription to the blessed spirits on Roman tombs. Erwin von Steinbach was the architect of the first stage of Strasbourg Cathedral. The foundation stone (now in the Cathedral Museum) was inscribed: *A.D. 1277 in die Beati Urbani hoc opus gloriosum inchoavit Magister Ervinus de Steinbach.* Erwin's gravestone was not rediscovered until 1816, and Goethe took the inscription from an early guidebook.

2. In the woods at Sesenheim, near Strasbourg, Goethe had fixed a tablet with the names of himself and his friends on a tree.

3. *Acts*, X, 11 ff.

4. Goethe is alluding to the Abbé M. A. Laugier, *Essai sur l'architecture*, 1753, p. 3, where Gothic ornaments were described as *puérillement entassés*.

5. This example is also from Laugier (*Nouvelles Observations sur l'Architecture*, 1765, pp. 74, 76).

6. Cf. Laugier, *Essai*, p. 9. The source is Vitruvius, *Ten Books on Architecture*, II, i, 3-5.

7. i.e. Paris.

8. Cf. Laugier, *Essai*, p. 11., 288.

9. i.e. J. G. Sulzer, *Allgemeine Theorie der Schönen Künste*, 1771, I, p. 489.

10. See Sulzer, p. 609.

11. La Madeleine in Paris (begun in 1764) was also criticized by Laugier (*Essai*, p. 178) although he was not against the possibility of combining elements of classic and Gothic architecture. The vaults of the Madeleine are hardly 'German'. Laugier also (*Observations*, p. 149) opposed the use of Classical porches on Gothic façades.

12. Cf. Psalm 139, 9.

13. Cf. Psalm 17, 12.

Third pilgrimage to Erwin's grave, in July 1775[1]
[*Aus Goethes Brieftasche*, 1776]

Preparation
At your graveside again, holy Erwin, at and over the eternal memorial of the life in you, I feel, thank God, that I am still what I was; still as strongly moved by the great, and, oh wonder! still more uniquely, more exclusively touched by the true than before, since often out of childish devotion I strove to honour that for which I had no feeling, and, deceiving myself, lovingly excused objects devoid of truth and power. How my vision has cleared, and yet you are still in my heart, all-vitalizing love! You abide with truth, whether or not they are quick to say that you shun the light and flee into the fog.

Prayer
Thou art one and living, begotten and unfolded, not botched and patched together. Before thee, as before the foaming falls of the mighty Rhine, before the gleaming snow-caps of the eternal mountains, as in view of the serene expanse of lake and, grey Gotthard, of your cliffs of cloud and wild ravines, as before every great thought of creation, stirs in the soul what in her is also creative power. The soul rhapsodizes, clawing up the paper with her scribbles, in the worship of the creator, of eternal life, of the all-embracing, inextinguishable feeling of that which is, and was, and shall be.

First Station
I will write, for it does me good, and whenever I have written, it has done my readers good, if they had blood coursing through their veins and if their eyes were bright. I hope, my friends, that it goes as well with you as with me, as I take the air that every morning comes to this platform over the roofs of the distorted town.

Second Station
Higher up, looking down, already looking out over the magnificent

plain, out towards my country and my beloved, and yet feeling the fulness of the present moment.

I once wrote a pamphlet which seemed less inwardly felt than it was,[2] which few read, and those few did not understand it, though some good spirits saw glimmerings of what made them inexpressibly happy. It was extraordinary to speak of a building mysteriously, to wrap up facts in riddles, to mumble poetically about proportions! And yet I am no better off now. Well, let my fate be like yours, heavenward-striving tower, and yours, vast world of God! Aesthetes of all nations gape at us and then file us away like specimens in their tiny minds.

Third Station

If only you could be with me, creative artist, sensitive connoisseur, whom I have encountered so often on my walks, and you whom I have not met, but who must also exist. If these pages reach you, may they strengthen your hand against the insipid, relentless drool of mediocrity, and, if you should come to this place, may you remember me with love.

The world is for thousands a freak show; the images flicker past and vanish; the impressions remain flat and unconnected in the soul. Thus they are easily led by the opinions of others, are content to let their impressions be shuffled and rearranged and evaluated differently.

At this point the arrival of Lenz[3] interrupted the writer's devotions; feeling was converted into conversation throughout the remaining Stations. With every step we were more convinced that the creative power in the artist is a growing feeling for proportion, measure and decorum, and that only through these can an original work be produced, just as an individual power of growth produces other creations.

NOTES

1. Goethe had presumably made his second pilgrimage on his way to Switzerland in May 1775. The present essay is in the form of traditional manuals of devotion.
2. i.e. 'On German Architecture'.
3. J. M. R. Lenz (1750-1792), poet.

Strasbourg Minster
[*Dichtung und Wahrheit* II, ix (written 1812)]

When I think of what I have to say next, by some strange trick of memory there comes back into my mind that worthy Minster which in those days was the subject of my especial attention, for it was always in view, in the town and from the countryside around.

The more I contemplated its façade, the more my first impression was confirmed and developed: that here was a union of the sublime and the merely pleasing. If the vast is not to terrify us when we encounter it as mass, if it is not to confuse us when we try to investigate its detail, it must undergo an unnatural, a seemingly impossible union with the agreeable. But since we can only be impressed by the Minster if we think of those two incompatible characteristics as united, we must seriously undertake to account for the peaceful fusion of such contradictory elements.

We shall not consider the towers, but confine our observations to the façade, which presents us with the strong impression of a tall, upright rectangle. If we approach it at twilight, by moonlight, or on a clear, starry night when the details become more or less indistinct and finally vanish, we see only an enormous wall, whose height is happily related to its width. If we look at it in daylight, and abstract in our imagination from its detail, we recognize the front of a building which not only closes off the spaces within, but also screens several areas at the sides. The openings in this immense surface indicate the demands of the interior, and, according to these, we can divide it up into nine fields. The great central doorway, which indicates the nave, is the first thing to strike our eye. On either side of it are two smaller doorways belonging to the aisles. Over the main door we see a wheel-shaped window which is designed to let a foreboding light into the church and its vaults. To the sides are two large upright rectangular openings, which make a marked contrast with the central one, and show that they belong to the bases of soaring towers. On the third storey three apertures are grouped together, serving the needs of bell-towers and other church arrangements. The whole is completed horizon-

tally at the top by the balustrade of a parapet in place of a cornice. The nine areas just described are supported and delimited by four buttresses rising from the ground, which divide them up into three large perpendicular compartments.

Although it cannot be denied that there is already a beautiful relationship between the height and the width of the whole mass, these buttresses, by the slender divisions between them, lend it something equally light in detail.

But let us continue to abstract, and imagine this enormous wall without ornament, with solid buttresses, with the necessary apertures, but only insofar as they are necessary, and let there be an harmonious relationship between these divisions. Then the whole will certainly be earnest and worthy, but it will also be depressing and, without ornament, it will appear unartistic. For a work of art whose *ensemble* is conceived in large, simple, harmonious parts certainly makes a noble and worthy impression, but the peculiar pleasure of charm can only be found where all the developed details are in unison with each other.

Here the building we are considering satisfies us in the highest degree, for we see each and every ornament appropriate to the part it decorates, subordinate to it and as if growing out of it. Such variety gives us great enjoyment in that it derives from what is appropriate, and hence at the same time arouses a feeling of unity. Only in such cases is the treatment prized as the highest peak of art.

By such means as this a solid wall, an impenetrable screen, which must manifest its role as the base of two towers rising to heaven, must convey an idea of unshakeable firmness, must appear to the eye as self-supported and entirely self-dependent, but must at the same time be light and decorative.

This paradox has been resolved in the happiest way. The apertures and the solid parts of the wall, and its buttresses, each have their particular character deriving from their particular function. This character is communicated step by step to the subordinate parts, so that the decoration is harmonious throughout: everything, great and small, is in its place and can be easily taken in at a glance; and so the charming is made manifest in the gigantic. I need only mention the portals receding in perspective in the thickness of those walls, ornamented with countless buttresses and pointed arches, or the artificial rose growing out of the circle of the window, or the outline of its spokes, or the slender, reed-like columns of the perpendicular compartments. Imagine the buttresses, receding

step by step, striving heavenwards with their thin pointed canopies with spindly columns, designed to shelter the images of saints. And then think of the way every rib, every boss has the form of a cluster of flowers or a spray of leaves or some other petrified natural object. If you cannot look at the building itself, use illustrations of the whole and of the details to bring my words to life and to assess them. They may seem exaggerated to some, for I myself, although I was strongly attracted to this building from the start, nevertheless took a long time to recognize its merits thoroughly.

Having grown up among the critics of Gothic architecture, I nursed a distaste for its frequently overladen and confused ornament, whose arbitrary character increased the repugnance I felt for the gloomy religious aspect of the style. I was confirmed in this distaste by having encountered hitherto only insignificant examples, without proportions or consistency. Now, however, I felt I had experienced a revelation, since here there were none of those defects, but rather the forceful impression of their opposite.

The more I looked and reflected, the more I felt I was discovering still greater merits in what I have described. I had picked out the just proportions of the larger divisions, with their decoration, down to the smallest detail, as meaningful as it was rich; but now I recognized the links between these ornaments, the bridge between one major member and another, the interweaving of details similar, yet highly varied in their form, from saints to monsters, from leaves to scallops. The more I investigated the more I was astonished, and the more I busied myself with measuring and drawing, the more my attachment to the task grew, so that I spent a good deal of time both studying what was available and restoring in my imagination and on paper what was missing or incomplete, especially the towers.

As I discovered that this building had been founded in an old German city and was extended in a truly German period, and since the name of the master I found on the modest gravestone had similarly a German ring and origin to it, I found the merit of this building a challenge, and dared to change the hitherto disparaging term 'Gothic style of building', so as to vindicate our nation with the title 'German Architecture'. And I did not hesitate, first in conversation and subsequently in a short essay dedicated to D. M. Ervini a Steinbach, to proclaim to the world my patriotic idea.

On German architecture, 1823
[*Kunst und Altertum* IV, ii, 1823]

There must be a great fascination about that style of architecture which Italians and Spaniards already called German (*tedesca, germanica*) from the earliest times, but which we Germans have only just begun to designate as such. For many centuries it was used for buildings of all sizes, the greater part of Europe adopted it, thousands of artists and thousands more craftsmen practised it, Christian ceremonial increased its diffusion, and it had a powerful effect on the spirit and the senses. It must thus embrace something great and fundamentally felt, something considered and developed, and it must both conceal and manifest proportions whose effect is irresistible.

Hence it was remarkable to find the testimony of a Frenchman, whose own style was opposed to the one we are celebrating here, and the judgement of whose time was exceptionally unfavourable to it, but who yet speaks as follows:

All the pleasure we derive from artistic beauty depends on the observation of rule and measure: on proportion. If this is lacking, no matter how much surface ornament is employed, the beauty and the charm which are not there in essence cannot be replaced. Indeed, it may be said that ugliness is made even more hateful and intolerable if the outward ornaments are heightened by richness in the craftsmanship or the materials.

To take this assertion further, I maintain that Beauty, which derives from measure and proportion, has no need of precious materials and fine workmanship, but rather shines out and is manifest amongst the confusion and disorderliness of both these materials and their treatment. Thus we look with pleasure on the proportions of those Gothic buildings whose beauty seems to derive from and is seen in symmetry and the relationship of the whole to the parts, and of the parts among themselves, without taking account of, indeed, in spite of, the ugly ornaments with which they are covered. But what must surely convince us most is the fact that, if we investigate these measurements precisely, we find for the most part the same proportions as in those buildings which, since they were built according to the rules of good taste, give us so much pleasure to look at. (François Blondel *Cours d'Architecture* (1675) V, v,ch. xvi, xvii)

Here we may recall somewhat earlier years, when the Strasbourg Minster had so great an effect on us that we could not help expressing our unsolicited delight. What the French architect had estab-

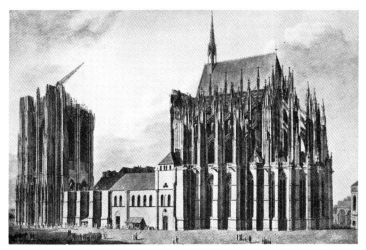

9 Angelo Quaglio, *Cologne Cathedral*, 1809. Engraving.

lished by studious measurement and investigation came to us all unawares, and not everyone is asked to account for the impressions which astonish him.

If these buildings stood for centuries like a hangover from the past without making any special impact on the ordinary man, the reason is not far to seek. But, on the other hand, how powerful has been their effect in recent times when feeling for them has been re-awakened! Young and old, men and women, have been so over-whelmed and swept away by such impressions that they have not only been refreshed and educated by the frequent examination, measurement and drawing of them, but have also adopted this style in new buildings destined for use, and, like their forefathers, have felt at home in such surroundings.

Now that this sympathy for the works of the past has been arous-ed, our great thanks are due to those who *make* it possible for us to feel and recognize their value and dignity in the proper – that is, the historical – way; and I want to talk about this, since I feel that my close relationship with such important objects demands it.

After moving from Strasbourg, I saw no important or impressive buildings of this type. The impression weakened, and I could hardly remember the circumstances in which such a sight had aroused the most vivid enthusiasm in me. My stay in Italy was not conducive to revitalizing such feelings, the more so that the recent modifications to Milan Cathedral made it impossible to see its ancient character;[1] and so for many years I lived away from this sort of art, if not act-ually out of sympathy with it.

In 1810, however, through the intermediary of a noble friend, I came into close touch with the Boisserée brothers.[2] They gave me a brilliant sample of their efforts; carefully executed drawings of Cologne Cathedral, some in plan, some of the various elevations, acquainted me with a building which, after careful investigation, certainly deserves the first place in this style of architecture.[3] I took up my earlier studies again, and, through reciprocal visits and the laborious examination of many buildings of the period, by means of engravings, drawings and paintings, so familiarized myself with them that in the end I felt quite at home with these objects.

But, in the nature of the case, especially at my age and in my position, it was the historical aspect of the whole affair that seemed most important, and in this the important collections of my friends offered the best aids.[4]

Now, as luck would have it, it happened that Herr Moller,[5] a

highly cultivated and perceptive artist, was also enthusiastic about these things, and contributed to the project in the happiest way. The discovery of an original outline drawing of Cologne Cathedral gave the thing a new aspect, and a lithographic copy of it, indeed a tracing, in which the whole twin-towered profile could be represented with some joining-up and filling-out with wash, had a significant effect. What must also have been welcome to the amateur of history was this excellent man's project of laying before us a series of early and recent illustrations of the Cathedral, in which we could easily see and understand the rise, perfection and finally the decline of this style. This is the more readily done that the first work lies complete before us, and the first numbers of the second, which will deal with single buildings of this type, have already arrived.[6]

I hope that the public will support the projects of this perceptive and industrious man, for it is high time we occupied ourselves with such things if we are to form a complete idea of them for ourselves and for posterity.

And we must also hope for the same attention to and participation in the work of the Boisserée brothers, the first instalment of which we have already noticed in a general way.[7]

I am honestly delighted to see the public now enjoying the advantages I have had for thirteen years, for it is during that period that I have witnessed the long and arduous work of the Boisserée circle. During this time they have not failed to send me new drawings and old drawings and engravings relative to such things, but particularly important were the proofs of the copper-plates, which their outstanding engravers had brought nearly to completion.

Yet however beautifully this fresh participation took me back to the tendencies of my youth, I nonetheless found the greatest advantage was a short visit to Cologne, which I had the good fortune to make in the company of Minister von Stein.[8]

I cannot deny that the sight of the exterior of Cologne Cathedral aroused in me a certain indefinable apprehension. If an important ruin has something impressive about it, we sense, we see in it the conflict between an admirable work of man and time, still, mighty and wholly inconsiderate: here we are confronted with something at once incomplete and gigantic, whose very incompleteness reminds us of the inadequacy of man, the moment he undertakes something that is too big for him.

To be honest, even inside, the Cathedral makes a pronounced but

also a discordant effect; only when we step into the choir, where the completeness surprises us with an unexpected harmony, are we happily astonished and pleasantly awed, and feel our yearning more than satisfied.

But I had already spent some time over the ground-plan and discussed it a good deal with my friends, and hence I could follow the traces of the original conception on the spot, for almost all the foundations are laid out.[9] Likewise the engraved proofs of the side elevation and the drawing of the front elevation went some way towards giving me a mental picture of the whole. Still, what is missing remains so immense that we cannot attain the heights.

But now that the Boisserées' work is nearing its end, the illustrations and their commentary will reach all amateurs, and the friend of art, even if he is far away, has the opportunity of completely convincing himself that this is the highest peak to which this style of architecture attained. For if, perhaps as a tourist, he should approach that miraculous spot, he will no longer be left to personal feeling, gloomy prejudice, or, on the other hand, to a hastily-formed dislike, but he will rather observe what is there and imagine what is not like someone who is knowledgeable, and is initiated into the secrets of the masons. I, at least, hope for this enlightenment after fifty years of striving through the efforts of patriotic, intelligent, industrious and indefatigable young men. It is only natural that I should often recall my earlier attachment to Strasbourg Minster in the course of my renewed study of the German architecture of the twelfth century and that I should be pleased that I have nothing to be ashamed of in rereading that pamphlet which I wrote in 1773[10] in the first flush of my enthusiasm. For I had felt the inner proportion of the whole, I had recognized the development of the individual ornaments out of this whole, and I had discovered, after long and repeated observation, that there was something incomplete about a tower even though it was built high enough. All this agreed with the later convictions of my friends and of myself, and if there is something incoherent about the style of that essay, I hope it may be forgiven, where the inexpressible is to be expressed.

We shall often return to this subject, and we close here with thanks to those to whom we owe the basic preparatory work, Moller and Büsching,[11] the one for producing the engraved plates, the other for his introductory essay on the history of Early German architecture, added to which we have the welcome aid of Herr

Sulpiz Boisserée's well-grounded introduction and captions to the plates.

Meanwhile, we hope that a reprint of our frequently-cited early essay will soon follow, so as to clarify and point up the difference between the earliest seed and the final fruit.

NOTES

1. Goethe had made a disparaging remark about the work in progress on Milan Cathedral in a letter of 22 May 1788 to Duke Carl August of Weimar. The 'recent modifications' apparently refer to the seventeenth-century additions to the façade after designs by Pellegrino Pellegrini.

2. Baron Karl Friedrich Reinhard, who notified Goethe of the work of Sulpiz and Melchior Boisserée in April 1810. For Goethe's relationship with the brothers, W. D. Robson-Scott, *The Literary Background to the Gothic Revival in Germany*, 1965, Pt. IV, ch. 3.

3. In a letter of 14 May 1810 to Reinhard, Goethe still preferred Strasbourg to Cologne.

4. On the Boisserées' collection of early art, see *Heidelberg*, below, pp. 130-9

5. Georg Moller (1784-1852), architect.

6. G. Moller, *Bemerkungen über die aufgefundene Originalzeichnung des Doms zu Köln, nebst 9 Kupfertafeln*, 1818. G. Moller, *Denkmäler der deutschen Baukunst*, 1818.

7. S. Boisserée, *Ansichten, Risse und einzelne Teile des Doms zu Köln, mit Ergänzungen nach dem Entwurf des Meisters*, 1821. Goethe had published a short notice of this in *Kunst und Altertum* IV, i, 1823.

8. The visit took place in June 1815.

9. Cologne Cathedral was begun in 1248.

10. 'On German Architecture' (pp. 103-12) bore the date 1773, although it was written in 1772.

11. J. G. G. Büsching, *Versuch einer Einleitung in die Geschichte der Altdeutschen Baukunst*, 1821-1823 (Ruppert 2334).

Early paintings and recent restorations in Venice (1790) [*Kunst und Altertum* V, ii, 1825]

The earliest monuments of post-classical art here in Venice are the mosaics and the Byzantine pictures; among the oldest mosaics I have not yet seen any that deserve attention.

The Byzantine paintings are to be found in various churches, the best in the Greek church [*S. Giorgio dei Greci*]. Because of their age they must have been painted in tempera and only afterwards covered with oil or a varnish. In these pictures there is still a certain traditional idea of art and handling of the brush; there is also a concept of the ideal: where it came from may perhaps be discoverable.

The face of the Mother of God, seen close to, seems to be modelled on the features of the Imperial family;[1] a very early picture of the Emperor Constantine and his mother suggested this to me: the large eyes, the small nostrils, which made the nose long and narrow with a fine tip, were striking, as was the delicate mouth which was similarly small.

The most important conception in Byzantine painting depends on the worship of ikons, on the holiness of the panel. The identity of the figure is always carefully written beside it; even the Mother of God and the Christ Child, who can hardly be mistaken, always bear their inscription.

There are half-length ikons, life-size, or nearly so, and full-lengths, invariably less than life-size, with very small narrative panels as accessories beneath them.

It seems to me that the Greek Orthodox, more than the Catholics, worship the image as an image.

A great gap will have to be bridged, for it is an enormous leap to Domenico Veneziano [d. 1461[2]]; nonetheless, all artists up to Giovanni Bellini maintained the holiness of the panel.

When large altarpieces began to be used, they were made up of several images of saints grouped together, each with their gilded compartments, which is why the wood-carver and gilder is often named together with the painter.

Furthermore, a very simple artistic device was used to fill out the panel: the saints were raised up on steps, on which infant musicians in the guise of angels were set, and the space at the top was decorated with painted architecture.

That idea survived as long as possible, for it has become a part of the religious cult.

Among the many pictures by Giovanni Bellini and his predecessors there are no historical subjects, and even the narratives depend on the earlier representations: there is always a saint preaching and a number of the faithful listening.

The earlier narrative pictures have very small figures: the Vivarini's picture of S. Rocco's coffin, for example, is painted in this way.[3] Even the enormous spread of art later on had its beginnings in these small pictures, as Tintoretto's beginnings as a tailor's apprentice show;[4] even Titian could shake off these religious origins only slowly.

It is known that the man who commissioned the great altarpiece in the Frari was very angry to see such large figures in it.[5]

The beautiful picture on the altar of the Pesaro family still has the representation of saints and figures in adoration.[6]

Titian generally kept closely to the old manner and simply handled it with great warmth and artistry.

The question arises, when did it become the custom for the patron and donor of the picture to have himself painted in it?

Everyone would like to leave some memorial of his life, and it can be seen as an enticement by the Church and the artist to confer by this means a sort of saintliness on pious people. And it can easily be seen as a pictorial signature. Thus, in the corner of a large image of the Virgin in high relief kneel the patrons in the form of humble dwarfs. Little by little they become whole families and major figures, and in the end the whole tribe of them takes part in the historical action.

The rich *Scuole* now offered their large walls, and the churches theirs, and the paintings, that otherwise stood only in tabernacles above the altars, now spread over every empty space.

Titian was still able to paint a miracle-working picture, although Tintoretto could hardly do so, even if lesser painters had this good fortune.

The Last Supper had long since edified the refectories, and Paolo Veronese had the happy idea of representing other great and pious feasts on their vast walls.

In the meantime, however, art and its expectations expanded, and the limits of religious subject-matter became clear. This is most sadly appreciable in the best works of the great masters; you cannot see what is really happening, for they have concentrated on accessories, and these are what dominate the eye. Now the executioner's assistant begins to play the main role, for he is the occasion for introducing some muscular nudity. But these beginnings always produce disgust, and were it not for the charming ladies and fresh-faced children in the crowd who maintain the balance to some degree, we should come away hardly edified by either art or religion.

It is remarkable how Tintoretto and Veronese use these beautiful women to make the disgusting subjects they were obliged to treat more or less appetizing. A couple of charming women in the prison in which the angel appeared to S. Rocco at night would otherwise be inexplicable.[7] Were loose-living women and saints locked up with other criminals in the same cell? It is in any case these figures in the picture, as we see it now, who remain the chief object of attention, for they are in better condition than the others, and were probably more carefully painted.

Everyone says that they are abandoned plague-victims, but they do not look like it in the least.

Tintoretto and Veronese sometimes had to return to the old manner in painting altarpieces, and group together in one picture saints who had been commissioned, probably the patron saints of the commissioning patron himself. But it is always done with the greatest artistry.

The oldest pictures painted in tempera have sometimes lasted well, because they have not darkened like the oils and they seem to tolerate damp fairly well, if it is not too extreme.

A technically-skilled painter would be able to explain the handling of the colours.

The earliest oil paintings are also well preserved, although not quite as bright as the paintings in tempera. This is said to be due to the care with which the early artists chose and prepared their colours, to their practice of grinding them first of all in water until they were clear, and then allowing them to settle as sediment, so that several tints were extracted from a single pigment. They similarly took infinite pains in the preparation of their oils. It has further been noted that they grounded their panels very carefully, with a chalk ground as in tempera painting: this absorbed the

superfluous oil during the painting and left the colours the purer on the surface.

This care grew less and less, and in the end vanished completely as larger paintings were undertaken. Canvas had to be employed, and this was only lightly grounded with chalk, or sometimes even lime.

Paolo Veronese and Titian worked chiefly in glazes; their under-painting was light, and this they covered with darker transparent tints, which is why their pictures have become lighter rather than darker with time, although Titian's have also suffered from his excessive use of oil in the upper layers.

The reason why Tintoretto's paintings have mostly darkened so much is said to be that he worked without a ground, or on a red ground, mainly *alla prima* and without glazing. Since he painted thickly and had to give the pigment the tone it was to have on the surface, there is no light underpainting, as with Veronese, and if the abundant oil alters with the pigment, the whole mass darkens together.

The most damaging effect is of the strong red ground dominating the thinner pigment layers, so that sometimes only the highest, thickly-painted lights are still visible.

A good deal probably depended as well on the quality of the pigments and oils.

How fast Tintoretto painted can also be seen from the number and size of his works, and one example will show how boldly he went about it. In large pictures which he had stretched and painted in the places where they were to go, he left out the heads, which were painted at home in his studio, cut out, and then glued onto the picture, as has been discovered during repairs and renovations. This seems to have been particularly the case with portraits, which he could comfortably paint from the model at home.

A similar practice has been discovered in the paintings of Paolo Veronese. Three portraits of noblemen were included in a religious picture; during restoration these faces were found to be lightly glued on and under them were three beautiful heads which showed that the master had originally shown three saints, but later, perhaps through the influence of persons in authority, he perpetuated their images in this public work.[8]

Many pictures have also been ruined by being coated with oil on the back because it was wrongly thought that this would freshen the colours. When such pictures were replaced on the wall or the

ceiling, the oil penetrated the canvas and destroyed the picture in several ways.

Given the large number of paintings in Venice that have been damaged in various ways, it is understandable that many painters, of varying capacities, should have been employed in their repair and renovation. The Republic, which keeps a great treasure of paintings in the Doge's Palace alone, since they have been somewhat damaged by the ravages of time, has established a sort of academy for picture restoration, gathered together a number of artists under a director, and given them a great hall and other large rooms in the Convent of SS. Giovanni e Paolo where damaged pictures are brought and restored.

This institute has the advantage that all the experimental findings made in this art are collected and preserved.

The methods and technique of restoring each particular picture are very different, according to the various masters and the condition of the painting itself. The members of this academy have, through many years' experience, familiarized themselves with every detail of the various methods of the masters: canvas, ground, underpainting, glazes, finishing and harmonizing or varnishing.[9] The condition of every picture is first of all examined and assessed before it is decided what to do with it.

I came across them quite by chance, for as I was examining Titian's precious picture of the murder of St Peter Martyr in this church, a monk asked me if I wanted to visit the gentlemen upstairs as well, and proceeded to explain their work to me. I was welcomed, and as my close interest in their work became clear – for I expressed it with German directness – I may perhaps say that they came to like me, for I returned frequently, always paying my respects to the Titian on the way.

It would have been more useful if I had written home at the time about what I saw and heard, but I will here record from memory only a quite special procedure in one of the most exceptional instances.

Titian and his followers certainly painted on occasion on figured linen damask direct from the weaver, unbleached and unprimed. This lent the whole a certain shimmer that is characteristic of damask, and the individual parts gained an inexpressible life, since the colours never stayed the same for the spectator, but had the effect of a certain movement of light and dark, so that they lost all sense of substance. I can still clearly remember a Christ by Titian

whose feet were seen close to, and through the flesh colour the rather bold, checkered texture of the damask was visible. If you stepped back, it seemed to be a living epidermis with all sorts of moving nicks and wrinkles playing over it.

If the damp eats a hole in this sort of picture, a metal stamp is made to the design of the support, and fine canvas with a chalk ground is stretched over it, impressing the design in it. This patch is fixed to the new lining canvas and fills the hole when the old painting is glued to it. It is painted over, and harmonizes with the whole simply because of the ground it is on.

I found the men at work on a vast picture by Veronese, in which there were more than twenty of these holes; I saw all the stamped patches ready, held together by linen threads like a spider's web and laid on the stretched lining canvas. They were now busy locating the exact spots where the little scraps of linen should be glued, so that when the great picture was stretched they would fit exactly into all the holes. It really needed a convent, a monk-like secure existence and an aristocratic patience as well, to carry out this sort of undertaking. And it is easy to understand that with this type of restoration the picture only retained its general appearance, and it was only possible in a large room to make the holes invisible to the populace, though not to the expert.

NOTES

1. Probably the twelfth or thirteenth-century Madonna brought to S. Giorgio in 1528 from the Imperial Palace in Constantinople.
2. Domenico Veneziano was probably a Florentine.
3. Probably part of the S. Rocco altarpiece (1480) by Bartolommeo Vivarini, now in S. Eufemia in Venice.
4. This is obscure. Tintoretto's father was a dyer, hence his nickname.
5. The name of the patron of Titian's Frari altarpiece, the *Assunta*, is not known (H. Wethey, *Titian* I, 1969, No. 14).
6. Wethey No. 55.
7. In Tintoretto's painting in the Presbytery of the Church of S. Rocco.
8. Goethe is perhaps alluding to the cutting out of heads from these paintings by thieves (cf. M. P. Merrifield, *Original Treatises on the Arts of Painting* II, 1849, pp. 862-3, and pp. 845-89 on the organization of the Venetian Government restoration workshops).
9. Goethe uses the term *Akkordieren*, probably in reference to the story of Apelles, who is said by Pliny to have applied a dark varnish to his finished works in order both to harmonize them and to heighten the colours (cf. E. H. Gombrich, 'Dark Varnishes: variations on a theme from Pliny', *Burlington Magazine* 104, 1962, pp. 51-5).

Heidelberg
[*Kunst und Altertum* I, 1816]

This town, which has many remarkable features, occupies and entertains the visitor in more ways than one. However, for our purposes, the route we took led first of all to the collection of early paintings brought here from the upper Rhine, which has been for several years the particular ornament of the neighbourhood.[1]

As I now look at the Boisserée collection for a second time, after the interval of a year, and go more deeply into its meaning and intentions, and especially as I am not disinclined to say something about it in public, I am confronted by all the difficulties I felt before. All the advantages of visual art consist in the fact that what it represents can be hinted at but not expressed in words, and the sensitive observer knows that he is attempting the impossible if he is not inclined to restrain himself. He then recognizes that the purest and most useful service can be done historically; he will conceive the plan of honouring such a well-presented and well-arranged collection by giving an account not so much of the pictures themselves as of their relationship to each other; he will be aware of detailed comparisons with works outside the collection, although he must trace the period under discussion here to artistic activities remote in time and place. And so he will give the precious works which concern us now their full due in their place, and he will deal with them in such a way that the historian will willingly accord them a niche in the great realm of art.

As an introduction to this, and so that the peculiarity of this collection is clearly apparent, we must consider its origins. The Boisserée brothers, who own it together with Bertram,[2] and freely share their enjoyment of it with other amateurs of art, were formerly merchants and had studied both at home [in Cologne] and in other great commercial cities. At the same time they wished to satisfy a yearning for culture and found a good opportunity for this in that the newly-founded school in Cologne employed chiefly Germans as teachers.[3] Thus they enjoyed an education rare in those parts. And although they must have been born and nurtured in the enjoyment and love of works of art, for they had been surrounded by them from their youth up, it was nonetheless

chance that aroused their desire to own them and presented the occasion for this praiseworthy enterprise.

Remember the youth who found a rowlock on the beach, and was so pleased with this simple device that he acquired an oar, a boat, mast and sail, and, after some practice sailing along the shore, at last set boldly out to sea and with larger and larger vessels in the end became a rich and successful shipper. The Boisserée brothers resemble him in that by chance they acquired for very little from a junk-dealer, a picture that had been thrown out from a church; then others and, since the owning and restoring them made them more deeply aware of the value of such productions, their interest became a passion which increased the more they acquired outstanding items, until it seemed no sacrifice to spend part of their fortune and all of their time on expensive journeys, new purchases and other activities in the furtherance of their project.

Their urge to rescue early German monuments from oblivion, to present the better examples in all their purity, and so to establish a means of judging the decline of this style of building, was equally vigorous. One effort proceeded side by side with the other, and they are now able to publish a magnificent art book of a type rare in Germany[4] and to exhibit a collection of two hundred pictures which in variety, integrity and fine condition, and especially in the completeness of the historical series, can hardly be paralleled.

But to make it as clear as words will allow, we must go back to earlier times, like one who has to draw up a family-tree and must penetrate as far as possible from the branches to the roots. We shall however always assume that the reader can see this collection, either in fact or in his mind's eye, and indeed that he knows the other works we mention, and wants soberly and seriously to be instructed.

The Roman Empire was so degraded and confused by military and political disasters that all types of institutions, and art with them, vanished from the face of the earth. Art, which a few centuries earlier had reached a peak, was now lost amid the turmoil of war and militarism, as we can see most clearly from the coinage of this depressed time when a swarm of Emperors and the creatures of Emperors were not ashamed to appear in caricatures on the most debased copper pennies, and to pay their soldiers not with a regular wage, but, like beggars, with miserable alms.

It is to the Christian Church, on the other hand, that we owe the

preservation of art, even though it was only like sparks beneath the ashes. For although the new, inward, morally gentle doctrine had to keep aloof from, if not actually destroy that outward and powerfully sensual art, yet nonetheless there was such a germ of variety, infinite variety, in the history of this as of no other religion, that it was in the nature of things that such an art would emerge in it, even without the wishes and the support of the new faithful.

The new religion recognized a supreme God, not conceived so regally as Zeus, but more humanly, for he is the father of a mysterious Son, who was to represent the moral qualities of the Godhead on earth. These two are joined by an innocent fluttering dove, forming a miraculous trefoil, around which a chorus of blessed spirits is gathered in countless gradations. It is possible to venerate the Mother of this Son as the purest of women, for the combination of virginity and motherhood is already to be found in pagan antiquity.[5] She is accompanied by an old man, but the *mésalliance* is approved from on high, in order that the new-born God shall, for the sake of appearances and for his own well-being, be provided with an earthly father.

How attractive this growing and ceaselessly active God-man was we know from the number and variety of disciples and followers of both sexes and of all ages and types who gathered round him, and from the Apostles who emerged from their number, from the four Evangelists, from the faithful of all sorts and conditions, and the long series of martyrs from Stephen onwards.

This new Covenant was furthermore based on an older one whose traditions reach back to the creation of the world and are of a more historic than dogmatic type; and if we take account of our first parents, the patriarchs and judges, prophets, kings and reformers, each of whom is distinguished or noteworthy, we shall see how natural it was that art should be intimately bound up with the Church, and that one could not exist without the other.

Hence, if Greek art started from the general, and only very late lost itself in the particular, Christian art had the advantage of being able to start with innumerable individual characteristics, and to evolve little by little towards the general. You only need to glance at the long list of historical and mythical figures given here, you only need recall that all of them have well-known and important stories told about them; and furthermore that the new Covenant sought to justify itself by discovering itself symbolically in the old, and in thousands of different ways set out earthly and historical

or heavenly and spiritual instances of this. Thus in art, too, the first centuries of the Christian Church left beautiful monuments.

But the world was too upset and oppressed; the increasing disorder drove culture from the west, and only in Byzantium did the Church and its art find a secure resting-place.

However, in this period the outlook for art in the east was gloomy; those individual characteristics did not flourish at once, but nonetheless prevented an archaic, stiff, mummy-like style from losing all significance. Figures were still distinguished from each other, but to make their differences appreciable, each name was written on the picture, or under it, so that, as the saints and martyrs became more and more numerous, one would not be reverenced rather than another, but each would get his due. And so it became the Church's business to make pictures, and this was done according to an exact prescription, under priestly supervision, until later they were also adopted, with consecrations and miracles, into the divine service. Thus, to this day, the holy ikons of the Greek Church which are worshipped both at home and abroad, are made under priestly surveillance in and around Susdal, a town in one of the twenty-one administrative districts of Russia; hence their family likeness.[6]

If we return to Byzantium in the period we mentioned, we shall see that religion itself took on a pedantic and diplomatic character, and the Church festivals the character of court and state celebrations.

This clear demarcation and this obstinacy is also due to the fact that Iconoclasm brought no advantage to art, since the images restored by the victorious party were perforce identical with the old ones so as to be accorded their rights.

How the most wretched of all innovations insinuated itself, namely that, probably under Egyptian, Ethiopian or Abyssinian influence, the Mother of God was depicted as black, and the face of the Saviour impressed on Veronica's handkerchief was also the colour of a Moor, may be discovered by a more exact investigation of the history of art in that quarter; but everything points to a slowly worsening situation, which was resolved far later than one might have expected.

Here we must try to make it clear what great merits the Byzantine School, of which we have been able to say little good, still bore within it, merits which came to it in an artistic way from the high inheritance of its Greek and Roman forefathers, but which were preserved in a narrow, institutional fashion.

For if we earlier, and not unjustifiably, called it mummified, we must realize that even in the hollow body, in the dried and embalmed sinews, the form of the bones asserts itself. And so it is here, as we shall see in more detail.

The highest task of art is to decorate a defined space, or to arrange ornament in an indefinite one: what we call artistic composition springs from this demand and in this the Greeks, and after them the Romans were supreme masters.

Hence everything that speaks to us as ornament must be articulated, and this in the highest sense, that it is made up of parts that relate reciprocally to each other. To this end it is expected that it will have a centre, an above and below, a here and a there which first generate that symmetry, which, when it is wholly comprehensible, may be called the lowest grade of ornament. The more various the elements become and the more that early symmetry, enlaced, concealed, converted into oppositions, appears to us as a manifest secret, the pleasanter the ornament is; and it is quite perfect when we no longer think of its first principles, but are astonished by it as a product of chance and caprice.

The Byzantine School persisted in that strict and dry symmetry, and although their pictures became thereby stiff and unpleasing, nonetheless there are cases where changes of posture in figures facing each other produce a certain grace. And this advantage, together with the above-mentioned variety of subjects from Old and New Testament traditions, spread the artists and craftsmen of the East over the whole of Christendom.

What happened in Italy is well known. Practical skill had completely vanished and everything that demanded it came from the Greeks. The doors of S. Paolo fuori le mura were cast in Constantinople in the eleventh century and their panels abominably decorated with chiseled figures. At the same time Greek schools of painting spread through Italy; Constantinople sent master masons and mosaic workers, who decked out the ruined West with their miserable art. But, as in the thirteenth century a feeling for the truth and loveliness of nature reawoke, the Italians at once took up the celebrated merits of the Byzantines, symmetrical composition and the differentiation of figures. This happened the more readily that a sense of form quickly made itself apparent, for it had not been completely submerged. The splendid buildings of antiquity had stood for centuries before their eyes, and the surviving parts of those that were ruinous or destroyed were instantly

converted to ecclesiastical or public use. The most magnificent statues were unspoiled, such as the colossal *Horse-Tamers*, which had never been buried.[7] So every lump of rubble still had form. The Roman in particular could not set his foot down without touching something that had been given form, nor till his garden or field without exposing the most precious objects. What was happening in Siena or Florence need not detain us, the less so that every amateur may inform himself in detail about this, as on all the topics we have discussed, in the valuable work of M. d'Agincourt.[8]

However, the observation that the Venetians, as inhabitants of coast and lowland, soon felt a sense of colour developing freely in them, is important here, for they provide our bridge to the Netherlanders, in whom we find the same quality.

And so we are approaching our particular objective, the lower Rhine, for which we have not been afraid to make this long detour.

Only let us recall briefly how the east bank of this magnificent river was overrun by the Roman armies, who built military defences there, and was then heavily populated and developed. Since the chief colony there bore the name of the wife of Germanicus,[9] we have no doubt that in those times great art enterprises were undertaken there, for all types of artists must have worked together: master masons, sculptors, potters, and mint masters, as is witnessed by the many remains that have been and are still being excavated. How far, at a later period, the mother of Constantine the Great, the wife of Otto, was active there, it remains for historians to investigate.[10] Our purpose is rather to get closer to the legend, and to discern, in or behind it, a universal historical meaning.

Let a British princess, Ursula, and an African prince, Gereon, reach Cologne by way of Rome, she with a train of noble virgins, he with a chorus of heroes. Acute observers, able to penetrate the mists of tradition, tell us the following about them: when two factions spring up within an empire, and separate themselves irrevocably from each other, the weaker will seek to leave the centre and move towards the frontiers where there is room for factions and where the tyrant's will is not immediately felt. There a Prefect or a Governor may make himself strong with the help of the disaffected, by tolerating, promoting and even sharing their feelings and opinions. This view appeals very much to me, for in our own day we have witnessed a similar, even identical spectacle to that which has taken place more than once in the mists of history.[11] A train of the noblest and bravest Christian emigrants

reaches, one after the other, the famous and beautifully-sited Colonia Agrippina, where, welcomed and protected, they enjoy a serene and pious life in the most magnificent surroundings, until they are shamefully subjected to the violent measures of the opposing party. If we look at the type of martyrdom that Ursula and her following underwent there, we find nothing like that absurd story of how in Rome tender, innocent and cultivated people were bestially martyred and murdered by executioners and savage beasts for the entertainment of a crazed rabble; no, in Cologne we see a massacre of one party by another, so as to eliminate them the faster. The death to which the Virgins were condemned was like a St Bartholomew's or a September massacre,[12] and Gereon and his associates seem to have fallen in the same way.

Now, since at the same time the Theban legions had been butchered on the upper Rhine, we find ourselves in a period when the ruling party no longer has to repress a growing opposition, but strives rather to extirpate a fully-developed one.

Everything we have said so far was essential to establishing an idea of the Netherlandish School. The Byzantine School of painting, in all its branches, had dominated on the Rhine for many years, as it had throughout the whole of the West, and had trained native apprentices and craftsmen for all types of ecclesiastical work. Hence many dry works, wholly in the style of that gloomy school, are to be found in Cologne and its neighbourhood. But the national character and climatic influences are nowhere more apparent in the history of art than on the Rhine; therefore we shall develop this point carefully, and ask for friendly attention to our discussion.

We shall pass over the important period when Charlemagne built a series of residences on the left bank of the Rhine from Mainz to Aachen, for the culture which emerged from this activity had no influence on painting, which is our proper subject. That gloomy oriental stiffness was not relaxed before the thirteenth century in this area either. Then, however, a joyful feeling for nature suddenly broke forth, not, indeed, as the imitation of real individual traits, but as a delight in seeing which was directed over all the sensible world. Children's faces round as apples, the egg-shaped features of men and women, wealthy elders with flowing or curly beards, the whole race of them good, pious and cheerful, and all of them, though sufficiently individualized, painted with a tender, even melting brushstroke. It is the same with the colours, which are

cheerful, clear, strong, not exactly harmonious, yet not gaudy either, and thoroughly pleasing to the eye.

The material and technical hallmarks of the paintings we are describing are the gold ground with a punched halo surrounding the head, bearing the name of the saint. Often the gleaming metal surface is also stamped with wonderful flowers like wallpaper, or appears to be transformed into gilded tracery with outlines in brown. That these pictures can be ascribed to the thirteenth century is proved by those churches and chapels where they are still in their original positions. But the strongest proof is that the cloisters and other areas of many churches and convents were decorated at the time of their building with pictures which show the same characteristics.

Among the pictures in the Boisserée collection a *St Veronica* (Fig. 10) is easily the most important, for it can illustrate many aspects of what has been said so far.[13] It may be discovered in the future that, as far as composition and drawing is concerned, this picture is based on a Byzantine model. The dark brown face of Christ under the crown of thorns, probably darkened with age, has a wonderful, pained but noble expression. The corners of the handkerchief are held by the saint, who stands behind it, scarcely a third life-size, and covered by it up to her chest. The faces and gestures are very graceful; the lower edge of the cloth touches a floor which is suggested beneath it, on each side of which are sitting three very small singing angels (if they stood up they would be no more than a foot high) grouped so beautifully and artistically that they meet the highest demands of composition. The whole conception of the picture points to a traditional, considered, thoroughly worked-out art, for it needs a great sense of abstraction to set the figures represented in three dimensions, and make the whole symbolic. The bodies of the angels, especially the heads and hands, are arranged and articulated so beautifully that it seems as if everything has been thought out. Although this is the basis of our attribution to a Byzantine origin, yet the grace and softness with which the saint is painted, and with which the children are represented, obliges us to place the execution of the picture in that lower-Rhenish period which we have already characterized extensively. Because it unites a powerful thought and a pleasing execution, it has an unbelievable effect on the spectator, an effect which is achieved very largely by the contrast of the frightening, Medusa-like face of Christ with the pretty virgin and the graceful children.

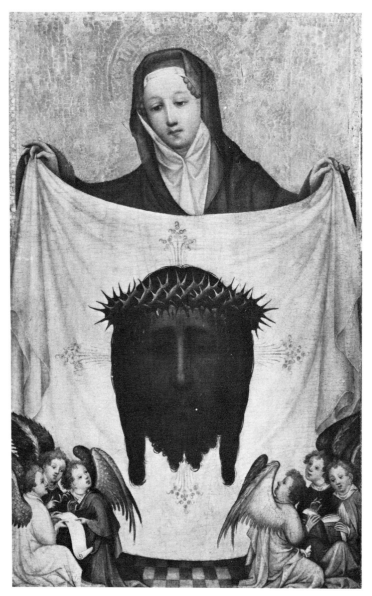

10 Cologne School, *St Veronica with the Sudarium*, early fifteenth century.
78 × 48cm. Munich, Alte Pinakothek.

Some larger panels, in which half life-size Apostles and Church
Fathers are painted like coloured statues equally softly and agree-
ably in cheerful and pleasing colours, between gilded pinnacles
and other painted architectural decorations, give rise to similar
observations, but at the same time point to new conditions.[14] For,
towards the end of the so-called Middle Ages, sculpture in Germany
had advanced further than painting, since it was more essential
to architecture, more apt to the sensuous tone of the age, and
could draw on more local talent. The painter, if he wishes to escape
from the more or less mannered through his personal vision of
reality, has to choose one of two ways: the imitation of nature, or
the adaptation of available works of art. We in no way detract from
the merits of the Netherlandish painters of this period if we ask
whether these holy men, executed with amiable softness and
tenderness, rich, but with free-flowing draperies, are not based on
the coloured or uncoloured carved statues which stood in similarly
carved and gilded three-dimensional niches. This hypothesis seems
particularly supported by the skulls at the feet of these saints in
their painted niches, from which we deduce that the model was
some reliquary with the same figures and decorations. This sort of
picture is all the more agreeable in that it displays, in its sympathetic
treatment, a certain sedateness that is proper to sculpture rather
than to painting. All that we claim here may be further substanti-
ated when in the future the only too-scattered remains of early
church art are studied with an unprejudiced attention.

If, at the beginning of the thirteenth century, Wolfram von
Eschenbach introduces the painters of Cologne and Maastricht
into his *Parsifal* as proverbially the best in Germany, no one will be
surprised that we have praised the early pictures of this region so
highly.[15] But now a new period, the beginning of the fifteenth
century, demands all our attention, if we hope to extract its peculiar
character in the same way. But before we go any further, and
speak of the style that now emerges, let us go back to the subjects
which especially offered themselves to the painters of the lower
Rhine.

We have already noted above that the chief saints of that area
were noble virgins and youths, and that their deaths have nothing
of the disgusting incidents which make the representations of other
martyrs so very unpleasant. But among the most happy accidents
for the painters of the lower Rhine was the bringing of the bones of
the Three Kings from Milan to Cologne.[16] We search in vain in

histories, fables, traditions and legends for a subject as favourable, rich, easily-managed and charming as this one. Between ruinous walls and beneath a miserable roof a new-born, yet fully self-conscious child is tended in his mother's lap and watched over by an old man. Before him bow the great and worthy of the world: the infant subjugates the venerable, poverty riches, humility the crown. A numerous following stands amazed at the strange object of a long and arduous journey. The Netherlandish painters owe their success to this much-loved subject, and it is no surprise that they never tired of repeating it for centuries. But now we come to the important step that Rhenish art took at the turn of the fourteenth and fifteenth centuries. Artists had long been sent to the variousness of nature because of the many characters they had to represent, but they remained content with a general expression of it, although here and there we may recognize some attempt at portraiture. Now, however, Meister Wilhelm of Cologne is express-ly cited as incomparable in the imitation of human faces. This quality appears most amazingly in the altarpiece at Cologne, which may be seen as the pivot of the history of art in the lower Rhine.[17] It is only to be hoped that its true merit may be recognized in an historical and critical way, for at present it is the object of so much adulation that I am afraid it will soon be as obscured in the mind's eye by such rhapsodies as it was formerly to the physical eye by the soot of lamps and candles. It consists of a centrepiece and two wings; on all three the gold ground is retained in the same way as on the pictures described above. Furthermore, the carpet behind Mary is punched and brightly painted. Otherwise this common device is scorned, for the painter is aware that brocade and damask, and whatever else has shot colours or a brilliant sheen, can be reproduced with the brush, and so he has no need of mechanical aids.

The figures of the main panel, as of the wings, face towards the centre, symmetrically, but with a great variety of significant contrasts in form and movement. The usual Byzantine precept is still the rule, but is followed freely and gently.

The whole crowd of followers who, with oriental, mask-like faces gather round St Ursula and St Gereon, share a family likeness, but the two kneeling kings are portraits, and we may say the same of the Holy Mother. We will say no more here of this rich gathering and its merits, since the *Taschenbuch für Freunde altdeutscher Zeit und Kunst* has provided us with a very welcome reproduction of this

outstanding work, and has added an adequate description, for which we would be even more thankful had it not been suffused with enthusiasm and mysticism, which cannot further the cause either of art or of knowledge.[18]

This picture presupposes a good deal of experience on the part of the master, and more precise research in the future might be expected to turn up more of its sort, if time had not destroyed much and later art not replaced it. For us it is an important document of a decisive step from the stereotyped reality and the generalized portrayal of national types to the complete reality of the portrait. We are convinced by this development that this artist, whatever his name is, was of a truly German origin and outlook, so that it is not necessary to point to Italian influences to explain his merits.

Since this picture was painted in 1410 it belongs to the period when Jan van Eyck was already flourishing as an important painter,[19] and it thus allows us to go some way towards explaining the puzzling excellence of Eyck by showing us what contemporaries he had. We called the *Dombild* the pivot between the old and the new Netherlandish art, and we will now look at Eyck's work as belonging to the period of the complete transformation of that art. Already in the Byzantine-Netherlandish pictures we find the punched carpets sometimes treated in perspective, although incompetently. In the *Dombild* there is no perspective, since the pure gold ground shuts everything off. Now Eyck throws off all this punched work and all gold grounds completely; a free space emerges, in which not simply the main characters, but even the subordinate figures are portraits in face, height and dress, and every accessory is precisely portrayed.

However difficult it remains to give an account of such a man, we shall risk it in the hope that the reader may have the opportunity of seeing his work, for we do not doubt for a moment that Eyck is in the first rank of those whom nature has endowed with the gift of painting.[20] At the same time, he was fortunate in living in a period when art was technically evolved and had everywhere reached a certain standard; and to this was added his enjoyment of a high, perhaps the highest advantage in art, for, whatever may be said about the invention of oil painting, we do not doubt that Eyck was the first to mix with the colours themselves the oily substances which had hitherto been used to cover pictures after they were finished, and to have selected the most easily drying oils and the clearest and least opaque pigments, so as to allow the light

of the white ground to shine through the colours over them as much as he liked.[21] Since the whole force of colour, which by nature is dark, is not released by light reflected from it, but rather by light shining through it, this discovery and method answered the highest physical and artistic demands. But, as a Netherlander, Eyck had a natural gift for colour; the power of colour was known to him, as it was to his contemporaries, so that, to speak only of draperies and hangings, the effectiveness of the picture was far greater than the effect of reality. This is indeed what true art should achieve, for normal vision is conditioned by innumerable accidents of eye and object; the painter, on the other hand, works according to the rules which separate objects by light, shade and colour, and presents them with the optimum visibility, as a fresh and healthy eye will perceive them. Eyck was furthermore in command of the art of perspective, and of landscape, especially vistas of buildings, which now replace the miserable gold grounds and hangings.

But now, it may seem surprising if we say that he, casting off the mechanical and material imperfections of earlier art, also renounced a hitherto quietly nurtured perfection, namely the idea of symmetrical composition. But this, too, was in the nature of an extraordinary mind which, when it bursts through the shell of material circumstances, never thinks that there is still around it an intangible intellectual barrier against which it fights in vain, to which it must either submit, or turn to its own purposes. Eyck's compositions are hence of the greatest truth and sweetness, but at the same time they do not satisfy the strictest demands of art; indeed, it seems as if he deliberately avoided using what his forbears had known and practised. In the pictures of his that we know, there is no group that can be compared with the angels beside St Veronica. But since no visualized thing can be attractive without symmetry, he, as a man of taste and sensibility, produced it in his own way, and achieved something more appealing and effective than what is conformable to the rules of art, but at the same time lacks spontaneity, and speaks only to the calculating mind.

If you have listened to us patiently so far, and if the experts agree with us that every step from a stiff, old-fashioned, artificial state of affairs into the free and vital truth of nature was accompanied by an equal loss, which was only made good very slowly, and often very much later, then we can see our Eyck in his uniqueness, for we are in a position to honour his individuality without reservation. The earlier Netherlandish painters were already inclined to

arrange the tender episodes of the New Testament in a certain order, and so we find it in Eyck's large work in this collection, which consists of a central panel and two wings, where the thoughtful artist has undertaken to represent a developing trilogy with feeling and good sense. On our left a heavenly youth announces an extraordinary event to the girlish Virgin (Fig. 11). In the centre we see the happy, astonished mother absorbed in the worship of her Son, and on the right she appears bringing her child for consecration into the Temple, already almost like a matron who has a grave premonition of what is to happen to the boy in the delighted hands of the High Priest. The expression of all three heads and the postures, first kneeling, then seated, then standing, is engaging and appropriate. The relationship of the figures in all three pictures shows the most delicate feeling. In the *Presentation in the Temple* there is also a sort of parallelism, achieved, without a central accent, by the opposition of the figures: a spiritual symmetry, so felt and well-judged, that we are drawn to it and involved in it, even though it does not match up to the most perfect standards of art.

Just as Jan van Eyck, as an eminently thoughtful and sensitive artist, has been able to achieve a greater variety in his main figures, so he has treated the backgrounds very successfully. The *Annunciation* takes place in an enclosed room, tall but narrow, and lit by a row of windows high up. Everything in it is as clean and neat as befits that innocence which is aware only of itself and its immediate surroundings. The benches along the wall, a prayer-stool, a bed, all elegant and polished. The bed with a red cover and hangings, everything, like the brocade at the bed-head, astonishingly rendered. The central picture, on the other hand, presents us with a distant prospect, for the noble but ruined chapel in the middle frames rather than covers the variety of objects. To the spectator's left is a fairly distant town, full of streets and houses, bustle and industry, which turns into the picture towards the background, leaving room for a broad field. This is covered with various rural objects and stretches down to an expanse of water in the distance. On the spectator's right is part of a round temple, of which several stories are included, but the interior of this rotunda abuts on the wing of the triptych, and its height, breadth and lightness contrasts magnificently with the Virgin's little room. If we repeat that all the objects in the three pictures are perfectly executed with masterly precision, the reader will gain a general idea of the excellence of

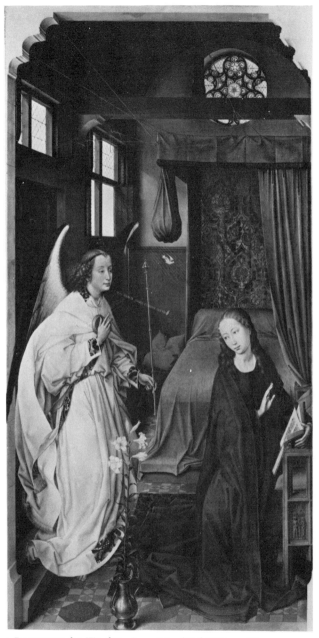

11 Rogier van der Weyden, *Annunciation* (Right Wing of the
Columba Altar), c.1460. 138×70cm. Munich, Alte Pinakothek.

this well-preserved picture. From the wattle on the weathered and crumbling ruin, from the grass growing out of the mouldering thatch, to the many jewels on the gift of gold, from the costume to the face, from foreground to background, everything is treated with equal care, and there is no part of these panels which would not gain from being examined through a magnifying-glass. The same goes for a single panel in which Luke sketches a portrait of the Holy Mother suckling her child.[22]

And here we allude to the important fact that the artist has shifted the symmetry we so urgently demand into the setting, and thus replaced the neutral gold ground with an artistic and striking means of expression. Even if his figures do not move very artistically in this space or relate to each other, it is nonetheless a determining setting, which prescribes fixed limits by which their natural and casual movements seem controlled in the most pleasing way.

Yet all this, however precisely we have tried to express it, remains empty words without the experience of the pictures themselves. It would thus be very desirable if the owner would publish reasonably sized and exact outline engravings of the pictures we have mentioned, by means of which anyone not fortunate enough to see the pictures themselves would be able to test and assess what we have said so far.[23]

In expressing this wish, we must the more regret that a young and talented man, who was formed by this collection, has died too soon. His name, Epp, is still precious to those who knew him, and especially to those amateurs of art who own his copies of early works, executed honestly, with truth and care. But we must not despair on this account, for a very skilful artist, Herr Köster,[24] has joined with the owners in devoting himself to the conservation of this important collection. He would best demonstrate his fine and conscientious talent if he would execute and publish these outlines. If they were to reach the hands of all amateurs, we would add much more that at present could only confuse them, as is usually the case with verbal descriptions of paintings.

Reluctantly I close here, for there is much charm and grace in what was to be discussed next. We can scarcely say much more about Jan van Eyck himself, since we shall return to him again and again when we speak of later artists. But next come those whom we need suppose as little influenced by foreigners as he was, and it is certainly a mean shift when, in assessing extraordinary gifts, we rush to point out where all their advantages came from. The man

who looks at nature from his childhood on does not find nature pure and unadorned around him, for the divine power of his forebears has created a second world within the world. He is so beset by imposed habits, traditional usages, favourite customs, worthy traditions, precious monuments, useful laws, and such a variety of the splendid products of art that he can never distinguish what is original and what derived. He takes the world as he finds it and is quite right to do so.

Thus the original artist may be described as the one who treats the subjects around him in an individual and national, and lastly, a traditional way, and forms them into a well-knit whole. When we discuss such a man, it is our duty to look in the first place at his powers and training, then at his surroundings, insofar as they offer him subjects, skills and feelings, and only then should we look outwards and investigate, not so much what foreign art he knew, but how he used it. For the breath of much that is good, enjoyable and useful blows over the world, often for centuries, before its influence is felt. In history we are often amazed at the slow progress of purely mechanical skills. The Byzantines had the inestimable works of Greek art before their eyes without being able to escape from the tedium of their own dessicated brushwork. And is it particularly noticeable that Dürer was in Venice? That excellent man can only be explained on his own terms.

And so I hope to find patriotism, to which every state, country, province, even town is entitled, for just as we bring out the character of the individual which consists in not being controlled by circumstances but controlling and conquering them, so we rightly recognize in every people or group a character which manifests itself in an artist or other remarkable man. And when we come to speak of worthy artists like Memling, Israel van Meckenen, Lucas van Leyden, Quentin Massys and others, we shall deal with them chiefly in this way.[25] They keep within their local circle, and it is our duty as far as possible to reject foreign influences on their leading characteristics. But now come Scorel, and later Heemskerk and others, who developed their talents in Italy, but nonetheless cannot deny that they are Netherlanders. Here the example of Leonardo da Vinci, Correggio, Titian and Michelangelo is felt, but the Netherlander remains a Netherlander, indeed, his national characteristics are so dominant, that in the end he shuts himself in his magic circle and rejects all foreign culture. So Rembrandt practised the highest gifts of the artist using only the material and

occasions of his immediate surroundings, without ever being in the slightest aware that there had ever been Greeks and Romans in the world.[26]

If we want to succeed in this proposed account, we must go to the upper Rhine, and there, as well as in Schwabia, Franconia and Bavaria, seek to penetrate the qualities and peculiarities of the upper German School. Here too it would be our most eminent duty to bring out the difference, indeed the opposition, between the two schools, so as to make the one value the other, and the remarkable men of each recognize each other, not denying each other's advances, and whatever good and noble may emerge from shared feelings. On these lines we shall happily honour the German art of the fifteenth and sixteenth centuries, and the froth of exaggerated praise which is already disgusting to expert and amateur alike, will slowly disappear. Then we can safely look still further east and south, and join willingly with neighbours and companions.[27]

NOTES

1. The collection of Early German and Netherlandish painting formed by the brothers Sulpiz, and especially Melchior Boisserée, from about 1803, later became the basis of the collection of the art of this period in the Munich Alte Pinakothek. Goethe learned of the collection in 1808, but did not visit it until 1814. It remained in Cologne until 1809.

2. Johann Baptist Bertram (1776-1841), lawyer, and early friend of Sulpiz Boisserée.

3. Cologne was under French rule from 1800, and the ancient university was replaced in 1805 by an *École secondaire communale de premier degré*. Goethe has in mind the propagandist for Romanticism, Friedrich Schlegel, who taught there in 1806 and 1807.

4. See 'On German Architecture', 1823, above, pp. 118-23.

5. Io, who bore Zeus' child Epalus, was nonetheless called a virgin (Ovid, *Metamorphoses*, I, vii).

6. Susdal is a town N. E. of Moscow, from which Goethe had received four ikons in 1814 (see H. Wahl, in *Goethe*, X, 1947).

7. The so-called Dioscuri, now on the Piazza del Quirinale in Rome, see above, pp. 96-8.

8. Séroux d'Agincourt, *Histoire de l'art par les monuments depuis sa décadence au IV siècle, jusqu'à son renouvellement au XVI siècle* (1810-1823). Goethe had met d'Agincourt in Italy, and he was using his book enthusiastically in January 1816, when he wrote to Sulpiz Boisserée that he treasured it 'because it instructs me greatly, and I curse it because it destroys my imagination'. His account of the bronze doors of *S. Paolo fuori le mura*, for example, depends on Vol. IV, pls. xiii-xx (see P. Schweinfurth, 'Goethe und Séroux d'Agincourt', *Revue de littérature comparée* XII, 1932).

9. i.e. Colonia Agrippina = Cologne. Agrippina was the daughter of Germanicus.

10. The legend of the founding of St Gereon in Cologne by St Helen, the mother of Constantine (d. 326) has recently been substantiated (A. von Gerkan, *Der Urbau von St Gereon in Köln*, 1952).

11. Goethe is thinking of the emigration from France occasioned by the Revolution of 1789.

12. The St Bartholomew massacre of 2000 Huguenots took place in Paris on the night of August 24/5 1572; the September massacre of some 7000 Royalists took place in Paris in 1792.

13. The picture, now in the Alte Pinakothek in Munich, was painted in Cologne at the beginning of the fifteenth century. Goethe's account is based on notes supplied by Sulpiz Boisserée.

14. The Altarpiece from Kloster Heisterbach, by a follower of Stefan Lochner (d. 1461), and now in Munich. Boisserée, in a letter to Friedrich Schlegel of February 1811, also stressed the influence of sculpture and sculptural decoration on the painting (M. Boisserée, *Sulpiz Boisserée* I, 1862, pp. 100 f.).

15. The reference was first made by F. Schlegel in *Europa*, 1804 (*Aesthetic and Miscellaneous Works*, 1849, p. 139).

16. They came to Cologne Cathedral in 1164 as a gift from Frederick Barbarossa, the conqueror of Milan, and made the city a major place of pilgrimage.

17. The name, Meister Wilhelm von Köln, was first published by J. D. Fiorillo (*Geschichte der zeichnenden Künste in Deutschland* . . . I, 1815, pp. 417 f.); the *Dombild*, now attributed to Lochner and dated from the 1440s, was recovered for the Cathedral by Biosserée in 1810, and attributed to Meister Wilhelm in his letter to Schlegel of February 1811, in which he also cited the Limburg Chronicle of 1380 where Wilhelm was reported to be a supreme portraitist. Goethe saw the *Dombild* in June 1815.

18. Goethe is referring to an article by Ferdinand Wallraf in this periodical for 1816, which had been reported to him by Boisserée in December (M. Boisserée, *op. cit.* II, p. 91).

19. This date was a misinterpretation by Boisserée of a mason's mark on the floor of the *Annunciation* panel. Jan van Eyck's dates are c. 1390-1441.

20. Goethe had seen no works by van Eyck himself, but he almost certainly knew the account of the Ghent Altarpiece published by F. Schlegel in 1804 (see note 15 pp. 38 f.). The following account is based entirely on his enthusiasm for the *Altarpiece of the Three Kings* in the Boisserée collection (now Munich, Alte Pinakothek), which is now recognized as a work of Rogier van der Weyden of about 1460. He was ecstatic about the picture, which he saw in 1814 and 1815, and said 'there is van Eyck who paints a picture which is worth more than all my works put together' (cf. Robson-Scott, *op. cit.*, pp. 190-1, 200).

21. Vasari, in his chapter on the technique of oil painting (1550), attributed its invention to van Eyck, but was more cautious in his *Life of Antonello da Messina*.

22. *St Luke painting the Madonna*, also from the workshop of Rogier van der Weyden (Munich, Alte Pinakothek).

23. A Collection of plates: *Sammlung altnieder- und oberdeutscher Gemälde der Brüder Boisserée und Bertram, lithographiert von I. N. Strixner*, was issued between 1821 and 1840.

24. The work of Peter Epp and Christian Philipp Köster (1784-1851) was described

in some detail by Boisserée in a letter to Goethe of October 1815 (M. Boisserée, *op. cit.* II, p. 71).

25. Works attributed to all these artists were in the Boisserée collection (E. Firmenich-Richartz, *Die Brüder Boisserée* I, 1961, pp. 448 ff.).

26. Goethe is repeating the views of seventeenth- and eighteenth-century writers on Rembrandt, which discounted the considerable effect of Italian Renaissance art on the painter (see K. Clark, *Rembrandt and the Italian Renaissance,* 1966).

27. Goethe never returned to the discussion of the upper German School, despite the urging of Boisserée, who supplied him with material (M. Boisserée, *op. cit.* II, pp. 120 ff.). An accident prevented Goethe's planned third visit to Heidelberg in July 1816.

The Triumph of Caesar, painted by Mantegna
[*Kunst und Altertum* IV, i, ii, 1823]

The Master's art in general

In the works of this remarkable artist and especially in the *Triumph of Caesar*, the major work which we are about to discuss, we feel a contradiction which at first sight seems irresolvable.

First of all we see that he strove after what we call style, after a general canon of proportions in the forms, for although some of his proportions are too long and the forms too meagre, there is nonetheless a generally strong, bold harmony between men and animals, and no less among the accessories, costumes, weapons and imaginary equipment. This convinces us that he studied the Antique, and we recognize that he was at home in the ancient world and steeped himself in it.

But he also succeeded in conveying the most immediate and individual naturalness in the representation of a great variety of figures and characters. He can depict men as they live and have their being, with all their merits and shortcomings, as they loiter in the market-place or join in processions, or throng together: every age and temperament is presented in all its particularity so that, if at first we are aware of the aim of a general idea, we soon see that the most particular, the most natural and the most common-place have also been caught and rendered, not as subsidiary to, but embodied in the higher ideal.

Biography

This achievement, which seems almost impossible, can only be explained by the events of Mantegna's life. The young Mantegna, one of many pupils of Francesco Squarcione, an outstanding painter of that period, showed his promise early, and became such a favourite that Squarcione not only gave him the finest and most rigorous training, but adopted him as a son, and declared that he wanted to work with and through Mantegna's work.[1]

But when, later, this pupil, who had been so fortunate in his training, met the Bellini family, they at once recognized and valued

the man as well as the artist, so much so that he became engaged to the daughter of Jacopo, the sister of Giovanni and Gentile. The jealous affection of his first master and protector now turned to unbounded hatred, his support became persecution, and his praise abuse.

But Squarcione was among those fifteenth-century artists who recognized the high value of antique art; he himself worked in its idiom as far as he was able, and he directed his pupils unswervingly towards it. It was his view that it is foolishness to look with our own eyes for beauty, sublimity or magnificence in nature, and to want to wrest them from her with our own efforts, when our great Greek ancestors were already in command of what is noblest and most worthy of representation, and when we can take the already purified gold from their refineries: what we would otherwise lament as the painful spoil of a wasted life scratched laboriously from the rubbish and rubble of nature.

The noble mind of that most gifted young man, Mantegna, persevered in this doctrine, to his own honour and to the delight of his master. But when master and pupil became enemies, Squarcione forgot his leadership and his aspirations, his teaching and instruction; and he now contradicted himself by blaming what the youth had achieved and was achieving on his advice and at his behest; and he joined that public which tries to bring an artist down to their level so that they may judge him. They demand naturalness and verisimilitude so that they may have some point of reference, not a high, spiritual one, but a commonplace external one which always wants to contrast and compare the original with the copy. Mantegna was now worthless; he could produce – so the story went – nothing lifelike; his most magnificent works were criticized as wooden or like stone, rigid and stiff. The noble artist, still at the height of his powers, grew angry, for he knew full well that nature was only the more natural, and his artist's vision only the more understanding from the standpoint of the Antique. He felt adequate to it, and risked swimming in its swell. From that moment onwards he decked out his paintings with the portraits of many of his fellow-townsmen; he immortalized a friend as an elder and his mistress as a delightful young girl, and thus gave the most enjoyable memorial to noble and worthy people; nor did he disdain to represent the extraordinary, the notorious, the strangely-formed, even, as the final contrast, the malformed.

We sense these two elements in his works not separately, but

inextricably intertwined. The high and ideal is manifest in the general layout, in the value and dignity of the whole; here is revealed the meaning and intention, the basis and the grasp of the subject. On the other hand, nature also forces her way in with a primitive violence, and as the mountain torrent finds its way between the rocks and crashes down with the same force with which it reached these falls, so it is here. The study of the Antique provides the form, but nature the skill, and, in the end, the life.

But since even the greatest talent, which suffers a division in its formation in that it found both contradictory opportunities and stimuli, is scarcely able to balance them, to reconcile these opposites, that feeling to which we alluded at the beginning, which comes over us at the sight of Mantegna's works, is perhaps provoked by the fact that this contradiction is not fully resolved. It was, however, perhaps the highest conflict that ever faced an artist, for he was called upon to undertake this adventure at a time when a developing high art was not yet able to give a clear account of its aims and capacities.

This double life which characterizes Mantegna's work so remarkably, and of which so much more might be said, is manifested particularly in his *Triumph of Caesar*, where he deployed all his great abilities to the full.

An adequate general idea of this work was given by Andrea Andreani towards the end of the sixteenth century in his woodcut reproductions of Mantegna's nine canvases, on nine large sheets, which spread the knowledge and enjoyment of them far more widely. We have them before us and will describe them in order.[2]

1. Trumpets and horns announcing war; musicians in front, their cheeks round as apples. Behind them press soldiers carrying emblems of field, war and fortune on long poles. The bust of Roma in front, the patron goddess Juno and the peacock proper to her, cornucopiae with fruit- and flower-baskets,[3] which wave above streaming pennants and swaying pictures. Between them torches flaming and steaming in the air honour the elements and stimulate the senses.

Other warriors, prevented from marching forward, stand still to resist the throng pressing immediately behind them. Each pair hold erect long, widely separated poles, on which, here and there, are stretched long and narrow paintings. These pictures, divided

up into sections, show what brought about this exuberant triumphal procession.

Fortified towns besieged by armies, stormed with siege-engines, taken, burned, destroyed; prisoners led away from defeat to death. It is the perfect symphonic introduction, the overture to a grand opera.

2. Here now is the greatest and most immediate consequence of an unconditional victory. Captured gods abandoning the temple which cannot any longer be protected. Life-size statues of Jupiter and Juno on carts drawn by two horses, a colossal bust of Cybele on a cart with a single horse, then a smaller, portable divinity in the arms of a servant. The background piles up with carriage equipment, models of temples, splendid architectural fragments, siege-engines, rams and catapults. But immediately behind is a quite boundless variety of weapons of all types, gathered and arranged with great and earnest taste. Only in the next frame,

3. however is the greatest quantity brought in. We see every sort of treasure carried by strong youths: squat urns overflowing with coins, and vases and jugs on the same litters; these weigh heavily enough on their shoulders, but each carries besides some vessel or important object. Groups of this sort continue onto the next sheet.

4. There are many varieties of vessel, but their chief function is to carry silver coins. Above this crowd, exceptionally long trumpets stretch up into the air, and from them streamers flutter down bearing the inscriptions: To the triumphant demi-god Julius Caesar! Animals adorned for sacrifice, pretty camellias, and priests who seem like butchers.

5. (Fig. 12) Four elephants, the foremost wholly visible, the three others foreshortened; flowers and baskets of fruit on their heads, like wreaths. On their backs tall, flaming candelabra, handsome youths reaching gracefully up to place aromatic wood in the flames, others leading the elephants, others occupied in other things.

6. The monolithic mass of these enormous animals is followed by diversified movement; the most precious booty is now brought on. The bearers take a different direction, stepping into the picture behind the elephants. But what are they carrying? Probably pure gold, gold coins in small containers, small vases and vessels. Behind them comes booty of even greater value and importance, the booty of booties which implies all that has gone before. It is the armour of the conquered kings and heroes; each of them has his own trophy.

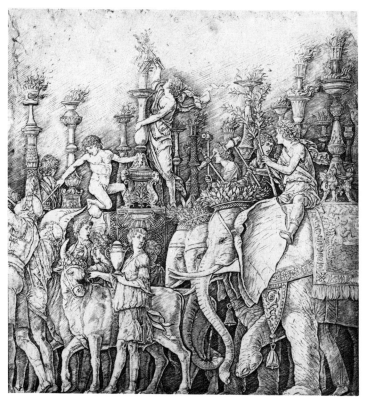

12 A. Andreani after Mantegna, *Triumph of Caesar*. Nr.7. Woodcut. British Museum.

The fortitude and valour of the conquered princes is shown by the fact that the bearers can hardly lift the weight on their poles; they carry them close to the ground or even set them down to rest for a moment before setting off again, refreshed.

7. (Fig. 13) They are less crowded together, and behind them come the prisoners; they have no badges to distinguish them, only their personal dignity. Noble matrons come first, with their grown-up daughters. Next, on the side of the spectator, comes a little lady of eight or ten years old, by the side of her mother, and as prettily dressed as if she was at the most solemn festival. Some admirable, dignified men in long robes follow them; serious, unhumbled, they are led on by a higher destiny. Thus in the following group a tall well-formed and respectably-dressed man stands out, looking behind him with a fierce, almost grotesque expression that we do not understand. We let him pass by, for he is followed by a group of attractive women. A young bride in the fullness of youth, shown full-face – we say a bride, for she deserves to be so called, even without a garland in her hair – stands towards the rear, partly hidden from the spectator by an older woman encumbered with children, with an infant in her right arm, and with her left hand steadying a small boy who is holding one foot up. He is crying because he wants to be carried.[4] An older woman, perhaps his grandmother, bends down and tries in vain to soothe him.

The artist earns the highest praise for not introducing any war-heroes or army commanders as prisoners. They no longer exist; their empty armour has been carried past. But the embodiments of the state, the old aristocratic families, the able statesmen, the wealthy and productive citizens, are brought into the Triumph, and everything has then been said: some are killed and the others suffer for it.

Between this and the following picture we see why the stately prisoner looks back so fiercely. Deformed fools and jesters creep up and mock the unfortunate noblemen; but this is too unfamiliar to this man's dignity; he cannot let it pass unnoticed; if he cannot complain out loud, he can at least pull a face.

8. But the nobleman seems to be hurt in an even more abusive way, for a band of musicians is following, composed of the most varied types: a good-looking, even pretty youth in a long, almost feminine dress, sings to a lyre and seems to be jumping about and gesticulating. No triumphal procession is complete without one: his role was to make strange gestures, sing bantering songs, and to

13 A. Mantegna, *Cartoon of the Prisoners*, c.1480/90. Tempera, 274×274cm.
Hampton Court, Royal Collection. Reproduced by gracious permission of
Her Majesty the Queen.

mock the conquered captives mischievously. The jesters point to him and seem to comment on his words with their foolish gestures, which may well irritate the nobleman.

And that we are not dealing with serious music can be seen at once from the next figure, for immediately behind comes a lanky, sheepskin-coated, high-capped bagpiper, and some boys with a tambourine seem to increase the uproar. But some soldiers looking back and other hints show us that the high point of the procession is about to follow.

9. And now, on an enormous but appropriately and tastefully decorated cart, Julius Caesar himself appears, and a handsome youth holds out a sort of standard with the words 'Veni, Vidi, Vici' towards him. This sheet is so crowded that we can only look anxiously at the putti holding victory-branches between the horses and the wheels, for in reality they must have been crushed long since. It would nevertheless have been better not to have represented such a crowd in a single picture, for it will never be grasped by the eye, and it confuses the understanding.

10. Now a tenth picture is of the greatest importance to us, for a feeling that the procession is not complete strikes everyone who arranges the nine engravings in order, one after the other. Not only do we find the triumphal car abrupt, but behind it we even see a figure cut by the frame. The eye demands some echo of the main figure, or at least some figures to approach him, and cover his rear.[5]

We are helped now by an autograph engraving (Fig. 14), very carefully executed and among the best works of the master in this medium.[6] A troop of people, old men and young, all with strongly-marked characteristics. It cannot be assumed that this is the Senate; the Senate would have received the procession at a suitable place with a deputation, but even this deputation would not have approached it more closely than was necessary to turn round and step ahead of it and present the newcomers to the assembled Fathers.

But we must leave this investigation to the classical scholars: we in our way can only look attentively at the engraving, for, like every excellent work of art, it speaks for itself. So let us say at once that it is a body of teachers, who willingly pay homage to the victorious military, for from them alone can they expect safety and patronage. Mantegna distributed the providers in the Triumph as bearers, bringers, celebrators, praisers, and as spectators in the

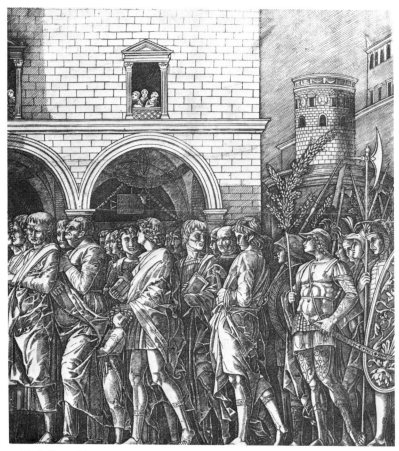

14 Workshop of A. Mantegna, *Procession*. Engraving. British Museum.

background. But now the teaching body is pleased to attend the Conqueror, for through him the state and its culture have again been safeguarded.[7]

From the point of view of variety of character, this engraving is one of the most valuable we know, and Mantegna had certainly studied this aspect in the School of Padua.

In front, in the first row, are three men of middle age in long robes with intricate folds, some with serious, some with cheerful features, as befits scholars and teachers. In the second row an old, large, comfortably corpulent, powerful man is prominent, stepping forcefully out behind all the vast confusion of the Triumph. His smooth chin reveals a fleshy neck, his hair is cut short, he folds his hands very easily over his chest and paunch and stands out, even after all his important predecessors. I have never seen anyone living to compare with him, except Gottsched,[8] who in a similar situation and dress would have walked in just the same way: he looks the perfect pillar of a dogmatic-didactic establishment. His colleagues are similarly clean-shaven and shorn, even if their hair is longer. The first, somewhat more serious and morose, has rather the air of a master of dialectic. There are six of these teachers, who seem to carry everything in their heads; the pupils, on the other hand, are not only distinguished by their younger and slighter figures, but also by the books they carry in their hands, to show that they like to learn by reading as well as by listening.

Between these older and younger men a boy of about eight is hemmed in, a representative of the first years of school, when the child wants to join in and take part; a pen-case hangs at his side to show that he has started his school career, in which many unpleasant things await the newcomer. It is impossible to think of anything more remarkable or charmingly natural than this little figure in such a place.

The teachers go straight ahead; the pupils talk among themselves.

Now, however, the military make a suitable conclusion to the whole, for it is, first and last, through them that the splendour of empire must be won abroad and maintained at home. Mantegna satisfies this vast need with only two figures: a youngish warrior, carrying an olive branch and looking upwards, leaves us in doubt as to whether he is glad at the victory or sad at the end of hostilities; on the other hand, an old, worn-out soldier, heavily-armed to represent the long-drawn-out war, shows only too clearly that this

Triumph is tedious to him, and he would think himself lucky to be able to rest somewhere this evening.

The background of this engraving, instead of the open prospect we saw in most of them hitherto, closes in like the crowd; on the right we see a palace, to the left a tower and walls. The proximity of the city gate may be suggested here, given that we are really at the end, and that now the whole procession has entered the city and is enclosed within it.

If this suggestion should seem to contradict the backgrounds of the previous sheets, in that landscape prospects, sky, ruins on hills as well as temples and palaces can be seen there, this allows us to assume that the artist here intended the hills of Rome, and represented them with the buildings and ruins to be found there in his own day. This interpretation is the more convincing in that once a palace, a prison, a bridge that may do service as an aqueduct, a high obelisk did indeed stand there, and must be assumed to have existed on civic soil. Yet we end here, or we shall go on indefinitely, and still not express, with no matter how many words, the value of the engravings which we have briefly described.

[*Most of Part II of this essay is an account of the* Mantegna Cartoons *at Hampton Court, and their history, for which Goethe depended chiefly on notes supplied by G. H. Noehden, the translator of the Leonardo essay* (pp. 166-95). *I have not included it.*]

Mantegna's own engravings in relation to the Triumph
Mantegna's engravings are prized for their character and masterly execution, although not in the sense of modern engravings. Bartsch lists twenty-seven, including copies; in England, according to Noehden, there are seventeen, of which only four relate to the *Triumph*, numbers 5, 6, and 7; 6 is double, in reverse, and has a pilaster on it.

A connoisseur still living in England is convinced that no more than these four plates appeared, and we, too, think that Mantegna never engraved all nine. We are not at all disturbed by Strutt's account in his Biographical Dictionary of Engravers, vol. II, p. 121:[9]

The Triumph of Julius Caesar *engraved from his own painting, on nine middling-sized plates, nearly square. A complete set of these engravings is exceedingly rare. They were copied in chiaro-scuro by Andrea Andreani.*

And if Baldinucci in his history of engraving says Mantegna engraved his *Triumph of Caesar* while he was staying in Rome, this should

in no way make us waver in our opinion, for we can easily imagine that this extraordinary artist made his preparatory studies on copper, and probably also in drawings which are lost or unknown, and on his return to Mantua executed the whole in this wonderful way.[10]

And now we must give the reasons, based on the internal characteristics of the art itself, which allow us vigorously to refute this account. By chance and the interest of friends, numbers 5 and 6 (Bartsch 12, 13) by Mantegna himself lie before us beside Andreani's cuts. Without trying to express the differences in detail with words, we can say in general that something quite original – primary – emerges from the copper engravings; we see there the great conception of a master who knows at once what he wants, and immediately represents everything that is necessary in the first sketch and allows the rest to follow. But as he has to think of carrying it out and on a large scale, it is wonderful to observe and to compare how he proceeded here. Those first beginnings are completely innocent, naïve though rich, the figures decorative, indeed, in a certain way casual, and each expressive in the highest sense. The others however, made after the paintings, are developed, powerful, the figures strong, their action and their expression artistic, sometimes, indeed, artificial. We are amazed at the flexibility of the master, for all his perseverance; here everything is the same yet different; the single-mindedness and the rule of composition are completely the same, the modifications are never botched or uncertain, but another, higher aim is successfully undertaken.

Hence the first engravings have an incomparable ease, for they came direct from the soul of the great master, apparently without the idea of any future use. We might compare them with an amiable, simple girl, whom any young man would be happy to woo; in the executed designs we would find the same girl, but now mature and a newly-wed. Where at first she was simply dressed and busy with her domestic duties, we now find her in all the finery with which a lover likes to deck his love. We see her coming out into the world at festivals and dances; we miss her earlier personality while we admire her present one. And yet we should not miss innocence if it is sacrificed to higher purposes.

We hope every true friend of art will have this pleasure, and that it will convince him of our argument.

We have been strengthened in this conviction by what Dr Noehden says of Mantegna's third plate, which is not in Bartsch, in

comparison with Andreani's plate 7: 'If changes can be seen between the two other plates, Nos. 5 and 6, and the paintings, they are still more marked in this one. The noble captives are shown, but the lovable group of the mother and child and the older woman is not there at all, although it was later restored to the composition by the artist. Furthermore, an ordinary window is shown in the copper engraving, with three people looking out of it; in the painting it is a wide window with a grille, like the window of a prison, behind which stand several people who might be taken for prisoners. We regard this as a reference to the procession which is passing, in which changes have also been made.'

And we, for our part, see an important intensification of the subject, and are sure that this engraving, like the two others, precedes the painting.

Vasari's account, with notes on it
Vasari praises this work very highly, as follows:
For the same marquis Andrea painted the Triumph of Caesar in the palace of S. Sebastiano at Mantua, and this is the best thing which he ever did. It shows in an excellent arrangement the beauty and decorations of the chariot, a man cursing the victor, the relations, perfumes, incense, sacrifices, priests, bulls crowned for sacrifice, prisoners, booty taken by the soldiers, the array of squadrons, elephants, spoils, victories, cities and fortresses represented in various cars, with a quantity of trophies on spears and arms for the head and back, coiffures, ornaments and vases without number. Among the spectators is a woman holding by the hand a child, who has run a thorn into his foot, and he is weeping and showing it to his mother very gracefully and naturally.** Andrea, as I may have intimated elsewhere, had the admirable idea in this work of placing the plane on which the figures stood higher than the point of view, and while showing the feet of those in the foreground, he concealed those of the figures farther back, as the nature of the point of view demanded. The same method is applied to the spoils, vases and the other implements and ornaments.*[11]

We have indicated with an asterisk a gap which we now wish to fill. Vasari believes that the youth standing just in front of the triumphal car is a soldier who is trying to humiliate the victor at the centre of this magnificent procession with contemptuous abuse, a species of bravado which is certainly known to us from Antiquity. But we would interpret the incident differently: the youth standing in front of the car holds on a pole, which is also a standard, a wreath with the words 'Veni, Vidi, Vici'; he may well be there to crown Caesar at the end. For if we have earlier seen Caesar named on

many ribbons and banners, on cornets and trumpets and on all types of picture, so as to show that this festival refers to him, here at the end his praiseworthy expeditiousness is proclaimed and held up before him by a joyful supporter. If we look more closely, there can be no doubt about it.

The double asterisk also denotes a difference of opinion with Vasari. Since there was no sign of Vasari's thorn in Andreani's plate No. 7, we asked Dr Noehden in London how far the painting could inform us about this. He very kindly hurried to Hampton Court with this and other questions and, after a close examination of the picture, communicated the following:

On the left side of the mother is a boy (perhaps three years old), who is trying to climb up her. He raises himself on the toes of his right foot, his right hand grasps his mother's dress; she stretches her left hand down to him, and has grasped his left arm with it, to help him up. The boy's left foot is raised off the ground, apparently as the simple consequence of the upstretched body. I would never have guessed that there was a thorn in this foot, or that the foot was hurt in any other way, for the picture, if my eyes are not remarkably deceived, certainly shows nothing of the sort. Certainly the leg is drawn up stiffly, as would suit an injured foot, but this agrees just as well with the body's stretching upwards. The completely unpained expression of the boy's face, which looks up cheerfully, if demandingly, and the calm downward look of the mother seem to me to contradict the supposed injury entirely. One ought to be able to detect a trace of the injury in the foot itself, for example, a drop of blood, but there is nothing of the sort to be seen. It is impossible that the artist, if he wanted to impress this image on the spectator, could have left it so doubtful and mysterious. To be quite free of prejudice, I asked the guide who has for several years shown the rooms and paintings at Hampton Court Palace, a quite ordinary and ignorant man, whether he had ever noticed an injured foot, or a thorn-prick on the boy. I wanted to see what impression the subject had on a common eye and an ordinary mind. 'No,' was the answer, 'there is nothing like that to be seen: it cannot be, the boy looks far too cheerful and happy to be thought of as hurt.' Over the left arm of the mother, as over the right, is thrown a red cloth or shawl, and the left breast is also quite uncovered. Behind the boy, to the left of the mother, an elderly woman stands bending over, with a red veil over her head. I take her to be the grandmother of the boy, for she is so preoccupied with him. In her face, too, there is nothing like pity, which probably would have been expressed, if her grandson were suffering from a thorn-prick. In her right hand she seems to be holding the boy's headgear (a little hat or a cap), and with her left she is touching his head.

General observation and criticism of a false method of describing from the wrong end. If we look with an alert eye at the whole passage in which Vasari hoped to inform us about this *Triumph*, we can at once feel the

essential shortcomings of his mode of proceeding: it produces nothing but empty confusion in our minds, and hardly allows us to guess that those details were arranged in a well thought-out sequence. This was already overlooked by Vasari at the outset, in that he started from the end and laid most emphasis on the beautiful decorations of the triumphal car; thus he is prevented from allowing the crowded but separate groups in front to follow each other in order, but rather he picks out striking subjects arbitrarily, and hence creates an irreducible tangle.

But we do not want to criticize him on this account, since he is describing pictures in front of him which he thought all could see. From this point of view he could not have intended to re-create them for those who could not see them, or for a posterity to whom they were lost.

It is just the same with the Ancients, who often drive us to distraction: how otherwise would Pausanius have acted had he known it would be his task to console us with words for the loss of marvellous works of art![12] The Ancients spoke as witnesses to witnesses, and thus they did not need many words. We owe it to the self-conscious rhetorical devices of Philostratus that we dare form a clear idea of precious pictures that are now lost.[13]

Emendation of Bartsch's description

Bartsch, in his *Peintre-Graveur* , vol. xiii, p. 234, says of Mantegna's engravings: 'The Roman Senate accompanies a Triumph. The Senators process towards the right, they are followed by several warriors, seen on the left, one of whom, holding a halberd in his left hand and an enormous shield on his right arm, is particularly striking. The background reveals a building on the right, and to the left a round tower. Mantegna engraved this plate after a drawing, which he probably wanted to use for his *Triumph of Caesar*, but did not.'

Our account of this plate can be seen in the first part of our essay on Mantegna, and so we will not repeat our conviction on this occasion, but only register the thanks we owe to our immortal Bartsch.

This excellent man has made it possible for us to acquire the most important and varied information without much effort; and we can see him, from another point of view, as our predecessor, whom we must ourselves help here and there, especially with the subject-matter. For it is one of the greatest merits of engraving, that it

acquaints us with the thought of so many artists, and even if it teaches us to do without colour, it shows us clearly the intellectual merit of invention.

Schwerdgeburth's drawing

Now, to allow ourselves as well as other interested amateurs the full enjoyment of the whole series, we have commissioned our skilful and experienced engraver Schwerdgeburth to make this appendix, the same size as Andreani's cuts, and in a style of drawing imitating them in outline and shading, and also in reverse, so that the figures move towards the left. We lay this sheet immediately behind Caesar's car, so that when the ten sheets are seen in a row, it provides a charming display for the intelligent connoisseur and dilettante, in that what was intended by a most remarkable man over three hundred years ago, is now visible for the first time.

NOTES

1. Francesco Squarcione (1397-1474) adopted Andrea Mantegna (1431-1506) in 1441.
2. Goethe had acquired the suite of nine woodcuts by Andreani (1599) in June 1820 (Schuchardt, I, No. 406). The first draft of his essay is dated October 1820.
3. There is only one figure carrying a cornucopia in the print.
4. Here Goethe disagrees with Vasari, whose *Life of Mantegna* provided him with many details of the prints. See above, pp. 162-4.
5. In fact, Mantegna's successor at Mantua, Lorenzo Costa, was commissioned to complete the series.
6. Bartsch II, now regarded as a workshop production. For Goethe's copy by K. A. Schwerdgeburth (1785-1878) (Schuchardt, I, p. 45), see this page.
7. Goethe's interpretation of this subject has not had much following. See Andrew Martindale's forthcoming *Andrea Mantegna's Triumph of Caesar*.
8. J. C. Gottsched (1700-1766), Professor of Poetry, Logic and Metaphysics at Leipzig. See *Dichtung und Wahrheit*, Book 7.
9. J. Strutt, *A Biographical Dictionary of Engravers*, II, 1786, p. 121.
10. F. Baldinucci, *Cominciamento e progresso dell'arte d'intagliare in rame*, 2nd ed. 1767. Work on the *Triumph* was, however, begun before Mantegna's visit to Rome in 1488. The engravings after it are now given to Mantegna's school, but Goethe saw correctly that they were not made from the Cartoons, but from lost drawings.
11. G. Vasari, *The Lives of the Painters, Sculptors and Architects*, ed. Gaunt, 1963, II, pp. 105-6.
12. Pausanius wrote a guide to Greece in the second century A.D., in which is a famous account of paintings by Philostratus at Delphi. Goethe discussed the paintings at length in the *Jenaische Allgemeine Literatur-Zeitung*, in 1804.
13. Goethe discussed the *Pictures* of the Sophist Philostratus (second century A.D.) in *Kunst und Altertum* for 1818.

Observations on Leonardo da Vinci's celebrated picture of The Last Supper

[*Kunst und Altertum* I, iii, 1817][1]

The picture, which is the subject of these remarks, is known to all that have ever heard the name of art pronounced. It has almost ceased to exist, in its own substance, but is still an object of wonder, from the recollection that has remained. To this recollection a degree of durability has been given by an admirable composition of mosaic, calculated to transmit to posterity a noble copy of the original. This work was undertaken by Joseph Bossi,[2] of whom it is proposed to say a few words in the following pages, in which some observations will likewise be offered concerning the picture of Leonardo da Vinci itself.

Joseph Bossi was born at Milan in the year 1777. Being endowed by nature with exquisite talents, which were developed at an early period, and possessed of a singular inclination, and a happy disposition, for the fine arts, he formed himself, as appears, partly by the resources of his own genius, and partly by the study of Leonardo da Vinci's works. We find that, after a stay of six years at Rome, being returned to his native city, he was placed at the head of an academy of arts, which was to be new modelled. Being equally fitted for reflection, and for executing his conceptions, he had made himself master of the principles and the history of the arts, and was thence qualified to engage in the difficult task of restoring, by a well-considered copy, the celebrated picture of The Lord's Supper, by Leonardo da Vinci, which was to be transferred on a table of mosaick and thus preserved for future ages. In the book, quoted below,[3] he describes the method by which he proceeded, and it is our design to present a concise view of his exertions.

The book in question is, generally, well received by those acquainted with the arts: and to those who, like myself, live at Weimar, an opportunity is afforded of judging of it with some

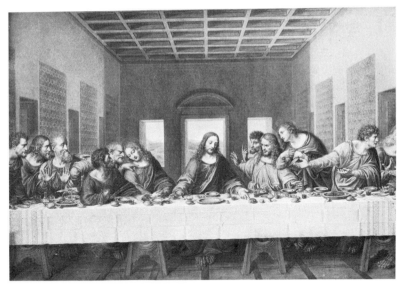

15 André Dutertre after Leonardo da Vinci, *The Last Supper*, 1789-94. ?Graphite, pen and ink overpainted with brownish wash, 61 × 112cm. Oxford, Ashmolean Museum.

accuracy, on account of the following circumstance. Bossi, not being able to make the original painting (which was almost totally effaced and destroyed) the foundation of his work, was compelled carefully to study the existing copies of it. He traced, or drew upon transparent paper, from three of them, the heads, and partly also the hands, endeavouring to penetrate, as much as possible, into the spirit of his great master, and to guess at his intentions. By means of his judgement, taste and feeling, he, at last, completed his labour, and produced a picture, after which the mosaick alluded to was ultimately composed. Those tracings, or transparent drawings, are, at present, all to be found at Weimar, being an acquisition made by His Royal Highness the Grand Duke, during his last journey into Lombardy. Of what value they are will appear in the sequel of this treatise.

SOME ACCOUNT OF THE LIFE OF LEONARDO

Vinci, a castle and manor in the Val d'Arno, near Florence, acknowledged for its owner, about the middle of the fifteenth century, a gentleman, by the name of Pierro, who had a natural son by a mother, whose name has remained unknown.[4] This child, called Leonardo, even when a boy, showed himself endowed with every quality befitting a person of noble birth; he possessed agreeable and pleasing manners, strength and activity of body, and excelled in all manly excercises. But, above all, he discovered not only a passion, but also an extraordinary aptitude for the fine arts; for which reason he was placed at Florence under the tuition of *Verocchio*, a man of much knowledge and judgement, and deeply versed in the theory of his art, whom Leonardo quickly surpassed in the practical part, so that the master not only felt mortified, but was almost disgusted with painting.

Art stood, at that period, upon a point, where any great genius might step forward with success, and shine in all the splendour of its powers. It had, for more than two centuries, emerged from the meagre pedantry of the Byzantine School, and, by the imitation of nature, and the expression of pious and moral feelings, at once commenced a new life. Artists wrought in a superior manner, though themselves unconscious of their merit, and they succeeded in what genius inspired, or where their feelings directed and their taste guided them; but none of them was able to account to himself for the excellence which he produced, or the defects that belonged to him, though he might be sensible of their existence.

Truth and *Nature* were the objects of all; but there was wanting that unity and harmony, which is the very life and soul of the art. You may meet with the most exquisite talents, and yet not find any performance of these days, perfectly conceived, and thoroughly digested. Much of what you see is adventitious, and foreign to the subject; nor do you as yet remark any established principles, by which those works were regulated.

At such a time it was that Leonardo came into the world, and as he found it easy with the abilities bestowed upon him to imitate nature, his penetrating mind soon began to be aware that behind the outside of objects, which he succeeded so well in copying, there still lay concealed many a secret, the knowledge of which it would be worth his utmost efforts to attain. He, therefore, set about enquiring into the laws of organick formation, the ground of proportion, the rules of perspective, the composition and colouring of his objects, the effect of light and shade in a given space; in short, he strove to compass all the requisites of art; but what above all he had at heart, was the variety of the human countenance, in which not only the permanent character of the mind, but also temporary emotion is presented to the eye. And this will be the point upon which, contemplating the Last Supper, we shall have chiefly to dwell.

THE PUBLICK WORKS OF LEONARDO

To whatever circumstances it was owing, we find, that Leonardo quitted Florence, and fixed his abode in Lombardy. There Lodovico Sforza, surnamed *il Moro*, had, after the death of his brother *Galeazzo Maria* (who was assassinated in the year 1477) first assumed a share, and, by degrees, the whole of the government of Milan, during the minority of the young duke, *Giovanni Galeazzo*, his nephew, which power he retained, undisputed, even with the increasing years of the latter, till he was ultimately, on the death of his nephew (in 1494), also invested with the title and emblems of sovreignty, and became the reigning duke of Milan. Lodovico was a most distinguished patron of the arts; and under his auspices, it seems Leonardo fully established himself at Milan, though perhaps he had gone there, at an earlier period. It appears that the first order he received from Lodovico was for an equestrian statue, in honour of his father, the duke *Francesco Sforza*, a prince of great merit. In the course of some years, the model of the horse was finished, and gained general approbation. But when, on some publick occasion,

it was made use of to adorn the representation, being considered as a most interesting object, it was unfortunately broken, and the artist was obliged to begin another, which was likewise completed. Soon after, the French invaded Italy, and this second model was destroyed by the enemy's soldiers, to whom it served as a mark to shoot at. Nothing remained of two works, upon which the labour of sixteen years had been consumed. In the one instance, a vain display of pomp, and in the other, the gross ignorance of a brutal multitude proved equally fatal; both of them causes, that have not unfrequently been hostile and destructive to the arts. We only notice, as it were, in passing, the battle of Anghiari, of which Leonardo drew a cartoon, in competition with Michael Angelo; and the picture of St Anne, in which the grandmother, mother and children, are skillfully grouped together, sitting lap in lap.[5]

THE LAST SUPPER

We now come to what is the particular object of our attention, The Last Supper of our Lord, which was painted upon the wall, in the convent *alle Grazie*, at Milan (Fig. 15). If the reader will please to take before him Morghen's print, it will enable him to understand our remarks, both in the whole, and in detail.[6]

The place, where the picture was painted, is first to be considered; for here the judgement of the artist appears to the greatest advantage. There is hardly a subject that could be fitter, and more becoming, for the refectory of a holy fraternity, than the parting meal, which was to be a sacred remembrance for all ages to come.

We have, in our travels, seen the refectory, several years ago, yet undestroyed. Opposite to the entrance, at the bottom, on the narrow side of the room, stood the Prior's table; on both sides of it, along the walls, the tables of the monks, raised, like the Prior's, a step above the ground; and now, when the stranger, that might enter the room, turned himself about, he saw, on the fourth wall, over the door, not very high, a fourth table, painted, at which Christ and his Disciples were seated, as if they formed part of the company. It must, at the hour of the meal, have been an interesting sight, to view the tables of the Prior and Christ, thus facing each other, as two counterparts, and the monks at their head, enclosed between them. For this reason, it was consonant with the judgement of the painter to take the tables of the monks as models; and there is no doubt, that the table-cloth, with its pleated folds, its stripes and figures, and even the knots, at the corners, was borrowed from the

laundry of the convent. Dishes, plates, cups, and other utensils, were, probably, likewise copied from those, which the monks made use of.

There was, consequently, no idea of imitating some ancient and uncertain costume. It would have been unsuitable, in the extreme, in this place, to lay the holy company on couches; on the contrary, it was to be assimilated to those present. Christ was to celebrate his last supper, among the Dominicans, at Milan.

In several other respects also was the picture calculated to produce a great effect. Being raised about ten feet above the ground, the thirteen figures, exceeding by nearly one half the natural size, occupy the space of twenty-eight feet, Parisian measure, in length. Two of them only, at the opposite ends of the table, are seen entire; the rest are half figures, but even here the artist derived an advantage from the necessity of his situation. Every moral expression appertains only to the upper part of the body; the feet are, in such cases, generally in the way. Here the artist produced eleven half figures, of which the thighs and knees are covered by the table and table-cloth, and the feet below are scarcely noticed, in their modest obscurity.

Transfer yourself into this place, and picture to your mind the decorous and undisturbed calm, which reigns in such a monkish refectory; then you will admire the artist who knew how to inspire into his work a powerful emotion and active life, and, while approximating to nature, as much as possible, at the same time, effected a contrast with the scenes of real existence, that immediately surrounded it.

The means of excitement, which he employed to agitate the holy and tranquil company, at table, are the words of the Master, *There is one among you that betrays me.* The words are uttered, and the whole company is thrown into consternation; but *he* inclines his head, with bent-down look, while the whole attitude, the motion of the arms, the hands, and everything, seems to repeat the inauspicious expressions, which silence itself conforms: *Verily, verily, there is one among you that betrays me.*

But, before we proceed any further, let us analyse one great expedient, whereby Leonardo chiefly enlivened his picture: it is the motion of the hands. This resource was obvious to an Italian. In this nation, the whole body is animated; every member, every limb participates in any expression of feeling, of passion, and even of thought. By a varied position and motion of the hands, the

Italian signifies: *What do I care! – Come! – This is a rogue – take care of him! – His life shall not be long! – This is the point! – Attend to this, ye that hear me!*

Such a national peculiarity could not but attract the notice of Leonardo, who was, in the highest degree, alive to everything, that appeared characteristick, and, in this particular the picture before us is strikingly distinguished, so that it is impossible, with this view, sufficiently to contemplate it. The countenance and action are in perfect unison, and there seems to be a co-operation of the parts, and, at the same time, a contrast, most admirably harmonized.

The figures, on both sides of our Lord, may be considered by *threes* together, and thus they appear, as if formed into *unities*, corresponding in a certain relation, with each other. Next to Christ, on the right hand, are *John, Judas* and *Peter*.

Peter, the farthest, when he has heard the words of the Lord, rises quickly, in conformity with his vehement character, behind *Judas*, who, terrified and looking upwards, leans over the table, holding the purse with his right hand, which is tightly compressed, but making, with his left, an unvoluntary convulsive motion, as if to say, *what is the matter, what is to happen?* Peter, in the mean time, has, with his left hand, grasped the right shoulder of *John*, who is bending towards him, and pointing to Christ, seem to signify to the beloved disciple, that he should ask, who is the traitor. Holding a knife in his right hand, he accidently, and without design, touches with the handle of it the side of Judas, by which the attitude of the latter, who is stooping forward, as if alarmed, and by his motion overturns a salt-cellar, is happily effected. This group may be regarded as the one first conceived in the picture; it is certainly the most perfect.[7]

While on the right hand, with a certain degree of emotion, immediate revenge seems to be threatened, horrour and detestation of the treachery manifest themselves on the left. *James* the elder draws back, from terrour spreads his arms, gazes, his head bent down, like one who imagines that he already sees with his eyes those dreadful things, which he hears with his ears. *Thomas* appears from behind his shoulder, and, advancing towards the Saviour, lifts up the forefinger of the right hand towards his forehead. *Philip*, the third of this group, completes it in a most pleasing manner; he is risen, and bending forward, towards the Master, lays the hands upon his breast, as if distinctly pronouncing: *Lord, I am not he – Thou knowest it – Thou seest my pure heart – I am not he!*

And now the three last figures on this side, afford new matter for contemplation. They are conversing together on the dire intelligence they have just received. *Matthew* turns his face, with an eager expression, to his two companions, on the left, while he extends his hands, with a quick motion, towards the Master; and thus unites this group, by an admirable contrivance, with the foregoing. *Thaddaeus* shows the utmost surprise, doubt, and suspicion; he has placed the left hand open on the table, and raised the right in such a manner, as if he were going to strike, with the back of it, into the left, a movement, which may sometimes by observed in common life, when at some unexpected occurrence a man would say, *Did I not tell you so! – Did I not always suspect it! Simon* sits, with great dignity, at the bottom of the table; his whole form, therefore, is to be seen. He, the oldest of all, is dressed in a full garment. His countenance and motion indicate that he is troubled, and in thought, though not agitated and terrified.

If we turn our eyes at once to the opposite end of the table, we see *Bartholomew*, who is standing on the right foot, the left being crossed over, his body bent forward, and supported with both hands, which are placed on the table. He listens, as if to hear what John may learn from the Lord; for altogether, the application to the favourite disciple seems to proceed from this side. *James* the younger, near Bartholomew, but behind him, puts his left hand upon the shoulder of Peter, in a similar manner as Peter has laid his on the shoulder of John; but James appears mild, as if only desiring information, whereas Peter seems to threaten vengeance. And, as Peter did behind Judas, so James the younger stretches out his hands behind *Andrew*, who, being one of the most prominent figures, expresses, by his half uplifted arms, and outspread hands, the fixed horrour with which he is seized. This expression only occurs once in the picture, though it is sadly repeated in inferior works, composed with less genius and reflection.

The technical process

Though something still remains to be said concerning figures, countenances, motion, dress, we will, for the present, turn to another part of our subject, for which, however, but little satisfaction is to be expected: namely, the mechanical, chemical, physical and technical aids, which the artist employed to produce so splendid a work. From the latest investigations it is but too evident, that it was painted, upon the wall, with oil-colours, which method,

having some time before been advantageously practised, could not but be acceptable to an artist, like Leonardo, who, being born with the happiest disposition for the contemplation of nature, and eager to follow her in her operations, would gladly profit by those expedients, which might assist him in successfully representing even her inward and hidden qualities, by his outward deliniation. In attempting this, much certainly depended upon the material to be used.

How arduous this undertaking was, nay, how presumptuous, easily appears, when it is considered, that Nature herself, while working from her intrinsick stores, has occasion to prepare an infinite extent of means, before she is able, after many efforts, to develop organick formation, in order to produce a being like man; who, indeed, manifests the highest inward perfections, but appears rather to increase the mystery, in which Nature involves herself, than to explain it.

To represent faithfully what is inward, by that which is outward, was the highest and almost only aim of the greatest masters; they endeavoured not merely to copy the object with striking accuracy, but the copy was to replace Nature itself, or, in point of effect, even to surpass it. For this purpose, a minute execution was required, which could not otherwise be attained than very gradually. It was, moreover, indispensable that a power should remain of altering and correcting; which advantages, besides many others, oil-painting offered.

Accordingly it has been found, after a careful inquiry, that Leonardo coated the plaster of the wall with a mixture of mastick, pitch and other ingredients, laying it on with a hot iron. And, in order to obtain a perfectly smooth surface, as well as an additional security against any action from without, he put upon the whole a slight coating of white lead, mixed with some fine, yellow, argillaceous earths. But this very precaution seems to have proved injurious to the work; for, although this last coating, at first, while the colours of the picture, laid in it, contained sufficient nourishment to feed it, was, for some time, preserved; yet, when the oil was, by degrees, dried up, that effect ceased, and the surface cracked. The moisture of the wall then forced its way through, and generated the mould, by which the picture was ultimately effaced.

Place and situation
But what is still more melancholy, is that when the picture was

painting, its destruction was not anticipated, from the nature and position of the building. Lodovico, either intentionally, or from caprice, compelled the monks to rebuild their decaying convent in a situation, by no means desirable; and being done by constraint, it was negligently and ill executed. You see now, in the cloisters, miserable pillars, wrought in a slovenly manner, great arches alternating with small, tiles of different size and form, and partly worn out, with other materials claimed, as it would seem, from the rubbish of old buildings. Now if such negligence was admitted in objects exposed to the view of the beholder, it is to be feared that the interior construction of walls, which were to be plastered over, was managed in a way still worse. Probably, old decaying bricks and other mineral substances, saturated with noxious salts, which imbibed the surrounding moisture, and exhaled it again, to the detriment of whatever was near, might have been employed. The unfortunate wall, besides, to which so great a treasure was to be entrusted, was on the north side, and in the vicinity too of the kitchen, larder and buttery. How much it is to be lamented, that so careful an artist, who was most scrupulous in choosing and refining his colours, in purifying his varnishes, and other particulars, was obliged by circumstances, to overlook and disregard the place and situation, where the picture was to be put, though almost everything depended upon this consideration!

If, however, in spite of these objections, the convent had been built upon an eminence, the evil might not have risen to such a degree. But it is situated so low, and the refectory even beneath the level of the rest, that, in the year 1800, during a continuation of rain, the water stood in it more than two feet high; from which we may conclude, that the great flood in 1500 must, in a corresponding proportion, have reached it. Let it be supposed, that the monks, at that period, did everything in their power to dry the place, yet a great deal of moisture must have been imbibed, and remained behind; and this was even visible, at the time when Leonardo yet painted.

About ten years after the picture was finished, a dreadful pestilence invaded the good city; and how was it to be expected from poor monks, when deserted by the whole world, and themselves in imminent danger of their lives, that they should pay attention to the picture in their refectory!

Troubles of war, and many other calamities, which visited Lombardy, in the first half of the sixteenth century, occasioned

that total neglect of such objects; and the picture, of which we are speaking, which laboured, besides, as we have intimated, under other disadvantages, such as the state of the wall and the plaster, and we may perhaps add the manner in which it was painted, must be considered as having been given up to ruin.

A certain traveller, about the middle of the sixteenth century, remarks that the picture was half spoiled, another only sees one flaw in it, a third regrets it as lost, a fourth asserts, that you can hardly, or very imperfectly, distinguish it, a fifth that it is almost quite gone; and this is the language of all the subsequent writers of that period.

Still, however, the picture existed; and though a shade only, compared to what it was originally, yet it was in being. But soon the apprehension began to prevail of losing it entirely; the cracks increased, and ran into one another, and the large and superb surface, being split into innumerable small crusts, threatened to drop off by pieces. Touched by this condition, Cardinal Borromeo caused a copy to be taken, in the year 1612, which we now only mention transiently, though not without a feeling of gratitude.[8]

Progressive deterioration
However, not only the course of time, in conjunction with the circumstances alluded to, but the possessors themselves, who ought to have been its guardians and protectors, contributed most to its destruction, and thereby covered their memory with eternal disgrace. The door by which they entered the refectory, appeared to them too low; it was inserted in the foot, or lower part of the wall, upon which the picture rested, and corresponded, symmetrically, with another door. They required a grand entrance into this room, so dear to them.

A door, much larger than was wanted was opened in the middle, and, without any regard either for the painter, or for the holy persons represented, they destroyed the feet of some of the Apostles, and of Christ himself.[9] Here the ruin of the picture properly commences. For, as it was necessary, with a view to form an arch, to make in the wall a much larger opening than the door, not only a great portion of the surface of the picture was lost, but the strokes of the hammers, and pick-axes shook the whole in its position, so that in many places, the crust was loosened, of which the pieces were again fastened with nails.

Subsequently to this, the picture was darkened, by another piece

of absurdity; namely, the armorial bearings of the sovereign were affixed to the ceiling, which almost touching the head of Christ, narrowed and dishonoured the presence of the Lord from above, as much as the door did from below. From this time, the restoration of the picture was constantly spoken of; but it was undertaken considerably later. For what artist of merit would venture on such a responsibility? At length, unfortunately, in the year 1726, Bellotti, a man very deficient in skill and knowledge, but, as is usual in such cases, abundantly supplied with pretensions, offered himself, and, like a mountebank, boasted a particular secret, whereby he would engage to recall the fading picture into a renewed existence. By means of a trifling experiment, he imposed upon the ignorant monks; that precious object was placed at his disposal, and he immediately surrounded it with boards, behind which, unseen, he carried on his nefarious proceedings, painting it all over, from top to bottom. The silly monks admired his secret, which, in order still farther to deceive them, he pretended to communicate, by telling them of some common paint, or varnish, by means of which, he assured them, they would be able to meet all future emergencies. Whether they made use of this valuable remedy, when the picture grew dim again is not known; but there is no doubt, that it was several times partially retouched, and with water-colours, as is to be seen in different places.[10]

In the meanwhile, the picture became more and more deteriorated; and the question, how it might be preserved, was agitated anew, with great diversity of opinion both among the artists and those who were otherwise concerned in the matter. De'Georgi, a modest man, and a painter of the second order, but intelligent and inspired with proper feelings, constantly refused to put his hand to a work, at which that of Leonardo has been employed.

Finally, in the year 1770, by an order not wrong in its intentions, but erroneous in its views, and by the complaisance of a courtly Prior, the business was committed to one Mazza, who proved himself a true bungler. Those few parts, which had remained of the old original, though they had been twice before sullied by profane hands, were still a stumbling-block to his licentious pencil. He scraped them with iron instruments, to prepare for himself places, where he might daub the strokes of his shameless art; even several of the heads were treated in this manner. This proceeding was resented, at Milan, by men of spirit, and taste, and formed a subject of reproach, both against the employers, and those em-

ployed. Others, of a lively and irritable temper, took part in the question; and there arose a general ferment. Mazza, who had begun to paint on the right hand of our Saviour, so industriously applied himself to his work, that he also arrived at the left; and the heads only of Matthew, Thaddaeus, and Simon remained untouched. But these, likewise, he meant to attack, and to coat over the work of Bellotti, entering with the latter into a competition, as it were, for the character of an Herostratus.[11] But fate ordained it otherwise. The servile Prior having been called away to fill another situation; his successor, who had some notion of art, did not hesitate to dismiss Mazza immediately; and by this means the three heads alluded to were so far preserved, that, from them, a judgement may be formed of Bellotti's work. This circumstance probably gave rise to the report, that three heads of the genuine original painting were still remaining.

Since that period, notwithstanding many a deliberation, nothing has been done; and what could have been done with an object of that kind, which in the long space of about three hundred years, had experienced all the effects and influence of time! In 1796 the victorious French army, commanded by Bonaparte, passed the Alps. Young, ambitious, and eager after everything that might lead to glory, he was by the name of Leonardo drawn to that spot, of which we have been speaking. He instantly ordered, that no military quarters should be established there, and that no damage of any kind should be done; which order he signed upon his knee, before he mounted his horse. Shortly after another general, disregarding it, had the door broken open, and converted the dining-hall into a stable.

The embellishments of Mazza had already lost their brilliancy, and the steam from the horses, much worse than the fumes from the table of the monks, now settling upon the walls, generated a fresh mould upon the picture; and the moisture collected so strongly, that it ran down in streaks, and marked its way with a white track. Afterwards this hall was used as a magazine for hay, and for other military purposes. At length the magistrates succeeded in shutting the place, and even walling up the entrance, so that those who desired to see the picture, were obliged to descend, by a ladder, from the pulpit, formerly used for the recital of prayers before and after dinner, to which pulpit there was an access from without.

In the year 1800 a great inundation took place, which, spreading,

also filled the hall and very much increased the damp. At the suggestion of Bossi, who, as secretary to the Academy thought himself authorized to take an active part upon this occasion, a door was again made, and further measures of precaution were intended to be adopted. Finally, in 1807 the Viceroy of Italy ordained that the place should be thoroughly repaired, and restored to a decent appearance. Windows were put in, the floor mended, and an accurate examination took place to see what other improvements might be made. The door was removed to the side wall, and since that period no particular alteration has been made. The picture appears to the attentive observer more or less obscure, according to the state of the atmosphere. It is to be desired, that, since the work itself is as good as lost, the vestiges of it may be preserved, as a melancholy but pious memorial, for future ages.

Of copies in general

Before we proceed to speak of the copies made of our picture, which in number amount to about thirty,[12] we must say a word of copies in general. They did not come into vogue, till everybody acknowledged, that art had attained its highest pinnacle, when talents of an inferior order, viewing the works of the greatest master, despaired of their own powers to produce anything like them, either from nature or from imagination. It was then that Art, assuming the character of a profession, began to repeat her own performances. This incapacity of most artists did not escape the lovers of the art, who, when they were not in a situation to apply to the first masters, addressed themselves to persons of meaner abilities, whom they engaged and paid (in order to obtain something which was not destitute of merit), to make copies of acknowledged works, that must, at any rate, have a certain value. Both those who purchased pictures and the artists themselves, favoured this new mode of proceeding, the former from economy, the latter from hurry, and the art was thus intentionally degraded to the practice of copying.

In the fifteenth century, as well as in that preceding, artists had a high notion of themselves and of their art, and did not easily condescend to repeat the inventions of others; for which reason copies, strictly speaking, of that period, are not to be met with, a circumstance, which he who studies the history of the art, must well attend to. Subordinate arts might have recourse, for their diminutive productions, to higher originals, as was the case with

what is called *Niello*,[13] and other enammelled work; and if, from religious, or other motives, some copy was desired, they were contented with an inaccurate imitation, which nearly expressed the motion and action of the original, without any strict regard to form, or colour. Hence, in the richest galleries, no copy is to be found of the sixteenth century.

The time, however, arrived, when by a few extraordinary men (among whom, without contradiction, our Leonardo may be reckoned, and considered as the earliest) art was, in every part, brought to perfection; men learnt to see better, and to judge better, and it was not difficult to satisfy the desire for copies, especially in such schools where many pupils were crowded, and where the works of the master were much sought after. But even then the wish for copies was limited to small objects, which might be easily handled, and compared with the originals. As to greater works, the case was different, at that time, from what it was afterwards; because in such, the original and the copies cannot conveniently be brought together, and the orders for copies of this description are naturally less frequent. The artists as well as the amateurs were satisfied with imitations of diminished size, in which great latitude was allowed to the person that copied; and the consequences of this freedom appeared abundantly, in those few instances where large copies were required. These were almost always copies of copies, and, what is strange, formed after copies on a reduced scale, very remote from the original, frequently even after mere drawings, and what was still worse, sometimes perhaps only from memory. Common painters, who wrought, as it were, by the dozen, increased, and were employed at the lowest prices. Painting became a matter of show; taste declined; copies were augmented, and covered lobbies, and staircases; hungry apprentices lived upon small pay, while engaged in copying the most important works, after any arbitrary scale; and many painters spent their whole life in copying. In every copy almost, some deviation from the original was visible, whether owing to the fancy of the person who had ordered it, or the whim of the painter, or to a presumption, on his part, to be himself original.

In addition to the former came the demand for tapestry, in which no representation was thought to appear to advantage except through the medium of gold, the most excellent pictures being esteemed poor and meager, if they were exhibited in sober and simple colours. The copying artist, therefore, to enrich and

diversify his scene, would perhaps introduce pieces of architecture and landscapes, in the background of his representation, ornaments in the dresses, golden rays, or crowns, about the heads; strange forms of children, animals, chimeras, grotesques, and other silly embellishments. Frequently the case might also arise, that an artist, who ascribed to himself the power of invention, received an order from a person, who did not know how to appreciate his talents, to copy other work; and while reluctantly employed in this task, he could not resist the temptation of showing himself, here and there, an original painter: he consequently altered, or added, as either his understanding, or his vanity, might suggest. Similar changes were likewise made, occasionally, for the purpose of adapting the subject to time, or place. Many a figure was used in a different signification from that, in which the first author had designed it. Subjects profane were, by some additions, metamorphosed into sacred. Pagan deities and heroes were obliged to submit to become martyrs and evangelists. Often the artist might, for his private use, have copied some figure from a celebrated picture; he would then perhaps add something of his own invention to make a saleable article of it. Last of all, a share in the corruption of art may be attributed to the discovery, and the abuse of engraving, which, in the easiest way, furnished the common painters with subjects; they found it no longer necessary to study, and painting finally sunk so low that it was confounded with mechanical labour. The engravings themselves had already deviated from their originals, and he that copied them, multiplied the variations after his particular notion and caprice, or those of others. It was the same with drawings; artists sketched the most remarkable objects at Rome and Florence, in order to repeat them, after their own fancy, when arrived at home.

Copies of The Last Supper

From the foregoing it is easy to judge what expectations are to be formed concerning the copies of the Last Supper, though the most early were contemporary with the original; for the work excited great sensation, and the other convents desired to possess something like it. Among the many copies that are mentioned by Bossi, three only will engage our attention, those namely, from which the drawings that are at Weimar, are taken. They are however, founded upon a fourth, of which it will be necessary to speak first.

Marco da Oggiono, a pupil of Leonardo da Vinci, without being

endowed with comprehensive genius, acquired nevertheless the merits of his school, especially in the heads, though it must be confessed, that he was not always equal in this respect. About the year 1510, he made a small copy, with a view to employ it, subsequently, as a model for another, of larger dimension. As usual, that copy, was not very accurate; it however served as the pattern to the large one, which is on the Wall of the convent (now abolished) of Castellazzo,[14] likewise in the dining-hall of the former monks. Everything in it is carefully wrought, yet in the secondary matters the customary latitude is taken. Though Bossi does not seem to be inclined to say much in its favour, he does not deny that it is a work of importance, and that the character of several heads, where the expression is not carried too far, deserves praise. He has made tracings of them, and, in comparing the three copies alluded to, we shall be able to judge them from our own view.

A second copy, of which we have the tracings of the heads likewise before us, is to be found upon a wall, in *fresco*, at *Ponte Capriasca*. It is referred to the year 1565, and attributed to Pietro Lovino. Its merits will be mentioned afterwards: at present we will notice, that the names of the figures are written near them, which circumstance furnishes us with a sure and characteristic distinction of the different countenances.[15]

The gradual deterioration of the original we have dwelt upon sufficiently, and with much regret. It was already in an indifferent state, when Cardinal Frederick Borromeo, a zealous friend of the arts, in the year 1612, made an effort to prevent the total loss of the work by charging Andrea Bianchi, surnamed Vespino, an artist of Milan, with the task of making a copy in full size. This painter tried his powers, at first only with some of the heads, and when these succeeded, he went farther and copied all the figures singly, which he afterwards joined together, with the utmost care. This picture is to be found, at present in the Ambrosian library, at Milan, and may be considered as the ground-work of the latest copy, namely that accomplished by Bossi.[16] The latter owed its origin to the following circumstances.

Latest copy
The kingdom of Italy being established, Prince Eugene (*Beauharnois*) wished to throw a lustre upon the beginning of his regency, by showing a disposition, after the example of Lodovico Sforza, to protect and foster the arts. Lodovico had charged Leonardo with

the execution of the Last Supper; Eugene determined, as far as possible, to restore the picture (which, in the course of three centuries, had by the various injuries to which it had been exposed, been almost destroyed) by a new facsimile, and to preserve the latter to distant times by embodying it in mosaic, of which the manufactories, established at Milan, afforded convenient opportunities. Bossi, therefore, immediately received an order to carry that plan into effect, and accordingly entered upon the undertaking at the beginning of May, 1807. He found it advisable to make a cartoon, of the same size with the picture; and while resuming the studies and occupations of his earlier days, he turned his whole mind to Leonardo, and carefully examined both his productions and writings, convinced, as he was, that a man, who had left behind him such exquisite performances, must have been directed by the most unerring, and best principles. He had drawn the heads, and some other parts, of the copy of Castellazzo, and that of Bianchi. He now imitated everything he could procure of da Vinci's or even of some of his contemporaries, looked out for all the existing copies of the work in question, of which he got acquainted (more or less) with seven and twenty; and had drawings and manuscripts of da Vinci's readily communicated to him, from all quarters.

In executing the cartoon, he adhered chiefly to the copy of the Ambrosian library, which was the only one of the same size as the original. Bianchi had made use of netting and transparent paper, in order to obtain a most accurate imitation, and had constantly worked in sight of the original, which, though much damaged, was not yet painted over.

About the end of October 1807, the cartoon was finished. A piece of canvas was prepared, and covered with the ground colour, and the whole of the picture was soon sketched upon it. Immediately after this, in order to regulate his tints, Bossi painted upon it what little there was of sky and landscape that still remained clear and bright in the original, owing to the former vividness and brilliancy of the colours. He next painted the heads of Christ and the three Apostles, on the left; and as to the garments, he first painted those, concerning whose colours he had made himself sure, in order subsequently to choose the rest, conformably to the principles of the master, and to his own taste. Thus he filled the canvas, guided by a careful reflection, rendering his colours high and expressive.

Unfortunately, he was, in this damp and lonesome situation, attacked by an illness, which obliged him to suspend his labours:

but he made use of the interval, to put in order such drawings, engravings and papers, as either had a reference to the Last Supper, or at least related to some other work of the master. Fortune favoured him, by placing in his hands a collection of sketches, which, being derived from Cardinal Cesare Monti, contained among other precious articles, also some valuable things of Leonardo. He even studied the writers, who were coeval with Leonardo, that he might profit by their views and opinions, and applied his attention to every particular that might benefit and assist him. Thus he turned his indisposition to advantage, and having recovered his health, he recommenced his work with fresh ardour. No artist, no lover of art, will leave the account unread which describes, how he proceeded in detail, how he meditated on the character of the faces, and their expression, nay, even on the motion of the hands, and how he restored them. In a similar manner he considered the furniture of the table, the room, the ground, and showed, that he determined nothing without the most competent reasons. With the very feet he took an extraordinary degree of trouble, to give them a proper position under the table, which part of the picture was long since destroyed in the original, and negligently treated in the copies.

What hitherto has been said, gives a general idea of the book of the Chevalier Bossi. We have here and there interspersed translations, and extracts from it; and while we thankfully received his information, we participated in his actions, admitted his opinions, and, if we added anything, it was in unison with his declarations. But now, when the question is concerning the principles, by which he was swayed, and the course which he followed, in the execution of his copy, we are prompted in some degree to differ from him. We find that, on these points, he has sustained several attacks, that his adversaries have treated him harshly, and that even some of his friends have dissented from him; whereby a doubt is, at least, raised, whether all that he has done is to be approved. But since he is departed, and unable to defend himself, or to vindicate his reasons, it becomes our duty, if not to justify, yet, as much as possible, to excuse him, laying that with which he is charged to the account of the circumstances, in which he was placed, and endeavouring to show, that he was compelled to judge and to act, rather according to the necessity, that seemed to be imposed upon him than from his own views and conceptions.

Undertakings of this kind, which are intended to be striking, to

create sensation, or to excite astonishment, are generally carried beyond the natural measure. Leonardo himself, in representing the Last Supper, exceeded the human size, by one complete half: the figures were calculated at nine feet; and although twelve persons are sitting, or, at all events, placed behind the table, and consequently to be considered as principal figures, while only one is standing, but in a stooping posture, the picture must, nevertheless, even at a considerable distance, have an amazing effect. This effect was to be reproduced, if not with its characteristic delicacy, in detail, yet powerfully striking in the whole.

Something great and marvellous has been announced to the multitude: a picture of twenty-eight feet in length, and about eighteen feet high, was to be put together of many thousand small bits of glass, after an ingenious artist had carefully painted the whole on canvass, and in consequence of deep reflection, and by the aid of all the resources of his mind and his knowledge, had as far as possibly could be done, restored that which had been lost. And why should the execution of such an enterprise have been doubted, at the time of an important revolution in the state? Why might the artist not have been inspired, at this very period, to perform something, which, in the ordinary course of life, would have appeared utterly impracticable!

When it had been once determined, that the picture should be equal in size to the original, Bossi, who had engaged in the task, stands sufficiently excused for adhering to the copy of Vespino. The old copy in Castellazzo, which is justly looked upon as possessing great merit, is a good deal smaller than the original; and if he had exclusively made use of this, he must have enlarged the figures, as well as the heads, as those best know, who are judges of these matters.

It is long since acknowledged, that only the greatest masters can succeed in exhibiting the human face, upon a colossal scale, in painting. The form of man, particularly the countenance, is according to the laws of nature, confined within a certain space, beyond which it ceases to appear regular, characteristick, beautiful and expressive. Make the experiment, and look at yourself, in a concave mirror, and you will be terrified at the inanimate, unmeaning monstrosity, which, like a Medusa, meets your eye. Something similar is experienced by the artist, by whose hands a colossal face is to be formed. The expression of a picture arises from its *completeness*, and this completeness is brought about by the combination of

the single parts; but how ill will the single parts combine when they are so drawn out, and extended!

The high degree of finishing, which Leonardo had given to his heads is unhappily lost to our view. In the heads of Vespino, the drawings of which are lying before us, though entitled to every regard and acknowledgement, there is a vacancy to be perceived, which unavoidably obliterates the intended character; at the same time, however, they are executed with boldness, and cannot fail to have a striking effect, at a distance. Bossi found them ready at his hands; the hazardous task of magnifying, which he must, otherwise, have undertaken, at his own peril after smaller copies, was accomplished, and with these circumstances he had every reason to be satisfied. Like a man of determined and resolute character, he had decided for that, which he thought, it behoved him to attend to: what did not bear upon that point, or was even opposed to it, he had entirely set aside. Thence arose his disregard of the copy at Castellazzo, and his firm reliance on those principles, which he had deduced from the works and writings of the master. This gave occasion for a publick controversy with Count Verri, and a discussion, if not a difference, with his best friends.

Before we proceed, we have something to supply respecting the character and talents of Leonardo. The various endowments, which nature had bestowed upon him, were concentrated, if we may use the expression, particularly in his eye; for which reason, though possessed of abilities for every thing, he appeared decidedly greatest, as a painter. Being of a regular and handsome form, he might be considered as a model for the human species: and whereas the perception and penetration of the eye may, in a strict sense, be said to appertain to the understanding, a clear apprehension, and intelligence were peculiar to our artist. He did not rely upon the inward impulse of his innate, inestimable talents; no arbitrary, random stroke was admitted; every thing was meditated, and reflected upon. From the pure and tried proportion to the strangest and most contradictory forms, or monstrosities, everything was to rest on principles of nature and reason.

To this acute and intelligent intuition of the material world we owe that great precision and detail, with which he is able to set forth, in words, the movements of the most intricate events, just as if they were intended for pictures. Read his description of a battle, a storm and the like, and you will acknowledge, that you scarcely ever met with more accurate representations, which,

though they may not themselves be fit to be painted, yet are calculated to insinuate to the painter, what may be required of him.[17]

Thus we see from the papers, which he has left, how the tender and tranquil mind of our Leonardo was disposed to receive the most varied and powerful impressions. His precepts first urge, in general, a good form; but, in the next place, they insist upon a careful observation of every deviation from it, even unto deformity. The visible change of the child to grey-headed age, in all its gradations, the expression of passion, from joy to rage, and so forth, are to be quickly noted, as they occour in life. When subsequently such a delineation is to be made use of, an approximating form is to be looked for, in the real world, to be adapted to the occasion, and, under the guidance of the general idea, to be accurately modelled according to life. It is obvious, that this method, whatever merits it may have, can only be practised by talents of the very first order: for the artist, setting out from individual objects, and advancing towards generality, will always find a difficult problem before him, especially when several figures are to co-operate.

Let us survey the Last Supper, in which Leonardo has represented thirteen persons, from the youth up to the aged man, one of them in quiet resignation, one terrified, and eleven agitated by the thought of domestick treason. Here is seen, in one instance, the softest, gentlest demeanour, and, in another, the most passionate and violent emotion, with the intermediate steps between the extremes. If all this was to be taken from nature, what attention, upon all occasions, what time was necessarily requisite, to collect so many component parts singly, and to work them up into a whole! It is, thence, not at all contrary to probability, that he should have laboured sixteen years, at this work, and yet not have been able to come to a determination, with respect to the Traitor, nor the Son of Man, because both are notions that are not derived from the senses.

Now to the subject! If we consider what has been said before, and reflect, that this undertaking was only to be accomplished by some wonderful effort of art, and that after the mode of proceeding, which we have described, there still remained, in some of the heads, an undetermined and undefined expression which, by every copy, even the most accurate, was rendered still more uncertain, we find ourselves in a labyrinth, wherein the tracings alluded to, may perhaps guide us, but will not be able satisfactorily to relieve our embarassments.

First of all, we are obliged to confess, that the treatise, by which Bossi endeavours to throw a suspicion upon all the copies, though we do not mean to impugn its historical accuracy, seems to us to have been written for the sole purpose of degrading the copy of Castellazzo, which, though it may have many defects, yet with respect to the heads which are lying before us, has a decided advantage over those of Vespino, the general character of which we have before touched upon. In the heads of Marco d'Oggiono, there is evidently the first intention of Da Vinci perceptible: Leonardo may possibly have taken a part in the performance, and with his own hand have painted the head of Christ. It may further be presumed, that he might extend his instructive and directing influence to the other heads likewise, and perhaps over the whole picture. Though the Dominicans at Milan had been so unaccommodating as to exclude the artists from the free use of their picture, there was probably found, in the school of Leonardo itself many a sketch, drawing, or cartoon, with which the master, who withheld nothing from his pupils, might assist a favoured scholar, who, at no great distance from Milan, had undertaken to furnish an accurate facsimile of the painting.

Of the relation, in which those two copies (viz. that of Oggiono and that of Vespino – for the merit of the third, viz. that at Ponte Capriasca, cannot be judged by mere description; it ought to be seen) stand to one another, we will only in a few words, state what is necessary and most important, hoping that we may perhaps be so fortunate as to be able to lay before the lovers of art copies of those interesting sketches.

Comparison between the copies of Oggiono and Vespino
St Bartholomew. According to Oggiono, a youth in the vigour of manhood, with a sharp profile, a composed and clear countenance, with eye-lids and eyebrows pressed down, the mouth closed, as if listening with suspicion; a character entirely circumscribed within itself. In Vespino, there is no trace of physiognomy, individually characteristick; it is a sort of commonplace countenance, listening with open mouth. Bossi has approved, and retained, this opening of the lips, wherein we do not agree.

St James the Younger, likewise profile. An undeniable family resemblance with Christ, which seems again to be obliterated by the peculiarity of the projecting, and gently opening lips. In Vespino's picture, we have a common, studied Christ's face, the mouth

DA VINCI'S THE LAST SUPPER 189

opened rather in astonishment than in the act of asking a question. Our opinion, that Bartholomew ought to shut his mouth, is grounded upon the circumstance, that his neighbour has it open; a repetition, which Leonardo would never have permitted. On the contrary, the figure which follows, viz.

St Andrew, has the mouth likewise closed. He presses the lower lip rather against the upper lip, as elderly people are apt to do. His head has. in the copy of Marco, something peculiar, not to be defined by words: the eyes are drawn backwards, and the lips, though closed, are not destitute of expression. The outlines of the left side towards the background make a handsome profile; on the other side, there appears so much of the forehead, the eye, the nose and the beard, that the head rounds itself, and gains a great deal of life. Vespino entirely suppresses the left eye, but suffers so much to be seen of the forehead, and beard, as produces a vigourous, and bold expression, the face being turned upwards, which, indeed, is striking and interesting, but would be better suited to a doubled fist, than a flat, open hand.

Judas, reserved, terrified, looking before and behind, the profile angular, but not extravagant, of a form, by no means ugly: for good taste could not endure a monster, properly so-called, in the vicinity of men so pure and righteous. Vespino, however, has actually represented such a monster; and it is not to be denied, that, separately considered, this head has great merit. It expresses a bold and malicious love of evil, and would make an excellent, and prominent figure in the multitude, insulting over the *Ecce Homo*! and crying, *crucify! crucify!* It might also do for a Mephistopheles, in his satanick moments. But there is no vestige of fear and terrour joined with dissimulation, indifference and contempt. The bristly hair suits well with the whole; but its wild appearance can only exist in conjunction with the energy and vehemence of the other heads of Vespino.

St Peter: an undefinable countenance. With Marco, it shows merely a painful expression; nothing of anger, or threatening is to be seen; it exhibits solicitude; and here perhaps Leonardo has not agreed with himself. A tender interest in a beloved master, and menace against the traitor could not well be united, in the same features. Cardinal Borromeo, however, pretends to have seen, in his time, such a wonder. But plausible as his story is, we have reason to think that the Cardinal, a warm admirer of the art, rather described his own feelings, than the picture; for otherwise we could

not, by any means, defend Vespino, whose Peter has a disagreeable expression. He looks like an unbending Capuchin, whose Lent-sermon is to rouse the sinner. It is strange, that Vespino should have given him stiff, rough hair, while the Peter of Marco is distin-guished by a handsome, curly head.

St John has been painted, by Marco, quite in the spirit of Da Vinci: his fine round, or rather oval, face, and his smooth long hair, falling from the crown of the head, downwards, and gently form-ing into curls below, particularly where it rests on Peter's projecting hand, are extremely pleasing. What is seen of the pupil of the eye, is turned away from Peter – a very nice touch of truth and nature, since he that listens, with deep emotion to a person near, who is saying something low, and with secrecy, always turns away his look from such a person. With Vespino, it is a youth, in a state of comfortable repose, almost asleep, manifesting no feeling of sympathy.

We now turn to the left side of Christ, so that we shall speak of the figure of the Saviour at the conclusion.

St Thomas. Here are to be noticed the head, and the right hand, of which the forefinger, being raised, is somewhat bent towards the forehead, in order to indicate thought. This movement, so well suited to the suspicious and doubting character of this disciple, has hitherto been misunderstood, and the thoughtful attitude been taken for a menacing posture. In Vespino's copy, he is likewise pensive; but as the artist has again omitted the passing glance of the right eye, there arises a perpendicular and monotonous profile, wherein no trace is to be seen of that prominent and inquisitive expression of the older copy.

St James the Elder. The most violent emotion in the countenance, a gaping mouth, horrour in the eye – an original, and bold concep-tion of Leonardo; but we have reason to think, that with this head also Marco admirably succeeded. The tracing of it is excellent. On the other hand, in Vespino's copy everything is lost; position, attitude, expression of the countenance, all is gone, and diluted with an insignificant commonplace figure.

St Philip. Inexpressibly pleasing, resembling the youths of Raphael collected, on the left side of the School of Athens, around Bramante.[18] Vespino has unfortunately again suppressed the right eye; and not being able to deny that, here, something more than a profile is to be looked for, he has produced an ambiguous sort of a head, bent over in an odd manner.

St Matthew. Young and of an unsuspecting disposition, with curled hair; an anxious expression about the mouth, which is opened a little; the teeth, which are visible, seem to indicate a sort of silent anger, according with the strong emotion of the whole figure. Of all this nothing has remained in Vespino's copy: with an unmeaning stare, the person looks before him, so that nobody would, in the least, suspect the great agitation under which he labours.

The *St Thaddeus* of Marco is, likewise, a most invaluable head: fear, suspicion, indignation present themselves in every feature. The unity of these emotions is admirable, and perfectly corresponds with the movement of the hands, which we have before explained. Vespino has, as usual, generalized everything, that is, rendered it common instead of distinguishing it by some characteristick peculiarity. The head is made insignificant, by being too much turned towards the spectator, whereas in Marco's copy, the left side of it scarcely occupies a fourth part of the space, in which manner the suspicious and oblique look is most expressively given.

St Simon the Elder, quite in profile, opposed to the equally distinct profile of the youthful St Matthew. In this person, the projecting underlip, which Leonardo loved so much, in old faces, is somewhat extravagant, but produces, in connection with the serious, and prominent forehead, the most striking expression of vexation and thoughtfulness, which forms a strong contrast with the powerful emotion of the youthful Matthew. With Vespino, it is a superannuated, good-natured old man, who is no longer capable of taking an interest in the most important event, happening under his eyes.

Having thus surveyed the Apostles, we turn to the figure of *Christ* himself. Here we encounter again the legend, that Leonardo was at a loss how to finish either Christ or Judas, which we readily believe, since, according to his mode of proceeding, it was impossible to put the finishing hand to these two extremes of his picture. After the many obscurations (if we may say so), to which the picture has been exposed, the condition in which the face of Christ, which was probably little more than sketched, was found, cannot have been very consolatory. How little Vespino must have traced of it, may be concluded from this circumstance, that he represented a colossal head of Christ, quite contrary to the spirit of Da Vinci's, without regarding even, in the least, the inclination of the head, which necessarily ought to correspond with that of John. Of the expression we will say nothing: the features are regular, good-

natured and intelligent, as we are accustomed to see them in Christ, but, at the same time, destitute of all sensibility, so that one might doubt to which part of the New Testament the head ought to belong.

But now it fortunately happens, that competent judges maintain, that Leonardo had himself painted the head of the Saviour in Castellazzo, and in the work of another had risked that, on which he did not venture, in his own great picture. As we have not the original before our eyes, we must say of the tracing, that it perfectly answers the idea, which we form of an exalted being, whose breast is oppressed by an agony of soul, that, instead of being relieved by the words uttered to his confidential friends, is still more painfully aggravated.

By this process of comparing, we have arrived pretty nearly at the method of that extraordinary artist, as he has set it forth, and proved clearly, and at large, in his writings, and his pictures; and we have the means of still advancing a step farther. In the Ambrosian Library, a drawing is preserved, which indisputably is by the hand of Leonardo: it is on a bluish paper, and sketched in with white, and coloured chalks.[19] Of this drawing the Chevalier Bossi has taken a most accurate facsimile, which we have likewise before us. It is a fine countenance of a youth, drawn after nature, evidently with a view to the head of Christ, for the Last Supper. Distinct, regular features, smooth hair, the head inclined to the left, the eyes bent down, the lips half open, and the whole figure brought into the most exquisite harmony, by a gentle touch of sorrow. Here is a man who does not conceal his inward sufferings: but how it was to be effected, that, without annihilating those feelings, the majesty, the uncontrolled will, the power and might of the Deity should be expressed, that was the problem, which it might be difficult for the skill of the greatest genius to solve. In his youthful countenance, which balances between Christ and John, we see the boldest attempt to adhere to nature, while, at the same time, the object is supernatural.

The old Florentine and Sienese schools departed from the meagre forms of the Byzantine art, by employing portraits everywhere, in their pictures. This was easy to be done, because, in the peaceful subjects of their paintings, the persons, composing them, might be represented in a state of calmness and tranquillity. The meeting of holy men, the listening to a sermon, the collecting of alms, the burying of a revered and pious individual, required of

those around only such an expression, as can easily be laid into a countenance that bespeaks common sense and feeling. But when Leonardo wanted to add life, motion, passion, a great difficulty arose, particularly, when the question was not, to assort together persons of a similar stamp, but to contrast characters of the most opposite description. This problem, which Leonardo distinctly enunciates in words, and finds almost impracticable to solve, is perhaps the cause, why, in subsequent times, great talents rendered the matter more tractable, by suffering their pencil to float between existing, and individual reality, and the general idea, with which they were inspired, and thus to move freely, as it were, from earth to heaven, and again from heaven to earth.

More might still be said concerning this very intricate, but, at the same time, highly legitimate composition of art, respecting the relation and mutual correspondence of the parts to one another, such as the heads, the bodies, the arms, hands, and the like. Of the hands, in particular, we might be entitled to speak, since the tracings of them, after the copy of Vespino, are before us. But it may be proper to conclude this preliminary essay, because it will be fit to wait for the remarks of our Transalpine friends. For to them alone belongs the right of deciding on several particulars, as they have, for many years known, and still have before their eyes, all those objects, of which we can only speak from report, and have, besides, personally witnessed the occurrences of the later times. In addition to their opinion, on the points alluded to, they will be pleased to inform us, how far Bossi has, after all, made use of the heads of the copy at Castellazzo, a circumstance the more probable, as that copy was generally much esteemed, and also contributed greatly to the value of Morghen's print, in the production of which it had an ample share.

Before parting, we have gratefully to acknowledge, that our old friend, fellow-labourer, and contemporary, whom, remembering our early years, we still take pleasure in designating by the name of *Müller the painter*,[20] has presented us, from Rome, with an excellent treatise on Bossi's work, inserted in the Heidelberg Annals (*Heidelberger Jahrbücher*) for December 1816, which, meeting our essay as it were in its course, has in such a manner benefitted it, as to enable us in several parts, to be more concise, and to show, by appealing to that tract, how near we have approached to the sentiments of a tried artist, and experienced judge, or rather how closely our notions have coincided with his. For these reasons we conceived

it to be our duty, to dwell more particularly on those points, which that distinguished individual, according to his own views and purposes, had less fully discussed.

In conclusion, we will notice a publication that has lately appeared at Rome: *Trattato della Pittura di Leonardo da Vinci; tratto di un Codice della Biblioteca Vaticana.* Roma 1817 4to. It is a large volume, containing a great deal of matter, previously unknown, from which a new and deep insight into the art and method of Leonardo may probably be derived. It is accompanied by a small folio volume of 22 copper plates, giving light and expressive sketches, quite in the manner and spirit of those, with which Leonardo was wont to illustrate his writings. We shall, perhaps, by this work, be induced to resume our subject, on a future occasion, and we may then hope with the assistance of our kind friends at Milan, to afford it some additional elucidation.

NOTES

1. This translation by G. H. Noehden was published as a pamphlet in 1821. Goethe approved of Noehden's free handling of the German (p. xxxvi). The original spelling and punctuation have been retained.
2. On Bossi, *Dizionario Biografico degli Italiani* XIII, 1971. The mosaic to which Bossi refers on p. 259, n. 15 of his book (see note 3), was completed by Giacomo and Vincenzo Raffaelli in 1818, and is now in the Minoritenkirche in Vienna.
3. *Del Cenacolo di Leonardo da Vinci libri quattro di Giuseppe Bossi,* fol. Milan, 1810.
4. Leonardo's peasant mother was apparently called Caterina (K. Clark, *Leonardo da Vinci,* Pelican ed., 1958, p. 18).
5. Leonardo's *Madonna and Child with St Anne* is in the Louvre.
6. Instead of Raphael Morghen's reproduction of 1800 we reproduce the small copy made in 1789-94 by André Dutertre (Oxford, Ashmolean Museum), which is now regarded as the best copy of Leonardo's work.
7. The earliest known drawings do not in fact concentrate on this episode (L. H. Heydenreich, *Leonardo: The Last Supper,* 1974, Figs. 28-9).
8. Bossi, *op. cit.* pp. 153-6. Bossi used it as the basis of his own copy. The Ambrosiana copy (*ib.* pp. xxi f) is now in store (L. Steinberg, 'Leonardo's *Last Supper*', *Art Quarterly* XXXVI, 1973, No. 34).
9. In 1652 (Bossi, *op. cit.,* p. 198).
10. Bossi (p. 195) speaks of *ritocchi a tempera.*
11. Herostratus set fire to the Temple of Artemis at Ephesus, in 356 B.C. to immortalize himself.
12. Steinberg, *op. cit.,* pp. 402-407, records forty-two copies up to and including Bossi's. Heydenreich, *op. cit.,* Fig. 63, includes the copy by André Dutertre.
13. Goethe is probably thinking of the origins of engraving in fifteenth-century *Niello* work. In the sixteenth century, many paintings were reproduced in Limoges enamel.

14. Steinberg, Fig. 26 and No. 11 (Royal Academy, London); Fig. 30 and pp. 409-10 (destroyed in 1943).

15. Steinberg, Fig. 35 and pp. 407-9.

16. See note 8.

17. Leonardo discusses a storm in chapter 66 of his *Trattato*, and a battle in chapter 67. Goethe consulted several German and Italian editions of the treatise between 1791 and 1821 (Keudell, Nos. 21, 1124, 1133, 1402-4).

18. Goethe is referring to the fresco of the *School of Athens* in Raphael's *Stanza della Segnatura* in the Vatican.

19. The drawing is now in the Brera (Heydenreich, *op. cit.*, Fig. 47).

20. Friedrich 'Maler' Müller (1749-1825) had been a friend of Goethe's in Rome in the 1780s.

Palladio
Architecture (1795)
[Not published by Goethe]

In every art it is harder than we imagine to establish what deserves praise or blame; and in order to find some sort of norm for our judgement of architecture, I shall for the time being assume that some of what I say is common to all the arts, although, to avoid confusion, I shall confine my remarks chiefly to architecture.

Architecture presupposes a material which can be adapted to three sorts of use, in ascending order of importance.[1]

The architect learns the characteristics of his materials, and either allows himself to be controlled by them – stone, for example, will support and be supported only vertically, whereas wood will support horizontally over a considerable length, which is sufficient for most ordinary work – or he imposes himself on his material: on stone with vaulting and clamps, on beams with trusses; and this already demands some knowledge of and insight into engineering.

We now turn to the three aims of architecture, which are: the most immediate, the higher, and the highest.

The most immediate, if it is simply a necessity, can be achieved appreciably by a crude botching-up of nature; if this need is more ramified, for what we call usefulness, it already requires some practice in craftsmanship to attain it. But this immediate purpose and the assessment of it can be left to more or less cultivated commonsense, and the need can be easily met.

But if the practice of building aspires to the name of art, it must, besides the necessary and the useful, produce objects harmonious to the senses. This sensible harmony is different in, and conditioned by, each art, and it can only be judged within the framework of these conditions. They arise from the material, from the purpose and from the nature of the sense to which the whole must be harmonious.

It might well be thought that, as a fine art, architecture works for the eye alone, but it ought primarily – and very little attention is paid to this – to work for the sense of movement in the human

body. When, in dancing, we move according to certain rules, we feel a pleasant sensation, and we ought to be able to arouse similar sensations in a person whom we lead blindfold through a well-built house.[2] The difficult and complicated doctrine of proportion, which enables the building and its various parts to have character, comes into play here.

But here, too, appears the observation of the highest purpose of architecture, which undertakes, if we may be allowed the expression, the super-satisfaction of the sense, and raises the cultivated mind to astonishment and rapture. This can only be effected by genius, which has mastered all the other demands, and this is the poetic part of architecture, the proper realm of invention. Architecture is not an art of imitation, but rather an autonomous art; yet at the highest level it cannot do without imitation. It carries over the qualities and appearance of one material into another: every order of columns, for example, imitates building in wood; it carries over the characteristics of one building into another: for example by the union of columns and pilasters with walls;[3] and it does this for variety and richness. And just as it is always difficult for the artist to know whether he is doing the right thing here, so it is difficult for the connoisseur to know whether the right thing has been done.

This separation of the different purposes will be very useful in looking at different buildings, and will serve as a guide throughout the history of architecture.

As long as the immediate purpose was the only object in view, and the material was more in control than controlled, art was out of the question, and it is doubtful whether, in this sense, the Etruscans ever had an architecture. As long as large stones were laid, just as they were found, in every shape and direction, not even chance could point the builder's way to symmetry; he will have laid rectangular stones upon each other in horizontal rows for some time before it struck him that he should sort them out, lay like against like, lay them symmetrically, or even make them all the same size.

If we look at the history of Greek architecture, we see that the Greeks had the advantage of working on a small scale throughout, and thus practised and refined their senses: the Doric temples of Sicily and Magna Graecia were all built on the same plan, and yet they are so different from each other.

It seems as though in the early period of architecture, the con-

cept of the character which a building should have predominated over the concept of mass, for character cannot really be expressed by mass, and we see from the measurements of actual buildings how difficult it is to reduce their parts to numerical ratios. It was certainly no advantage to modern architecture when these ratios (according to which the different orders are to be set up), began to be taught, rather than indications of character.

But we generally come back to the same important point, that the peculiarity of invention and the appropriate manner of imitation, have rarely been understood when they have been needed most, in that what was alone appropriate to temples and public buildings was now transferred to private dwellings in order to give them a magnificent appearance.

It might be said that in modern times this has produced a double fiction and a twofold imitation, which demand intelligence and sensitivity both to use and to assess them.

In this no one has surpassed Palladio; none moved in this direction more freely than he, and if he overstepped the mark, nonetheless even when he is criticized, he can always be forgiven. It is necessary to confront certain purists with this doctrine of invention and its intellectual principles, for they would like to turn everything in architecture into prose.

Now that we have gone through the details of the different parts of architecture, it will be more precisely expressed and understood. *Bases of whole buildings*, from which socles and bases later develop. The bases of the earliest temples were steps, and these buildings were accessible from every side. But in the earliest period these steps were so high in proportion to the building that they could not be climbed, and so, at the front of the temple, these high steps were divided into lower ones.

Other temples had steps on the way round of a suitable size for climbing.

The tread of each step had a sharp angle, which was made to project first at the time of Augustus.[4] When temples came to be sited so that they could only be seen from the front, or were of the type called *in antis*, the base was pushed forward and the steps went up the middle of it.

It is also the case that some steps go up between the columns themselves, for example, in the temple at Assisi, but I believe this was only done out of necessity, since the temple was sited on the side of the hill, and there was no room for a flight of steps in front

of it. It remains to be investigated whether there are other examples of this, and whether Galiani⁵ is justified by Vitruvius in drawing the plans and elevations of the Doric temple in the way he does in Plate V.

He has made the columns appear to stand on pedestals, whereas in fact they stand on the floor of the peristyle, which is simply cut into by the steps.

Palladio must have drawn the temple entirely from hearsay, as a comparison of his Book IV, cap. 26 and the *Monumenti antiqui inediti* (1786) fol. 20 will convince us.⁶

The question arises of when columns on fully free-standing bases first make their appearance.

Bases as projections from the whole base of the building, where there are no steps: Palladio Book IV, chap. 29.

The transition is made by bases which are clearly pierced (Palladio Book IV, chap. 25), in which we can easily deduce how the architect, who was, moreover, hardly very conscientious, was obliged to resort to this type of base for his columns.

This is what Palladio always did in public buildings, where he was free to do so.

The question arises whether there are any really free-standing bases by him; usually he simply used them as projections from the base of the building.

In villas, where he enjoyed greater freedom, there is one instance of them, but still as the ideal extension of the base of the building. The particular circumstance of the site, and the function, will show the origin of this variation, and there is only one trace of it in his more serious buildings.

In the instances mentioned above, he liked to have a socle running round the building at the height of the bases of the columns, so as to accent a certain horizontal sequence.

NOTES

1. Goethe takes over from the Roman architect Vitruvius the three demands of *firmitas, utilitas* and *venustas* (*Ten Books of Architecture*, VI, 3, § 2).
2. This seems to be an original conception of Goethe's, and was not generally accepted by practising architects until the end of the nineteenth century (N. Pevsner, 'Goethe and Architecture', *Studies in Art, Architecture and Design*, I, 1968, p. 243 n. 22). Herbert von Einem has related this passage especially to Goethe's experience of Palladio ('Goethe und Palladio', *Goethe-Studien*, 1972, pp. 144 f.).
3. Goethe probably derived his idea of the wooden origin of columns from

Winckelmann (*Anmerkungen über die Baukunst der Alten*, 1761), and he also discussed it with Aloys Hirt in Italy in 1787 (*Italienische Reise*, Bericht, Nov. 1787), but in early 1796 Meyer wrote to him that he was doubtful of its universal validity (*Briefwechsel*, I, p. 199). The example of columns and walls shows that Goethe had Palladio in mind, for, as he wrote from Vicenza to Charlotte von Stein in September 1786: 'To unite columns and walls without clumsiness is almost impossible . . . But how [Palladio] has worked on what was unruly, how he impresses us with the presence of his works, and makes us forget that they are monsters! There is really something divine in his gift, truly the power of a great poet, who from truth and falsehood forms a third thing which enchants us.'

4. i.e. between 27 B.C. and 14 A.D.

5. *L'Architettura di M. Vitruvio Pollione colla trad. Italiana e comento del Marchese Bernardo Galiani.* 1758 (Ruppert 1461).

6. Andrea Palladio, *Quattro Libri dell'Architettura*, ed. Smith, 1770-1780 (Ruppert 2362); J. J. Winckelmann, *Monumenti Antichi Inediti* 1767 (Ruppert 2138).

IV BAROQUE AND CONTEMPORARY ART

Rubens
[Goethe to Eckermann,
11 and 18 April 1827]

We had returned too early for dinner, and Goethe had time to show me a landscape by Rubens, of a summer's evening[1] (Fig. 16) . . . The whole seemed to me to be composed with such truth, and the details painted with such fidelity, that I said Rubens must have copied the picture from nature.

'Not at all,' said Goethe, 'so perfect a picture was never seen in nature; we are indebted to the poetic mind of the painter for its composition. But the great Rubens had such an extraordinary memory that he carried the whole of nature in his head; she was always at his command, down to the minutest details. Hence his truth in the whole and in the details, so that we think it simply a copy from nature. Such landscapes are not painted any more today; that way of feeling and seeing nature is quite gone, and our painters have no poetry . . .'

[18 April[2]]

'You have already seen this picture,' said he, 'but no one can look enough at something really excellent, and this time there is something very special about it. Will you tell me what you see?'

'Beginning from the background,' said I, 'I see in the far distance a very clear sky, as if after sunset. Then, a village and a town in the evening light. In the middle is a road, along which a flock of sheep is hurrying to the village. On the right of the picture are several haystacks, and a cart piled high with hay. Unharnessed horses are grazing near by. On one side, among the bushes, are several mares with their foals, which seem as if they are going to stay out all night. Then, towards the foreground is a group of large trees, and finally, right in the foreground, to the left, are various labourers returning homewards.'

'Good,' said Goethe, 'that seems to be all. But the main point is

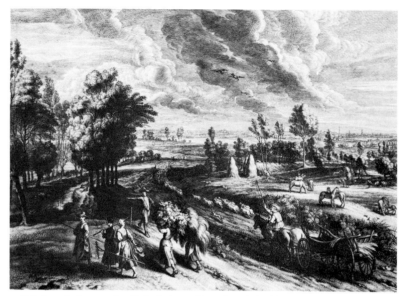

16 Schelte a Bolswert after P. P. Rubens, *Return from the Fields*. Engraving.
Cambridge, Fitzwilliam Museum.

still lacking. All these things – the flock of sheep, the haycart, the horses, the returning labourers – which side are they lit from?'

'The light falls,' said I, 'on the side facing us, and the shadows are thrown into the picture. The returning labourers in the foreground are especially brightly lit, which gives an excellent effect.'

'But how has Rubens achieved this beautiful effect?'

'By placing these light figures on a dark ground,' I answered.

'But how is this dark ground produced?' said Goethe.

'It is the strong shadow thrown towards the figures by the group of trees,' I said, and then went on with surprise: 'But how? For the figures cast their shadows into the picture, while the trees, on the contrary, cast theirs towards the spectator. Thus we have light from two different sides, which is quite contrary to nature.'

'That is the point,' said Goethe with a little smile. 'It is thus that Rubens proves himself great, and shows the world that he has the freedom of spirit to stand *above* nature, and handle her according to his higher purposes. The double lighting is certainly a violation of nature, and you may well say that it is contrary to it. But if it is against nature, I must say at once that it is *higher* than nature. It is the bold stroke of the master, by which he, as a genius, shows that art is not subject to natural demands, but has its own laws.

'The artist,' Goethe continued, 'must certainly copy nature faithfully and reverently in his details: he must not arbitrarily change the structure of the bones, or the position of the sinews and muscles in an animal so that its peculiar character is destroyed. But in the higher regions of artistic activity, when a picture becomes an independent image, he has freer play, and here he may have recourse to *fictions*, as Rubens has done with the double lighting in his landscape.

'The artist has a twofold relationship to nature; he is at once her master and her slave. He is her slave in that he must work with ordinary means, so as to be understood, but her master in that he subjects these ordinary means to his higher purposes, making them subservient to them.

'The artist wants to speak to the world through a whole, but he does not find this whole in nature; it is the fruit of his own mind, or, if you like, of the influx of a fructifying divine breath.

'If we look at this landscape of Rubens cursorily, everything appears as natural to us as if it had been copied from nature. But this is not so: so beautiful a picture has never been seen in nature –

any more than a landscape by Poussin or Claude Lorrain, which appears very natural to us, but which we look for in vain in the natural world.'

NOTES

1. *The Return from the Fields* (Florence, Pitti), of which Goethe owned two proofs of an engraving by Schelte a Bolswert (Schuchardt, I, C. Nos. 370-1). The painting has now been attributed to Lucas van Uden.

2. The section for April 18 was written by Eckermann much later than that for April 11, and was probably much expanded from memory (Petersen, pp. 139, 142).

Rembrandt as a thinker
[8 July 1831. Not published by Goethe]

In the picture of the Good Samaritan (Bartsch No. 90) (Fig. 17), you see in the foreground a horse almost in profile, with a page holding its bridle. Behind the horse a servant lifts the injured man in order to take him into the house up a flight of steps leading in across a balcony. In the doorway we see the well-dressed Samaritan, who has just given the landlord some money, and is earnestly commending the wounded man to him. On the far left, a young man with a feather in his hat is looking out of a window. On the right is a cultivated plot and a well from which a woman is drawing water.

This plate is one of Rembrandt's most beautiful works; it appears to have been etched with the greatest care, and yet the needle was used very freely.

The excellent Longhi's attention was concentrated on the old man in the doorway, of whom he says: 'I cannot pass over the etching of the Samaritan, where Rembrandt has shown the good-natured old man in the doorway in a posture completely suited to him, for he has a tendency to tremble, and seems really to be trembling at his recollection: something that no painter before or after him could achieve with his art.'[1]

We continue the remarks on this important plate.

It is striking that the injured man, instead of offering himself to the servant who is about to carry him in, is turning painfully to the left, with arms folded and head raised, and seems to be begging for mercy from the man with the feathered hat, who is looking out of the window coolly and indifferently, rather than insolently. By this movement, he has made himself twice as cumbersome to the man who has just lifted him onto his shoulder; the man's face shows that he finds the burden troublesome. We are convinced that the injured man recognizes in the arrogant young man at the window the chief of the band of robbers who recently robbed him, and that in that instant he is afraid he has been brought to the robbers' den, and that the Samaritan is also in the plot to ruin

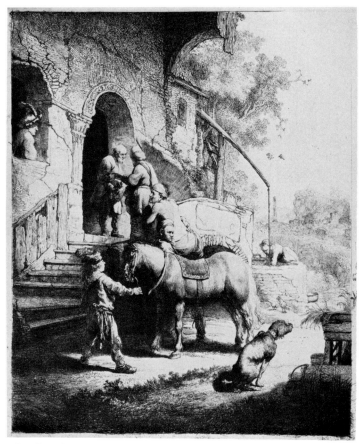

17 Rembrandt van Rijn, *The Good Samaritan*, 1633. Etching. Cambridge, Fitzwilliam Museum.

him. Too bad that he finds himself in the most perplexing situation of weakness and helplessness.

If we look at the faces of the six people here, we see nothing at all of the physiognomy of the Samaritan, and little of the profile of the page holding the horse. The servant, encumbered with the body, has a bad-tempered and contorted face, and his mouth is closed. The injured man has the most perfect expression of helplessness. The physiognomy of the old man is excellent, amiable and trustworthy, contrasting with our robber-chief in the corner, who is both tight-lipped and determined in his manner.

NOTE

1. G. Longhi, *La Calcografia propriamente detta ossia l'arte d'incidere in rame coll'acquaforte, col bulino e colla punta*, 1830 (Ruppert 2460). Goethe began reading the book in July 1831. Rembrandt's print is Münz 196. Goethe conspicuously overlooks the large defecating dog in the foreground.

Ruisdael the poet
[*Morgenblatt für gebildete Stände,*
3 May 1816]

Jacob Ruisdael, born at Haarlem in 1635 [*in fact* 1629] and active until 1681, is recognized as one of the best landscape painters. His works satisfy all the demands that the senses can make of works of art: hand and brush work freely towards the most precise perfection. Light, shade, keeping and the effect of the whole leave nothing to be desired. A glance is sufficient to convince every amateur and expert of this. But here we want to look at him as a thinking artist, even as a poet, and in this respect, too, we must own that he is worth a great deal.

As the meaningful basis for our argument we will use three paintings in the Saxon Royal Collection, in which different aspects of the inhabited world are shown with great sensitivity, each one self-contained and independent. The artist has had the admirable good sense to understand the occasions on which skill and pure thought come together, and he has given the spectator a work of art which is both pleasing to the eye and stimulating to the imagination, exciting thought and expressing an idea, without being at all dampened or cooled in the process. We have good copies of these pictures in front of us, and can thus discuss them at length with a good conscience.[1]

I

The first picture[2] (Fig. 18) shows in one place the successive stages of the human settlement of the world. On a rock overlooking a narrow valley stands an old tower, and, near by, newer buildings in a good state of repair. At the foot of the rock is the impressive dwelling of a wealthy landowner. The ancient fir-trees around it show us that several generations have had a long and peaceful enjoyment of their inheritance in this place. In the background, under an over-hanging hill, is a large village, which also demonstrates the fertility and commodiousness of this valley. In the foreground, a swift-running stream tumbles over rocks and the broken stumps of fallen trees, so that this life-giving element is not absent,

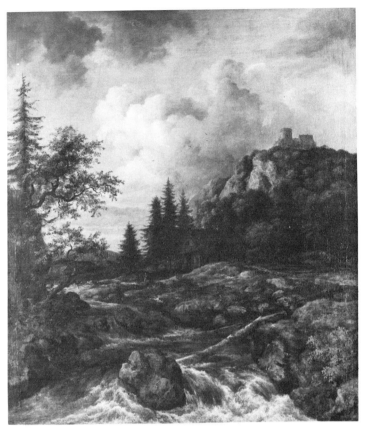

18 Jacob van Ruisdael, *The Waterfall*, 99 × 85cm. Dresden, Staatliche
Kunstsammlungen—Gemäldegalerie Alte Meister.

and we imagine that it is used upstream and down by water-mills and iron-works. The movement, clarity and keeping of these forms give an exquisite vitality to the calm of the remainder; and it is for this reason, too, that the painting is called *The Waterfall*. It satisfies everyone, even if they do not have the time or occasion to go into the meaning of the picture.

II

The second picture, which is renowned as *The Convent*,[3] has the same objective, although its composition is richer and more attractive. It represents the past in the present, and this is done in the most admirable way, by visibly uniting the living and the dead. On the left, the spectator sees a ruined, indeed desolated convent, at the back of which, nevertheless, some well-kept buildings are to be seen, probably the lodging of some functionary or tax-official, who is still collecting the duties and tithes that come flowing in, although they no longer have any vital function to perform.

Opposite this building is a circle of lime-trees, which were planted long ago and are still thriving, to show that nature's works live and endure longer than the works of man, for beneath these trees crowds of pilgrims have for centuries gathered to rest after their pious journeys to fairs and Church festivals.

Another sign that many have gathered here, and that this was the scene of continual coming and going, is the foundations of a bridge in and by the water, and which now serves the picturesque function of obstructing the stream and creating little rapids.

But the destruction of this bridge cannot stop the traffic, which finds its way through everything. Men and cattle, shepherds and travellers, press on through the shallow water, and give its gentle ripples an extra charm.

These waters are still well stocked with fish up to the present, as indeed they were when such were needed for fast-days; for there are fishermen wading in after the innocent inhabitants of the stream in order to overcome them.

Since the hills in the background seem overgrown with young bushes, we deduce that the dense woods have been cut down, and that those gentle slopes have been given over to young plantations and scrub.

But on this side of the stream a remarkable group of trees has established itself on some weathered, crumbling, rocky ground. A magnificent old beech-tree is there; it has lost its leaves and most

of its branches, and the bark is pitted. But, so that we should not be depressed, but rather gratified by its splendidly rendered trunk, some thriving trees are grouped round it, and help out the bald stump with a rich display of branches and twigs. This luxuriant growth is helped by the moisture near by, which is well suggested by marsh plants, moss and reeds.

While a soft light passes from the convent to the limes and beyond, and seems to be echoed in the pale trunk of the beech, and as it returns over the gentle stream and the rushing falls, over herds and fishermen, bringing the whole picture to life, the artist himself sits drawing in the foreground, with his back to us, and we are touched to find this figure, which is so often abused, used so aptly and effectively here. He sits here as the observer, the representative of all who look at the picture in the future, and who will willingly immerse themselves in this spectacle of the past and the present so lovingly interfused.

This picture has been most happily conceived from nature, and elevated by thought, and since it aspires to and fulfils every expectation of art as well, it will always fascinate us, it will maintain its well-deserved reputation for ever, and even a copy, if it be more or less successful, will give us some idea of the great merits of the original.

III

The third picture (Fig. 19) is entirely devoted to the past, without allowing any rights to the life of the present. It is known by the title of *The Cemetery*;[4] and it is one. The tombs in their ruinous condition even point to something more than the past: they are tombstones to themselves.

In the background we see the mean ruins of what was once a vast cathedral, striving heavenwards, and now shrouded by a passing shower of rain. A free-standing, teetering end-wall will not last much longer. The whole precinct, which was once so fruitful, is now a wilderness, partly overgrown with shrubs and bushes, and even with old and withered trees. This wilderness has even invaded the churchyard, of whose former pious and peace-bringing function there is now no trace. All sorts of strange and imposing tombs, some in the form of sarcophagi, some marked by large, upright gravestones, show how important the diocese was, and what noble and wealthy families rest here. The decay of the tombs themselves is conveyed with great tact and artistic taste, and the eye dwells

19 C. Lieber after J. van Ruisdael, *The Jewish Cemetery*. Sepia. Weimar, Goethehaus.

willingly on it. But then the spectator is surprised, for in the far distance he senses – rather than sees – newer and more modest monuments around which the mourners are occupied – as if the past can leave us nothing but mortality.

But the most important idea in this picture also makes the most picturesque impression. A friendly, otherwise well-behaved stream has probably been silted up and diverted by the collapse of some large buildings, and it is now trying to find its way into the wilderness, among the graves. A shaft of light, which has struggled through the shower, lights up a pair of upright, already damaged gravestones, a hoary tree-stump, and, most of all, the advancing stream of water with its flashing falls and foam.

All these paintings have been copied time and again,[5] and many amateurs will have them in front of them. Whoever is fortunate enough to see the originals will be deeply struck by how far art can and should go.

We shall in the future look for more examples where the artist, in the purity of his feeling and in the clarity of his thought, shows himself to be a poet, achieves a perfect symbolism, and at once delights, teaches, refreshes and revitalizes us by the wholeness of his inner and outward feelings.

NOTES

1. Goethe had seen the Dresden Ruisdaels in 1768, 1790 and 1813, and he was to have received copies of the *Cemetery* and the *Waterfall* for his birthday in 1803 (E. Cassirer, *Künstlerbriefe aus dem 19ten Jahrhundert*, 1919, p. 23). He owned a sepia copy of the former by C. Lieber (Schuchardt, I, No. 64) and our Fig. 19.

2. J. Rosenberg, *Jacob Ruysdael*, 1928, No. 155.

3. Rosenberg No. 467. The figures are by Berchem.

4. i.e. *The Jewish Cemetery* (Rosenberg, No. 154). Goethe also owned engravings of Ruisdael's preparatory drawings (*Conversations with Eckermann*, 17 February, 1830).

5. A copy of the *Jewish Cemetery*, now in Detroit, was the occasion of an attack by John Constable on this type of allegorical landscape (J. Smith, *Catalogue Raisonné of the works of the most eminent Dutch Painters*, VI, 1835, p. 25 No. 60; J. Constable, *Discourses*, ed. Beckett, 1970, p. 64). Constable's view was shared by Caspar David Friedrich's friend and follower, C. G. Carus, who attacked Goethe's use of the word 'symbolic' (*Betrachtungen und Gedanken vor ausgewählten Bildern der Dresdener Galerie*, 1867).

Claude
[*Frankfurter Gelehrte Anzeigen,* 6 October 1772]

Two Landscapes after Claude Lorrain.[1] The product of the warmest poetic feeling, rich in thought, destiny and paradisaical prospects. The first (Fig. 20), engraved by Mason, a morning. Here on the coast of the happiest region of the world, a fleet of ships is landing, watched by the sun, which still gleams palely in the mist above the horizon. Here rocks and bushes breathe the morning air in youthful beauty, about a temple of the noblest architecture, the sign of noble inhabitants. Who are you, landing on these coasts beloved and protected of the gods and blooming with irreproachable nature? Do you bring your armies as the enemy, or the guests of this noble people? It is Aeneas, and the friendly winds of the gods are blowing you into the bosom of Italy. Hail to you, hero! Know your destiny! the divine morning announces a clear day, and may the high sun be the prophet of the magnificence of your empire, and its daily increasing greatness!

The second! (Fig. 21) The sun has set; her course completed, she sinks into the mist and gleams fitfully over a broad prospect of ruins. Night waits beside the rocky forest; the sheep stand looking at their homeward way, and the girls have some difficulty in driving their goats to water in the pond. Empire, you have fallen, your triumphal arches are in ruins, your palaces collapsed and overgrown with bushes, shrouded in gloom, and in your deserted cemeteries the mist glows palely in the sinking sun.

[Goethe to Eckermann, 10 April 1829]

'While we are waiting for our soup, I will give you some refreshment for your eyes.' With these words, Goethe placed before me a volume of landscapes by Claude Lorrain[2] ... 'Here for once you

20 W. Mason after Claude Lorrain, *The Landing of Aeneas in Italy: the Allegorical Morning of the Roman Empire*. Engraving in J. Boydell, *A Collection of Prints engraved after the most capital Paintings in England*, II, John Boydell London, 1772.

21 W. Mason after Claude Lorrain, *Roman Edifices in Ruins: The Allegorical Evening of the Empire*. Engraving in J. Boydell, *A Collection of Prints engraved after the most capital Paintings in England*, II, John Boydell London, 1772.

see a complete man,' said Goethe, 'who thought and felt beauty, and in whose mind there was a world such as you will not find outside of it. The pictures are true, yet have no trace of actuality. Claude Lorrain knew the real world by heart, down to the minutest details, but he used it only as the means of expressing the world of his beautiful soul. That is the true ideal, which can so use real means of expression that the truth which emerges gives the illusion of actuality.'

'I approve of this doctrine,' said I, 'and would apply it as well to poetry as to the plastic arts.'

'It could indeed be applied,' said Goethe. 'Meanwhile, you had better wait until after dinner for the further enjoyment of these admirable Claudes, for the pictures are too good for many to be looked at at once.'

<div align="center">NOTES</div>

1. *Sea-coast with the landing of Aeneas at Latium* and *Pastoral Landscape with the Arch of Titus* (both Radnor Collection), which were published in 1772 as *The Allegorical Morning of the Roman Empire* and *The Allegorical Evening of the Empire* (J. Boydell, *A Collection of Prints engraved after the most capital paintings in England*, II, 1772, pls. LIX, LX). For the late eighteenth-century tendency to pair and interpret Claude landscapes in this way, J. Gage, 'Turner and Stourhead: the making of a Classicist?', *Art Quarterly*, xxxvii, 1974, p. 76.

2. This may have been a volume of Claude's own etchings (Schuchardt I, D, Nos, 66-92), or reproductions after his works (*ib*. Nos. 93-101). Goethe also owned two Claude drawings, one of which he attributed to Elsheimer (Roethlisberger No. 586), and one of which was an imitation (Roethlisberger No. 1116).

The works of Henry Fuseli
[9 August 1797. Not published by Goethe]

The subjects he chooses are all fantastic, and either tragic or humorous. The former play on imagination and feeling, the latter on imagination and wit. In both cases he uses the physical objects only as a vehicle.

No true work of art should seek to play on imagination: that is the concern of poetry.

In the work of Fuseli poetry and painting are always in conflict, and they never allow the spectator to reach a state of quiet enjoyment; as a poet he is prized, but as a figurative artist he always makes the spectator impatient.

Temperament. Early training. Influence of Italy. Studies, which direction he took. Manner in all, especially anatomy, and hence also the poses. Painterly, poetical genius. Characteristics. Certain idiosyncrasies of pleasure, of enthusiasms. Girls in certain forms. Situation. Voluptuous tendency.

Effect of Shakespeare, of the period, of England. Milton Gallery.[1]

NOTE

1. Notes for an unwritten article. For an account of Goethe's intense interest in Fuseli's drawings and engravings, several of which he owned, and for his changing view of the artist between 1779 and 1831, E. C. Mason, *The Mind of Henry Fuseli*, 1951, Appendix III.

22 J. W. von Goethe (? and J. H. Lips), *Copy of Part of a Drawing by Fuseli in Goethe's Collection,* ?1774/5. Pencil. Geneva, Bibliotheca Bodmeriana.

Flaxman's work
[1 April 1799. Not published by Goethe]

I can now well understand how Flaxman must be the idol of all *dilettanti*, for his merits are easily grasped, and, from many points of view, are close to what is generally felt, known, loved and valued. I am speaking here especially of the *Dante*, which I have in front of me (Fig. 23).[1]

A lively, mobile imagination that can follow the poet easily; a tendency towards symbolic suggestion, a gift for transposing himself into the innocent feelings of the Early Italian School, a feeling for simplicity and naturalness. The naïvety of his subjects; a certain taste, I will not say for always composing his figures, but for setting them cunningly on the page; an ingenious, cheerful and at the same time relaxed personality, with which the adventurous and exaggerated, when they occur, make a good contrast. With all this he has, as a sculptor, so much experience of proportions, form and all the other advantages of the Ancients, that he is able to season these casually improvised drawings with a hint of seriousness and substance.

When he deals with Greek subjects (Fig. 24), we see that he has been impressed chiefly by vase painting; in this sense he has done a number of really praiseworthy things, even if they are otherwise his own inventions, and one cannot point to definite copies or reminiscences. Here too he is most successful with naïve and sentimental subjects, as has been noticed in the short review of the various publications.[2] He is usually at his weakest with the heroic. A good deal could be said about these works, if they were to hand for longer in the future, and it would be prettily seen how this ingenious, pleasant phenomenon, which in some ways is not without merit, is nonetheless not to be taken as a model.

It is remarkable that these drawings are conceived so much in series, that there is not one among them that one would want to see completely developed into a picture.[3]

NOTES

1. Goethe owned a number of later editions of Flaxman's *Dante* and *Homer* engravings (Schuchardt, I, p. 219; Ruppert 2450, 2449), but all of them seem to have been first published in 1793 (A. W. Schlegel, in *Athenaeum*, II, 2, 1799, pp. 193-247).

2. This earlier reference has not been traced.

3. That Goethe's view was totally unfounded see R. Rosenblum, *Transformations in Late Eighteenth-Century Art*, 1967, pp. 172 ff. and esp. pp. 176-8.

23 John Flaxman, *Paolo and Francesca*, 1793. Engraving. British Museum.

24 John Flaxman, *Achilles defending the Body of Patroclus*, 1793. Engraving.
British Museum.

Philipp Otto Runge
[Goethe to Runge, 2 June 1806]

I do not want to delay long, my dearest Herr Runge, in thanking you for the engravings,[1] which have given me a good deal of enjoyment. It is true that I did not want all art to follow the course you have entered on, but it is most agreeable to see how a talented individual can so develop his own peculiarity that one can only admire him. We do not believe that we wholly understand your meaningful pictures, but we gladly spend some time with them, and frequently immerse ourselves in their mysterious and charming world. We especially value the significantly precise and delicate execution. When you have time, perhaps you would let me know whether you did the engraving yourself, as the directness of the expression would lead us to suspect.[2] And tell me further whether you would care to send us both of them [sic],[3] illuminated and coloured, rather than fully painted, which would perhaps give us the opportunity to exchange ideas about their colour and meaning. But if you would even tell me something about this in words, it would be a great pleasure.[4] Another request. You cut flowers and garlands out of paper with such facility: do send me some of these when you have time, so that we can enjoy your fertile talent in this too. Finally, I ask you for your silhouette, and hope to be able to do you some good turn in the future.

[S. Boisserée to M. Boisserée from Weimar, 4 May 1811]

In the music-room hung Runge's arabesques, or symbolic, allegorical representations of Morning, Noon, Evening and Night. Goethe noticed that I was examining them closely, took me by the arm and said, 'What, have you not come across these before? Just look at it: it's enough to drive you crazy, beautiful and mad at the same time.' I replied, 'Yes, just like the Beethoven that is being played, and just like everything at the moment.' 'Certainly,' he said, 'it wants

25 Philipp Otto Runge, *Morning*, 1803. Pencil, pen and ink, 71.7 × 48.2cm.
Hamburg, Kunsthalle.

to embrace everything, and so loses itself in the elemental; still, there are infinite beauties in the details. You can just see his devilry; and here, what charm and splendour the fellow could produce; but the poor devil could not keep it up; he is already dead; there is nothing else for it: if you stand on the brink of the abyss, you must either die or go mad; there is no grace.' I am only writing down this conversation for you to show the familiarity and the enthusiasm of the old boy. You can well imagine that there was much more to it than that, and that we both brought a good deal to the discussion ...

<div align="center">NOTES</div>

1. The *Four Times of Day*, 1805 (J. Traeger, *Philipp Otto Runge und sein Werk*, 1975, Nos. 280A-283A). Goethe's favourable review in the *Jenaische Allgemeine Literatur-Zeitung*, in 1807, led to a second edition of the engravings in that year.
2. Runge replied on July 3 that he had not engraved the series himself.
3. Goethe had received all four engravings from Runge.
4. Runge does not seem to have taken up this idea, although later in 1806 he did write a letter outlining his general theory of colours, part of which Goethe published in his own *Theory* in 1810.

Caspar David Friedrich
[*Jenaische Allgemeine Literatur-Zeitung*, 1809]

Landscapes in sepia, drawn by Herr Friedrich.

An artist who holds fast to nature with earnestness and truth, who unfolds his inner self in his works, and strives towards significance, who, in a word, unites the particularity of the general idea with a characteristic rendering of the individual parts, this artist can never lack the support of the public, for he brings new things to light, and, at the same time, has the quiet reward of being right. But even those who are accustomed to making higher demands must praise him, for the endeavour to strike out an individual path itself demands no ordinary courage and talent, and since already in the simple, characteristic, true imitation of Nature an appreciable level of art is attained, there is no reason why the old and tried rules should not be strictly observed.

This is the point of view from which we look at the four large and three small sepia landscapes by Herr Friedrich, of Dresden [*in the 1808 Weimar exhibition*], and hope that they will be regarded by others; and we will give our readers an account of them.

In the first of the four large drawings we see over high hills lit by the rays of the rising sun, and over the tops of dark trees towards the edge of the sea, which, ruffled by a light breeze, is making barely perceptible waves. In the distance rises the steep coastline of an island.[1] On a nearby hill a cross has been erected under tall trees, which bend towards each other to form a natural arch or temple. Farther off stands another cross, and the artist was pleased to introduce in the foreground a real figure, who stands like a statue on a pedestal, and is presumably a symbol of Faith or Hope. The execution shows diligence, and a practised gift for observation: we have never seen the freshness, the perfumed cool of the morning in the wooded valleys between the hills better expressed in monochrome. Nor better and truer the gentle waves of the almost motionless sea. And the slightly misty atmosphere is handled with no less skill.

In the second large drawing the artist has made a memorial to

his family, and for this he has drawn on mystical and religious relationships.[2] Thus the drawing belongs to the category of allegories in landscape. The main object is a ruinous deserted church in the Gothic style, roofless and over-arched by a rainbow. Around it is the cemetery with the future graves of deceased members of the artist's family, and, at this moment, a body is being buried, accompanied by mourners. A cheering ray of light from above falls on the open grave, from which a butterfly emerges to be met by five others above it. This work is no less successful than the preceding one in diligence, and in the precise conception and representation of nature. It would be difficult to find anywhere more masterly and more naturally rendered birches than those around a large tomb by the church, and the lowering, drizzling rain-clouds are no less successful.

The third of the large drawings shows a stormy sea. (Fig. 26)[3] The foreground is simply a narrow strip of shore on which are three old and almost bare oaks and beeches. Under them are large, rugged rocks, and the remainder of the space is lushly grassed, although the whole foreground, except for the trees, is not quite finished. The sky is full of heavy, broken clouds through which, here and there, a few rays of sun are breaking. Black and white stormy petrels swoop over the breakers, and some of them seem to find it difficult to move against them. The truth, which dominates all the finished parts of this drawing, and the piquant contrasts, must please and satisfy every lover of art; but whoever knows the peculiar difficulties of working with sepia wash will admire above all the mastery and freedom with which Herr Friedrich has been able to represent the froth of the breaking waves simply by leaving the paper white. This drawing is now in the apartments of her Grace the Duchess of Sachsen-Weimar and Eisenach.

The fourth large drawing[4] maintains the standard of the others both in the diligent work and in the successful realization of the individual parts. It has the most powerful effect, and it is the best from the point of view of the poetic content of the idea. Behind the tallest peak or summit of a turfed and fir-covered mountain, the sun has already set, and sends up from the depths the splendour of its last rays through the dark, cloudy air. They light up the crucifix which stands on the peak, covered with ivy, between towering crags. The effect of the whole is exceptionally striking, even grand, for the whole dark mass of the mountain peak is powerfully contrasted with the clear twilight glow at the bottom

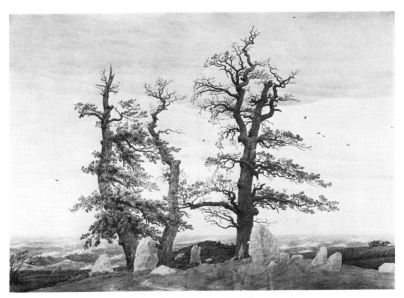

26 Caspar David Friedrich, *Dolmen by the Sea*, 1807. Pencil and sepia, 64.5 × 95cm. Weimar, Staatliche Kunstsammlungen. Kunstsammlungen zu Weimar, DDR, Graphische Sammlung.

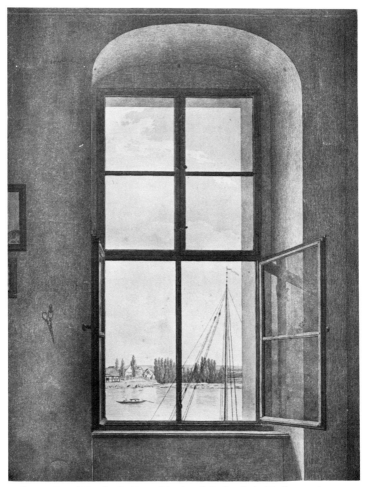

27 Caspar David Friedrich, *View of the Artist's Studio: Right Window*, 1805/6.
Pencil and sepia, 31 × 24cm. Vienna, Kunsthistorisches Museum.

of the picture. The clouds are very well observed, pressing together as they sometimes do around the peak of mountains, like a series of coffers on a ceiling. Some of the pines could not be improved upon, and the same goes for the truthful rendering of the sharp, craggy rocks.

Of the three small drawings, the first shows a window in the artist's house in Dresden. (Fig. 27)[5] Through the lower casement, which is open, we see the mast of a large ship moored on the Elbe and the delightful view over the river. Through the closed upper casement only the sky can be seen. The simple and happily-chosen subject, the skill of the execution, and especially the truth, verging on illusion, with which the artist has shown the difference between a view into the open air and the almost imperceptibly darker trans-parence of the glass, have earned this drawing the applause of all who have seen it.

The second of the small drawings shows a farmhouse at Loschwitz near Dresden, in the midst of rich vegetation.[6] Every-thing is very clear and precisely executed, as is usual with Herr Friedrich, although he seems to have chosen somewhat too close and too low a viewpoint so that the perspective of the building is too steep.

The third drawing, about the same size as the preceding two, shows a Dolmen.[7] Apart from the interesting subject of a record of a mighty pre-historic period, this drawing is also praiseworthy for its excellently realized heavy, but mobile atmosphere.

May Herr Friedrich pursue without delay the course he has so successfully started! He has, in the few years since we praised his prize drawings in these pages,[8] advanced considerably in technical facility and in the power of poetic and painterly invention he now has greater individuality and impetus. Nature, too, seems to have become a close friend of his during this time, for the imitation of it in particular subjects is now far truer, more characteristic, and both more abundant and more powerful than it was.

Weimar. January 1 1809. W. K. F.

NOTES

1. This is probably the lost *Cross on the Ostsee* (H. Börsch-Supan & K. Jähnig, *Casper David Friedrich*, 1973, No. 151).
2. The drawing, *My Grave*, which had already been shown at Dresden in 1804, is lost *(ib.* No. 112). Friedrich's model was Ruisdael's *Jewish Cemetery* (see above, pp. 210-15).

3. *Dolmen by the Sea*, 1807, (*ib*. No. 147) our Fig. 26.

4. The drawing, *Cross in the Mountains*, is untraced (*ib*. No. 146).

5. *View of the Artist's Studio: Right Window*, 1805/6, (*ib*. No. 132) our Fig. 27. Friedrich sent this drawing, with others, to Goethe in 1812, hoping to sell them in Weimar, but without success.

6. The drawing, which was also included in the parcel sent to Goethe in 1812, is lost (*ib*. No. 172/3).

7. The drawing has not been traced (*ib*. Nos. 149/50).

8. In 1805, Friedrich had won part of a prize in the Weimar Prize Competition, for two sepia drawings (*ib*. Nos. 125-6). They were noticed in the *Jenaische Allgemeine Literatur-Zeitung* by Heinrich Meyer, in a flat and summary style, which suggests that the present review is wholly or chiefly by Goethe (see *ib*. p. 64).

Peter von Cornelius
[Goethe to Cornelius, 8 May 1811]

The drawings (Fig. 28)[1] which Herr Boisserée brought have shown me in the most agreeable way what progress you have made, my dear Herr Cornelius, since I last saw your work.[2] The episodes are well chosen and the rendering of them well considered, and the ingenious handling of both the whole and the details is to be admired.

As you have transplanted yourself to a world you have never set eyes on but which is known to you only through old illustrations, it is quite remarkable how well you have made yourself at home in it, not simply in the costume and other extraneous things, but also in the mentality; and there is no question that the more you continue in this way, the freer you will be in your element. But you must be aware of one drawback. The art world of the sixteenth century in Germany, which, like a second nature, is the basis of your work, cannot be regarded as perfect in itself. It pursued its own development, yet, unlike the world of art south of the Alps, never fully achieved its aim. Thus, since your sense of reality is always so clear, you should at the same time exercise your feeling for breadth and beauty, for which these new drawings of yours already demonstrate clearly that you have a remarkable talent, on the most perfect specimens of ancient and modern art.

First of all, I would advise you to study the lithographs of the prayerbook in Munich (Fig. 29), which you surely know already, for I am convinced that Albrecht Dürer nowhere showed himself so free, so ingenious, so great or so beautiful as in these swiftly-executed pages.[3] You are advised, too, to look at the contemporary Italians, of whose works you will find the most excellent engravings in any passable collection. You will thus develop your sensitivity and feeling more and more successfully, and you will readily analyse the significant and the natural into the broad and the beautiful, and render it thus.

I need hardly mention that the neatness and facility of your pen and your great technical skill aroused the admiration of those who have seen your drawings. May you continue to please all amateurs

28 Peter von Cornelius, *Title-Page to Faust*, c.1815. Pen and ink, 48 × 34.1cm.
Frankfurt, Städelsches Kunstinstitut.

29 N. Strixner, *Albrecht Dürer's Christlich-Mythologische Handzeichnungen*, 1808.
Lithograph. British Museum.

in this way, and me in particular, for I have stimulated you with my poem. May you form your imagination to these subjects, and persevere in them so as to be an example.

Herr Boisserée's inclination to reconstruct the buildings of that remarkable period and to bring them before our eyes,[4] agrees so beautifully with your way of feeling, that it is highly agreeable to me to bring the efforts of this worthy young man, and yours, under one roof. I will have a word with Herr Boisserée about how to return your drawings to you.

Take good care of yourself, and let me hear from you again rather sooner, after so long a silence.

NOTES

1. The drawings for Goethe's *Faust*, published as lithographs in 1816.

2. Cornelius had competed in the Weimar Prize Competitions in 1803, 1804 and 1805 (Scheidig, pp. 355 f., 413 ff., 457 ff.).

3. The Maximilian Prayer Book (1515), published in 1808 as *Albrecht Dürers christlich-mythologische Handzeichnungen . . . in lithographischer Manier gearbeitet von N. Strixner*. Heinrich Meyer wrote a lengthy review of this in the *Jenaische Allgemeine Literatur-Zeitung* (Benz, pp. 147-153).

4. See *On German Architecture* 1823, above, pp. 118-23.

Eugène Delacroix [Goethe to Eckermann, 29 November 1826]

'Since we are speaking of Mephistopheles,' Goethe continued, 'I want to show you something that Coudray brought from Paris. What do you think of this?'

He laid a lithograph in front of me, showing the scene where Faust and Mephistopheles dash in the night past the executed criminal on their way to free Margaret from prison (Fig. 30) . . . We took a good deal of pleasure in this ingenious composition. 'You must admit,' said Goethe, 'that no one could conceive it more perfectly than that. Here is another plate; what do you say to that?'

I saw the wild drinking-scene in Auerbach's Cellar, at the most significant moment when the wine flares up, and the brutality of the drinkers is shown in the most various ways (Fig. 31) . . .

'M. Delacroix,' said Goethe, 'is a man of great talent, who has found in *Faust* his proper nourishment. The French criticize his wildness, but here it suits him well. I hope he will go through the whole of *Faust*, and I anticipate a special pleasure from the witches' kitchen and the scenes on the Brocken.[1] You can see he knows life; he has an excellent opportunity in a city like Paris.'

I observed that these designs are very helpful for the understanding of the poem.

'Undoubtedly,' said Goethe, 'for the more perfect imagination of an artist like this obliges us to conceive the situations as well as he conceived them himself. And I must confess that M. Delacroix has surpassed my own conceptions in these scenes; how much more will the reader find them vivid beyond his imagination!'

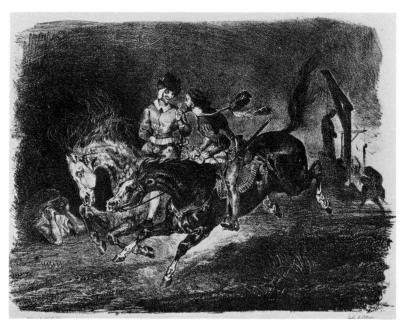

30 Eugène Delacroix, *Faust and Mephisto ride to the Brocken*, 1828. Lithograph.
British Museum.

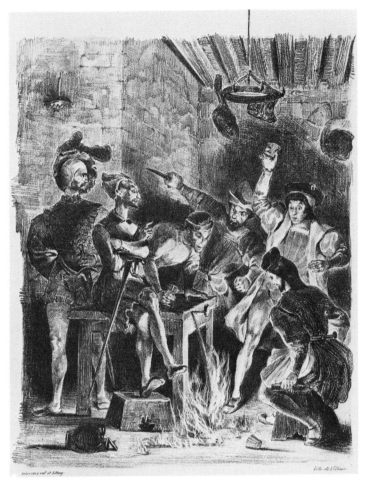

31 Eugène Delacroix, *Auerbach's Cellar*, 1828. Lithograph. British Museum.

Illustrations to Goethe's *Faust*
[*Kunst und Altertum* VI, ii, 1827]

When I see the French translation of *Faust* in a luxury edition before me[2] I am reminded of the time when I first conceived, composed, and, with quite peculiar feelings, wrote down this work. The reception it found at home and abroad, and which has now been demonstrated by this perfect presentation, is probably due to the rare characteristic that it has captured for ever the period of a man's intellectual life when he is tortured by all that flesh is heir to, gripped by all that disturbs mankind, caught by what it is revolted by, and also blessed by what it desires. These circumstances are at present very far from the poet, and the world, too, has a rather different battle to fight; and yet man's situation, in happiness and sorrow, remains more or less the same, and the younger generation will always find a reason for looking about at what has been enjoyed and suffered before their time, and to accommodate themselves, up to a point, to what has been prepared for them.

Now, if the poem is, by its nature, set in a gloomy element, if its scenario is, though varied, generally uneasy, in French, a language which is directed towards observation and understanding, it is already much clearer and more purposeful. And if I now see a folio volume, paper, typeface, printing, binding, all without exception raised to the highest degree of perfection, I almost forget the impression the work still has on me when I look at it again after a considerable time in order to determine its essence and characteristics.

There is one remarkable thing about this: that an artist has made himself familiar with the original conception of the work to such a degree that he has seized all the original gloom, and has accompanied an unruly, restless hero with an equal unruliness in his drawing.

M. Delacroix is a painter of undeniable gifts, yet, as so often happens to the young, he causes a stir among the elder Paris amateurs and connoisseurs, for they can neither deny his merits nor applaud a certain wildness in his handling.[3] M. Delacroix seems here to have found himself at home, and in the family, in a wonderful production, between heaven and earth, between the possible

and the impossible, the most rugged and the most tender, and between whatever other contraries on which the imagination may practise her outrageous game. Thus the luxurious gloss of this book is again toned down, the spirit of the lucid typography is led into a world of gloom, and the primitive feeling of a fairy-tale story is again aroused. We do not feel competent to say anything further; we trust that everyone who looks at this important work will feel more or less the same as we do, and we wish them the same satisfaction.

[*Here followed an analysis by Heinrich Meyer, stressing the sketchy quality of the lithographs and the inventiveness of the subjects.*]

NOTES

1. Neither of these scenes was illustrated by Delacroix (for the whole series, L. Delteil, *Le Peintre-Graveur Illustré*, III (1969)).

2. *Faust, Tragédie de Mr de Goethe, traduite par Mr Stapfer, ornée de XVII dessins par Mr De Lacroix* (1826).

3. It is notable that some Paris critics assessed Delacroix' illustrations very much in Goethe's terms (R. Escholier, 'Le Faust de Eugène Delacroix', *Gazette des Beaux-Arts*, 1929, II).

Further reading

I

W. D. Robson-Scott, *Goethe and the Visual Arts* (London, Birkbeck College, 1967).

N. Pevsner, 'Goethe and Architecture', *Studies in Art, Architecture and Design*, I, 1968.

J. W. von Goethe, *Conversations and Encounters*, trans. Luke and Pick, 1966.

J. W. von Goethe, *Truth and Fiction relating to my Life*, trans. Oxenford, 1903.

J. W. von Goethe, *Italian Journey*, trans. Auden and Mayer (Penguin Classics, 1970).

J. P. Eckermann, *Conversations with Goethe*, trans. Oxenford (Everyman's Library, 1970).

J. W. von Goethe, *Werke* (Hamburger Ausgabe), XII, 1953 (Notes by Herbert von Einem, and extensive bibliography).

G. Femmell (ed.) *Corpus der Goethe-Zeichnungen*, 1958-1973.

C. Schuchardt, *Goethes Kunstsammlungen*, 1848-9.

H. Ruppert, *Goethes Bibliothek*, 1962.

E. von Keudell, *Goethe als Benutzer der Weimarer Bibliothek*, 1931.

H. von Einem, *Goethe-Studien*, 1972.

II

H. Trevelyan, *Goethe and the Greeks*, 1941.

E. Grumach, *Goethe und die Antike*, 1949.

III

W. D. Robson-Scott, *The Literary Background to the Gothic Revival in Germany*, 1965.

H. Prang, *Goethe und die Kunst der Italienischen Renaissance*, 1938.

L. Mazzucchetti, *Goethe e il Cenacolo di Leonardo*, 1939.

IV

G. Varenne, 'Goethe et Claude Lorrain', *Revue de litterature comparée*, XII, 1932.

H. von Einem, 'Goethe and the Contemporary Fine Arts', Council of Europe, *The Age of Neo-Classicism*, 1972.

K. Andrews, *The Nazarenes*, 1964.

U. Finke, *German Painting from Romanticism to Expressionism*, 1975.

A. Feulner, *Der Junge Goethe und die Frankfurter Kunst*, 1932.

A. Landsberger, *Die Kunst der Goethezeit*, 1932 (well illustrated).

R. Benz, *Goethe und die Romantische Kunst*, 1940.

W. Scheidig, *Goethes Preisaufgaben für Bildende Künstler*, 1958.

Index